D0327407

Religion As Art: An Interpretation

SUNY Series in Philosophy
Robert C. Neville, Editor

Religion As Art
An Interpretation

T. R. MARTLAND

State University of New York Press
Albany

Published by
State University of New York Press, Albany

© 1981 State University of New York

For information, address State University of New York
Press, State University Plaza, Albany, N.Y., 12246

Library of Congress Cataloging in Publication Data

Martland, Thomas R
 Religion as art.

 Bibliography: p.
 Includes index.
 1. Art and religion. I. Title.
 N72.R4M33 700'.1 80-27104

 ISBN 0-87395-520-X
 ISBN 0-87395-521-8 (pbk.)

Table of Contents

vii Preface

 1 Overture

 13 Innocence

 27 Fascination

 43 Distance

 65 Craft and Magic

 87 Coalescence

109 Truth-To

133 Verification

159 Reprise

165 Notes

209 Index

Preface

IN THE EARLY Roman army, freemen of the lowest draftable rank were called *accensi*. In battle they would form behind the infantry in order to wait for someone in the front ranks to fall, whereupon they would pick up his sword and shield and join the battle.

I feel somewhat like an *accensus*: the only trouble being that the battle—which is this book—has been waged for so long a period, and has become so much a part of me, that I have forgotten whose swords and shields I have been using. Perhaps it will be obvious to all of you who read the book.

But I have not forgotten who has helped me in little skirmishes along the way, nor more importantly have I forgotten who has helped me wage the battle throughout. Gifts of time were provided by the State University of New York Research Foundation with its three Research Fellowships; technical and moral support was provided by William Eastman, Arnold Foster, John Gunnell, William Hedberg, Berel Lang, G. W. Linden, and Mercedes Randall. Critical, page-after-page support was provided by James S. Ackerman, Robert Neville, and John Herman Randall. It is they who are responsible for many of the merits which these pages reveal without in any way being responsible for the book's shortcomings. Alas, the shortcomings are mine, all mine.

Total support which includes all of the above, and then some, was provided by my friend Agatha, without whom none of the following would have been possible. I thank them all but it is to dear Agatha that I dedicate this book.

T. R. MARTLAND
Barnet Center, VT.

vii

Overture[1]

THE CHAPTERS which follow will consider religion as art. In them I argue that what art does, religion does. They both provide directions on how to see and indirectly on what to do. More specifically, the thesis of this study is that art and religion present collectively created frames of perception and meaning by which men interpret their experiences and order their lives. To follow a cue from Nelson Goodman, each presents something akin to the tailor's cloth swatch or sample, which displays the fabric itself rather than points to or illustrates another fabric that exists somewhere else. Art and religion, like Goodman's sample, display the swatches of 'reality' by means of which men see what 'is,' and from which they create their world. Rather than serving as illustrations which describe men's world, art and religion contribute the fabric of new worlds which men now come to see and understand as their world.[2]

My thesis is related to the rather frequently defended observation that art and religion are human enterprises by which individuals deal with their experiences, especially those experiences which, as Peter Berger points out, are "at the marginal situations in the life of the individual," where death is the "marginal situation *par excellence*."[3] But I will take this observation in the opposite direction. Whereas more traditional research has focused upon how artists and religious people adjust to what already is, my findings, derived from classic formulations and expressions of art and religion, suggest that their activities create what is. As such, they are initiating actions, rather than reactions. The common religious rite of initiation is an example. As the word suggests, it is a way to begin, to commence, to originate. This is the import of Goodman's swatch, which is a sample. Art and religion

1

provide the swatches with which men and women go out into the world, the standards against which they measure everything else. For those who use them, art and religion in a sense contribute the first forms to Plato's "receptacle" (*he hypodoche*), to that *tabula rasa* upon which the new world is to write. (*Timaeus* 50D-51A) Our conscious world is populated by Roman ruins and Italian landscapes ever since Claude Lorrain; by northern landscapes since Jacob van Ruisdael; by Dutch windmills since Jan van Goyen. Claude is a particularly good example, for it was his paintings which taught the English and which in turn influenced Americans to see the formal gardens in the style of Versailles as "artificial" and thus encouraged us all to construct in their place the "more natural" English park.

I will garner the supporting evidence for my argument from within the traditional limits of what ordinary language brackets to-gether as 'religion', that is, from those six currently available social and historical systems or patterns of meaning and regulation around which have gathered a multitude of supporters—Confucianism, Hinduism, Buddhism, Judaism, Christianity and Islam; and from within the tradi-tional limits of what ordinary language brackets together as 'art', that is, from material which since the middle of the eighteenth century men classify as the five fine arts—painting, sculpture, architecture, music and poetry in addition to the dance, theater, literature, and the opera.

1. For the most part, in this study I shall employ object-language in talking about art and religion; my concerns will be of the first-order variety. In other words, I shall talk about art and religion and not talk about talk about 'art' and 'religion'. I shall argue for the thesis that art and religion present collectively created frames of perception and meaning by which men interpret their experiences by citing evidence garnered from art and religion.[4]

But methodologically speaking this is no simple matter, for two reasons: first, as I have already implied, art and religion as such, unlike talk about 'art' and talk about 'religion', do not exist in any place or at any time. The various systems or activities to which we refer are art and religion, they are not variations of the essence Art, or of the essence Religion. Like bursitis and weather, art and religion are useful abstrac-tions elicited from certain chosen phenomena which exist in certain places and in certain times, but they themselves no more exist apart from the phenomena they classify than does the Aristotelian logic of subject and predicate or the commonsense logic embodied in our familiar parts of speech.

The second methodological difficulty is that even when the labels

'art' and 'religion' are usefully applied and do point out something, that which they thus designate does not constitute a single finished or continuing event or a functioning whole. Art and religion are open ideas or concepts, achievements perhaps, and most certainly ideas or concepts with their own histories. Closed concepts, on the other hand, like essences, are taken as given—as subjects of history perhaps, but not as the possessors of histories.[5]

These two difficulties are related. Whereas the first is that art and religion are abstractions which do not exist in themselves and therefore are doomed to being understood through certain chosen phenomena from which they are abstracted, the second difficulty is that even after they are so understood, identified, and labeled, they still are not discrete continuing entities in the way that the Great Depression, for instance, is for the historian. The certain chosen phenomena constituting their base have spaces in their togetherness, which is cemented, it is true, by talk such as the discussion in this book; but obviously such cement is of a different epistemic level from the phenomena which it causes to cohere.

2. For these reasons I shall develop my argument through analysis rather than through synthesis, by way of thesis to evidence rather than by way of detail to summary. For example, I argue that art and religion are similar and therefore must each be doing such and such, rather than that since art and religion do such and such, they must be similar. I acknowledge what already is the case, that as far as art and religion are concerned, meaning takes precedence over description. We cannot say what art and religion do until at least a tentative agreement has been established as to what they are, and this agreement is derived from substantive and methodological interests. Certainly, what is a legitimate example of what religion does, understood as a cultural manifestation, is not necessarily identical to what is a legitimate example of what religion does, understood as a personal experience.[6]

In essence this study does not effect a Husserlian *epoché*, or bracketing off of values. Values are there from the beginning. But this realization points up another difficulty. It is a commonplace that answers and evidence for answers are formed by the questions which we ask. "What is the soul?" inquires Derinda in Dryden's *Tempest*. "A small blue thing," replies her lover Hippolito, "that runs about within us." "Then I have seen it," concludes she, "in a frosty morning Run smoking from my Mouth." (act 5, lines 106-109) Since what constitutes evidence for my thesis is formed by the way in which art and religion are defined, I may be prescribing and not describing, like that ichthyologist of whom, I am

told, sir Arthur Eddington spoke. When the ichtyologist set about studying sea creatures, he made a net of strong cords, knotted at two-inch intervals, and after trawling, ranged the catch on the deck to study its characteristics. Not unexpectedly, his first conclusion was that all sea creatures were at least two inches long.

My defense against such a blunder is this: first, to recognize that without theses we will catch nothing; but second, to recognize that though theses provide meaning, they do not prove meaning. Art and religion are infinitely dense concepts. Given the impossibility and even the undesirability of illustrating religious and artistic phenomena by presenting a full-scale inventory of all their cultural and historical contexts, I narrow my focus here to a legitimate facet of their designated character; in short, I choose to collect *representative* data. This move is not unusual. History, too, without general structural schemes to classify, order, and organize its data, would lose itself in a boundless mass of disconnected facts. As Pieter Geyl attests, "Every historical narrative is dependent upon explanation, interpretation, appreciation. In other words we cannot see the past in a single, communicable picture except from a point of view, which implies a choice, a personal perspective."[7] As such, Eliade, the historian of religions, compares his situation with that of the depth psychologist. "One, like the other," he writes,

> is obliged not to lose touch with the given facts; they follow empirical methods; their goal is to understand 'situations'—personal situations in the case of the psychologist, historical situations in the case of the historian of religions. But the psychologist knows that he will not arrive at the understanding of an individual situation, and consequently cannot help his patient recover, except insofar as he can succeed in disclosing a structure behind the particular set of symptoms. . . the historian of religions proceeds no differently.[8]

From the standpoint of information theory, though the boundless full-scale inventory of facts has high information content, it has little communication value until the information becomes predictable, until its randomness is structured by finite and ordered systems of probability relationships.

But we must also remember our second qualifying point—that theses, though necessary, are not sufficient. Saying something does not make it so. Theses do not of themselves prove their meaning. Though Ramakrishna speaks approvingly of that fabled species of birds called Homa—birds which live so high up in the heavens that they never touch ground—and compares the likes of Nârada and Jesus to them, I

myself in this study must constantly be in touch with the ground.[9] In arguing with and for a system of probability relationship I must constantly refer back to the evidence and continually appeal to fresh data which arise independently of those from which my thesis is derived. Eliade concurs, going on to note that "the psychologist improves his means of research and rectifies his theoretical conclusions by taking into consideration the discoveries made during the process of analysis," and points out that "the historian of religions proceeds no differently."[10]

3. These methodological observations make clear why I characterize this study as an interpretation: it displays only the essentials which its thesis entails, and does not pretend to be an inclusive description or summary of art and religion. For example, I will not introduce those aspects of art and religion historically unique to particular societies. Although I am aware that primitive cultures, the Middle Ages, and the Renaissance, have a very different understanding of what it is that art and artists, religion and religious people do, and very different conceptions indeed of their relative social positions, these considerations contribute little toward my argument that religion does what art does. What we need is evidence of a different sort, evidence relevant to the nature of the thesis.

This selective displaying of appropriate evidence in defence of a thesis is characteristic of interpretations. Consider Peter Gay's historical study, *The Enlightenment: An Interpretation.* His very first sentence declares, "There were many philosophes in the eighteenth century, but there was only one Enlightenment."[11] A few pages later, he defines that one Enlightenment as "the dialectical interplay of their [the philosophes] appeal to antiquity, their tension with Christianity, and their pursuit of modernity" and sums it up with the assertion that "the Enlightenment was a volatile mixture of classicism, impiety, and science; the philosophes, in a phrase, were modern pagans."[12] Appropriately, he spends the rest of the book arguing for his thesis; first, by pointing out the philosphes' appeal to antiquity; second, by pointing out their tension with Christianity. He ends with a discussion of David Hume, "The Complete Modern Pagan," who "more decisively than many of his brethren in the Enlightenment, stands at the threshold of modernity and exhibits its risks and its possibilities . . . Hume makes plain that since God is silent, man is his own master."[13]

In studies such as Gay's, however, where the subject under scrutiny can be determined to exist in a particular place and at a particular time, and therefore constitutes a single finished or continuing event or a functioning whole, appropriate evidence is statistically indispensable

and can once and for all prove or disprove his thesis. On the other hand, in studies such as mine, where the subject under scrutiny is not a single or continuing event or a functioning whole, and does not exist in any particular place or at any particular time, I have to deal with what Gallie calls "essentially contested concepts," and the appropriate evidence is at best individually indispensable.[14] This limitation does not vitiate my claim to objectivity. The evidence advanced for my thesis— that art and religion do present frames of perception and meaning by which men do interpret their experiences—is taken from the appropriate data. The evidence is neither imposed nor prescribed. Nevertheless, since it is true that the concepts of art and religion are essentially open and contestable there is always more than can be said; disagreement may arise on the basis of the weight given to the evidence. The question of weight is important, and more will be said about it in section 6.

4. My search for individual and indispensable evidence also allows the omission of certain important developments in art and religion, for example, that seventeenth-century Dutch trend, made general with the Industrial Revolution, during which art—but not religion—became free from service to ecclesiastical patrons and land owning nobility, only to find itself subject to the whims of a public taste. In religious affairs, Luther's advice to the German princes to oppose the 1524-1526 Peasants' Revolt (which called for certain religious privileges, such as freedom to elect their own pastors) makes especially clear religion's lack of such freedom. Although at first glance this evidence would appear to damn my thesis, it is actually peripheral to the argument. As I explore the implications of my thesis in the first chapter, the necessary and indispensable data for supporting it will turn out to be demonstrably of a different sort.

What distinctively marks art and religion is not their serving things past, but their providing necessary equipment to move into the future. In chapter 1 I shall argue that art and religion are guides for action, certain ways of approaching or looking at the world. Thus what makes certain activities artistic or religious is the way they are used, what they do. We take them as patterns of meaning, frames of perception, or paradigms, by which we interpret our experiences and draw conclusions about the world. As such, Clifford Geertz points out, religious beliefs—and, we add, artistic beliefs—in contrast to scientific or philosophical beliefs, for example, are not conclusions from experience but patterns of meaning or frames of perception prior to experience. The world, he says, "provides not evidences for their truth but illustrations of it."[15]

What is expected of artists and religious people is akin to what Proust tells us we expect of ocultists: each is to provide us with a new pair of glasses with which we can see the world, and these glasses are quite satisfactory, "until the next Geological catastrophe is precipitated by a new painter or writer of original talent."[16] Art and religion are those kinds of activity that intervene in the world, or, following J. L. Austin, that "perform" (see below, chapter 5).

Consequently, we must look at the arts and the religions themselves, and at what they do. We must examine the socially available, constructed patterns of meaning which they offer to men and in terms of which men order their lives. William Gass dramatizes this very well:

> Think, for instance, of a striding statue; imagine the purposeful inclination of the torso, the alert and penetrating gaze of the head and its eyes, the outstretched arm and pointing finger; everything would appear to direct us toward some goal in front of it. Yet our eye travels only to the finger's end, and not beyond. Though pointing, the finger bids us stay instead, and we journey slowly back along the tension of the arm. In our hearts we know what actually surrounds the statue. The same surrounds every other work of art: empty space and silence.[17]

In this sense it is irrelevant whether a work of art is the result of a donor's commission or an attempt to sell a commodity on the open market, whether a religious utterance is a result of an individual feeling of glorification or a communal feeling of impotence. What counts are the activities themselves and what they do.

5. Much of this relates to how we attend to the conservative aspect of art and religion, that aspect which does anything *but* move into the future, which does in fact serve those feelings, goals, or techniques which men *already* sharply understand and already have defined. Both art and religion obviously do, to some extent, serve structures and needs men already know. Many of man's most important religious activities are simple attentions to gods and customs which he long has loved and cherished. Occasionally such conservatism even dominates a total religious expression, as it may have done in ancient Egypt.[18] In any case, it is always present. For example, although the Israelite Old Testament records that by the middle of the eighth century B.C., devotion to Baal—a god not unlike the Greek Dionysus, a god to whom votaries "cut themselves after their custom with swords and lances until the blood gushed out upon them" (I Kings 18:38)—dominated the land of Canaan, other Near Eastern texts suggest that though the people may have belonged to Baal, Prince Lord of Earth,

nevertheless it was El the King,—a god not unlike the Greek Apollo—
The Father of Man, The Creator of Creatures, who reigned supreme.[19]

The pervasiveness of this conservative element is no less marked
in art. Schiller, for one, finds room for such conservatism in his rec-
ognition of what he calls naive poetry written by the "realist" (Homer,
say, or Shakespeare) who revels in a nature already accepted, as con-
trasted to sentimental poetry, written by the "idealist" (not surprisingly,
himself) who revels in elevating that nature via free spontaneity. He
concludes that "in the final analysis, we must nonetheless concede that
neither the naive nor the sentimental character, each considered alone,
quite exhausts that ideal of beautiful humanity that can only arise out
of the intimate union of both."[20]

A readily available example which gives substance to his conces-
sion to conservatism is furnished by the Gothic cathedrals of Europe.
First there is the twelfth-century choir of the French abbey of Saint
Denis, "the edifice that became the prototype of the Gothic cathedrals.
Its builder, the Abbot Suger, sensed the significance of his achievement;
he attempted to define its meaning for the benefit of his contemporaries
and of posterity. To this end he composed a treatise in which he
described the new building and interpreted the important elements of
its design."[21] Immediately followed Notre-Dame of Paris, Bourges, and
Laon, and by the early thirteenth century the Gothic as a type was
perfected with Chartres, Reims and Amiens.

How then do we attend to these data? Negatively. We use them to
suggest how art and religion can fall away from doing what we argue
they do. If "decadence" still suggests a falling away from a standard—
in this instance, a falling into a reliance on a formula or fashion which
art and religion are unable or unwilling to expand further—then a
"naive" or a conservative art and religion could be considered decadent
if they have little power to transform or create their world. An example
would be that after Amiens we have Cologne, after Reims, Westminster
Abbey. As I will suggest in chapter 3, however, such a falling away is a
matter of degree. Thus we speak of these artistic and religious activities
which fall away from creating their world as minor or secondary; they
are activities that tend to cling to the prior ideas or life styles which
encapsulate them. In these cases Geertz's observation is challenged;
minor or secondary art and minor or secondary religion do not so
much dictate to experience as they tend to be conclusions drawn from
experience. Gass's striding statue no longer stands in empty space and
silence.

A great deal of the foregoing is elaborated upon in chapters 2 and 4. There I consider art and religion not as cultural components actively functioning in society but as carriers of other meanings or purposes beyond themselves, to the 'given' which they 'represent;' to the feelings, goals, or techniques they wish to conserve. Notice though, what is at the root of my negative evaluation. With an art and religion dominated by these concerns the focus of our consideration has shifted from what they actually do, to what they intend to conserve, to what they might have intended to do before they did what they did; and these two are not necessarily one.

6. The matter of weighing the evidence, broached in section 3 above, now comes into play. Because my accumulated evidence is selective, and because I am dealing with first-order material whose subjects are at root open and "essentially contested," my thesis is vulnerable to the counterexample. No single example can be decisive in proving or disapproving it. For this reason it is more accurate to speak of inference than to speak of entailment, to think of justifying the thesis rather than verifying it. As such, my logic is closer to that used in everyday situations than the idealized kind found in the classroom: "Does she love me or doesn't she?" "Is this dirt road passable?" "Should I take the job or shouldn't I?" Likewise, I ask, "Does religion do what art does?"

John Wisdom adduces a broad social example from courts of law, in which the judge settles questions such as whether somebody "did or did not exercise reasonable care, whether a ledger is or is not a document, whether a certain body was or was not a public authority." These are cases where there is "a presenting or representing of those features of the case which *severally co-operate* in favor of the conclusion, in favor of saying what the reasoner wishes said, in favor of calling the situation by the name which he wishes to call it."[22] Lawyers selectively cumulate independent and inconclusive premises which cooperate in favor of a particular decision; the judge then weighs the premises' massed effect, his decision compelled by their weight. The "massed impact" clarifies the situation; yes, we say, the road *is* passable. At its best the clarity is considered a justifiable one, never irrational, even for those who still disagree and had thought the drift of the argument was ambiguous or even going in the other direction. This is in part what it means to say there will always be reasons or counterexamples for thinking otherwise than my thesis indicates. But once someone sees a given argument or makes a certain decision, these other reasons have little weight for him

and no longer count. There is still a sensitivity to observables; but those observables that count come to do so through the cumulating argument, which, if determined to be true, establishes a base for further selective observation.

Of course, I am suggesting that the thesis that art and religion do provide frames of perception and meaning by which men interpret their experiences is to be argued in this way. The massed impact of the accumulating evidence will make things clear. My method will be not unlike that of the proverbial detective who begins with an important clue which others have overlooked, around which he constructs a tentative hypothesis, which he then proceeds to defend by massing evidence in its support. What follows in the chapters ahead is his second step. The clues have already suggested the formulation of my thesis, and I am now intent upon cumulating evidence which fits and reinforces it. It remains for the reader to consider the thesis and its evidence, and then to decide whether it is well founded. My parallel with the detective will hold even if the reader judges the cumulative evidence to be of insufficient weight, not cooperating sufficiently in favor of the hypothesis. As good detectives go back to the beginning once again to look for clues of a more substantial sort, so will I. Just as lawyers do not die with their clients nor doctors with their patients, neither shall I die with my theses. But this does not mean I will let go of them prematurely. As long as they have any life left in them I will fight to their death.

7. One final observation remains. If the truth of the thesis is to be determined by the weighing of accumulated evidence which only cooperates in favor of a decision, that decision itself becomes a cooperative venture which also involves the individual who makes the decision. Once again we are reminded of the impossibility of bracketing off values so far as art and religion are concerned. Not only are we involved in the selection of evidence and the manner of accumulating it, but we are also involved in deciding whether its weight is sufficient to carry the thesis. Arguments of this sort do not resolve themselves. We decide. The accumulation is or is not a compelling accumulation, the weight is sufficient or it is insufficient, only given a willingness on our part to go along with the accumulation, to weigh, and finally, to decide. What this means in the pages ahead is that we can never be like that sailor on the Bounty who when awakened from his sleep by the noise of the mutiny, lay still in his hammock quite undecided whether to take part with the Captain or to join the mutineers. "I must mind what I do," said he to himself, "lest, in the end, I find myself on the weaker side."

Finally, on hearing that the mutineers were successful, he went up on deck, and seeing Bligh pinned to the mast, he put his fist to the Captain's face and declared his position. We cannot be like him because without us there will be no stronger or weaker side. The argument needs our participation in order for us to approach a conclusion.

8. With all of this said and done, for whom is this book written and what is the significance of its thesis? Who are the 'we' who are fated to be on deck from the beginning, and just what will 'we' accomplish by contributing that kind of provisional receptivity without which there will be no accumulating argument?

In a technical sense, 'we' means philosophers, because this study uses philosophical tools and appeals to philosophical traditions without apology, for example in the already obvious adherence to Strawson's distinction between 'sentences' and 'statements'—sentences as combinations of words which are meaningful or meaningless, and statements as cognitively significant sentences.[23] More inclusively, 'we' means simply everyone who is preoccupied with religion and/or art and wishes to incorporate an understanding of these activities into a comprehensive world view.

Still, the 'we' will not include everyone who is preoccupied with religion and/or art. Just as there are certain philosophers who are preoccupied with topical disputes clearly defined in aesthetics and philosophy of religion—for example, "Is a deductive causal demonstration of God's existence possible?"—for whom this book will be irrelevant, so there are certain anthropologists who are preoccupied with anatomical evaluations of African face masks; certain bishops who are preoccupied with the impact of religious education on moral behavior; or certain Marxists who are preoccupied with the benefits which art brings to the masses of the people, for whom this book will be irrelevant. Their interests encourage them to fight on a different deck, as it were, with weapons forged to deal with current questions they have already defined whether with clearly distinguished terms or with what I referred to in section 1 as closed concepts. Whereas we might be on the bridge arguing with the Captain concerning which harbor art and religion will enter to have their keels overhauled, certain historians might be in the engine room arguing with the Chief Engineer on how art and religion came to be where they are, or certain psychologists might be in the galley arguing with the Cook about whether art and religion supply sufficient nutrients on board to keep their crews fit, or certain sociologists might be in the chain locker arguing with the First Mate as to the effect of dropping anchor here, or possibly there.

This may be the key. This book and its thesis is of immediate interest only for those who are working with art and religion as open concepts, for whom the question of overhauling and refitting bears significance. For the others, this book will be of interest only if we succeed in pinning Bligh to the mast, only if my thesis makes its way and I successfully raise new questions about art and religion and how they function in society. For example, an anthropologist interested in studying art among the Australian aborigines might well focus his attention upon particular found combinations of line, mass, color, that seem capable of arousing aesthetic responses. It is clear that he has already hypothesized what 'art' is—doubtless rather arbitrarily, but perhaps necessarily. In aboriginal Australian languages there are no separate words for 'art', or for that matter, for 'artist'. Either our anthropologist arbitrarily defines 'art' and begins his research, or he looks for evidences of it in its relation to other activities such as religion or economics, and in terms of its social implications. But what is this 'it' for which he looks? It is here that my thesis is relevant, if, as I say, I succeed here and now in pinning Bligh to the mast. I suggest a direction in which he can look; not toward those activities that express things past, which, I will argue in chapter 4, may be merely crafts executed by technicians, but toward those activities that lay out the roads leading into the future.

My thesis says that art and religion do not so much express fundamental feelings common to mankind as determine these feelings; they do not so much provide explanations for phenomena which men cannot otherwise understand as provide those data which men have difficulty understanding; they do not so much provide security or ways of adjusting to phenomena which men cannot otherwise handle as interpret the world in such a way that phenomena are delineated which men seem not to be able to handle. As I have said before: art and religion provide the patterns of meaning, the frames of perception, by which society interprets its experiences and from which it makes conclusions about the nature of its world. They tell us what is; they do not respond to what is. It is incorrect to think that they provide stone axes with which to enter the forest, whereas the sciences, for example, provide steel ones; to think as if the two are doing the same thing, albeit one more efficiently than the other. My thesis suggests a priority, not a parallel: Art and religion come first; the sciences follow. The first declares or determines what is, perhaps secondarily declaring or determining what needs to be done; the second responds, and does.[24]

But saying all of this does not make it so. I must argue my thesis. Let me begin.

Innocence

"To succeed thus in gaining recognition, the original painter, the original writer proceeds on the lines adopted by oculists. The course of treatment they give us by their painting or by their prose is not always agreeable to us. When it is at an end the operator says to us: 'Now look!' And lo and behold, the world around us (which was not created once and for all, but is created afresh as often as an original artist is born) appears to us entirely different from the old world, but perfectly clear. Women pass in the street, different from what they used to be, because they are Renoirs . . .The carriages, too, are Renoirs, and the water, and the sky . . . Such is the new and perishable universe which has just been created. It will last until the next Geological catastrophe is precipitated by a new painter or writer of original talent."

Proust

A writer on scholarly matters has an obligation to define his terms. This obligation stems from two related assumptions: (1) that a writer's discussion can only be fruitful if the author is at first quite clear about what it is he is writing, and (2) that a writer does not quite know that about which he is writing unless he can define his terms. Schopenhauer is typical of someone who makes such demands. He writes,

> Whoever is himself clear to the bottom, and knows quite distinctly what he thinks and wants, will never write indistinctly, never set up wavering and indefinite concepts, or pick up from foreign languages extremely difficult and complicated expressions to denote such concepts, in order to continue using such expressions afterwards.[25]

Similarly, Wittgenstein insists, "What can be said at all can be said clearly," and then willingly vows "to say nothing except what can be said."[26]

13

The matter contains further complications, however. Although it seems self-evident that a writer who is *not* quite clear about what he is writing will not be able to define his terms, it is not obvious that conversely a writer who *is* quite clear about his subject necessarily will be able to define his terms. For example, biologists concerned with reproducing life are clear as to what they wish to reproduce, but they have trouble defining it. If we nonbiologists insisted on a definition, they probably would specify an essential property or two which they would assert must be present for life to exist. 'Reproduction' is too broad a term, because in a way rain drops could be considered to reproduce when they reach a certain size; so is 'growth' or 'evolution', because in a way ideas also grow and evolve. Perhaps the biologists would settle on the biochemical capacity for metabolism, the capacity to take in simple substances from the environment and to build those up into the increasing complexity of the physical body. In that case, then to be alive is to be able to metabolize. Yet this is not so much a definition of what life *is* as it is a description of what life *does*, and to assume these are the same is to conflate the criteria for determining the meaning of what life is and the evidence by which we know what life is. In other words it is to ignore our inclination to think it is one thing for life to be what it is and another thing for us to know or have reason for believing life is what it is. Nevertheless, the biochemical capacity to metabolize may be the best definition that biologists can offer.

There is yet another difficulty with this insistence upon the necessity of definition. A writer cannot and should not define his terms initially if his task is not to represent or clarify these terms as we or he know them at the outset of the discussion, but to extend or to deepen their meaning as the discussion progresses. Rather than being intent upon directing the reader's attention to a clarity already existing in the author's mind, certain discussions are designed to involve both author and reader in a process of understanding which the author himself is working out. In discussions of this sort,

> "Words strain,
> Crack and sometimes break, under the burden,
> Under the tension," [27]

but in the end,

> Handling and use by able minds give value to a language, not so much by innovating as by filling it out with more vigorous and varied services, by stretching and bending it. They do not bring to it new words, but they enrich their own, give more weight and depth to their meaning and use; they teach the language unaccustomed movements, but prudently and shrewdly. [28]

These two difficulties are relevant to this inquiry into the nature of art and religion because, as suggested in the *Overture*, art and religion have no essence to define. At one time or in some place, men have considered almost every human activity or natural object as having had artistic or religious significance. This fact suggests that, at least potentially, everything is artistic or religious, or better, that nothing, in terms of what it is, in terms of its particular essence, is necessarily artistic or religious. Thus, if we insist upon asking "What is art?" or "What is religion?" like the biologist, we too can best direct our inquiry to what art and religion do, how they function. Since no-thing is artistic or religious by nature, everything which is artistic or religious is artistic or religious because it functions artistically or religiously.

This then will be my point of departure. I am interested in understanding what is art and what is religion. Because of the diverse nature of the material which society accepts as art and religion, I will try to understand these activities by asking, "What do art and religion do?" This emphasis is quite in harmony with various etymological associations of the two words. *Ar*, the Sanskrit root of 'art' means to join or to put together; *artizein* means to prepare. It is the same with the two traditional derivations of the Latin word *religio*. The first, *relegere*, means 'to gather together', the second, *religare*, means 'to bind' or 'to tie'. All of these derivations suggest that art and religion are activities which do something with what has come before. Their focus is not on what is prepared or gathered together but on the activities of preparing and gathering. Art *is* preparing, religion *is* gathering.

It is the same with the religiously associated Sanskrit words *Dharma* and *Upanishad*. Although the root of *dharma* is *dhar*, which means 'to hold', 'to sustain', or 'to maintain', that which the religious person holds is not what already is (for example, an experience or a feeling, not even a dogma), but a path. As for the *Upanishad*, it comes from the verb *Sad*, 'to sit', from *Upa*, meaning 'under', and from *Ni*, akin to 'beneath', obviously suggesting an instruction at the feet of a master, or because of the existence of the Upanishads themselves, equally obviously, a sitting at the feet of the master, or a reading of the texts, which would take the place of the master. The stress however, is upon the act of sitting, and if it be feared that our sense of religious doing is being unduly compromised even before we have a chance of pinning it down, remember what the pupil learns by sitting at the feet of a master or by studying a text is not dogma or a particular fact which already exists, but an activity or a method which the master or the text recommends as fruitful for achieving a particular wisdom. Thus, like the Buddha,

whose most noble truth is an eightfold path or a method to follow, so the Upanishads' most noble truth is a discipline. Insofar as there is content, it usually is advanced as that which will help lead the one who sits into wisdom, itself being of no more value than the Zen initiate's koan: a raft having no value in itself, something which the religious person must transcend.

> "(By me) is made a well-constructed raft," so said Bhagavat,—"I have passed over (to Nibbana), I have reached the further bank, having overcome the torrent (of passions); there is no further use for a raft."
>
> *Dhaniyasutta* II 4. 21

To understand art and religion as activities which do, whose contents are or value only so long as they lead to different shores, allies art and religion with Montaigne's previously cited "words [which] teach the language unaccustomed movements." In so far as they are effective they each lead the way to where men are heading, to understandings which will emerge, not to understandings men already possess. This explains why religious claims are so often proclaimed in terms of an insufficiency. For example, Cyril of Jerusalem unhesitatingly admits, "We do not declare what God is but we frankly confess that we have no exact knowledge concerning Him . . . On the subject of God, it is great knowledge to confess our ignorance."[29] A more general sense of insufficiency is expressed by the Eastern concept of the 'void', the 'nothing' of the West, and liturgical silence. This in turn can easily be reflected in a dissatisfaction with that which already is or that which men already know. Two examples are religious doubt and the Christian concept of original sin.[30] But the word which most forcefully catches this dissatisfaction is *māyā*, illusion. Hinduism and Buddhism assert that the world is *māyā*,[31] and their writers repeatedly tell us that "there is no happiness in anything small [finite]. Only the Infinite is happiness. But one must desire to understand the Infinite" (*Chandogya Upanishad* VII. 23. 1).

That Collect in the 1945 edition of the Anglican *Book of Common Prayer* which refers to God's service as "perfect freedom" reflects this same sense of dissatisfaction, but it focuses upon the necessary follow up, upon the positive, almost gleeful awareness that through religious activity old things are left behind and new things emerge. In traditional Christian language the Collect suggests that God's service, or simply "good works," is a freedom from the world and a freedom to work toward new relationships and new understandings. God's service is

perfect freedom. It detaches and it creates. The *Svetasvatara Upanishad* speaks of the former when it asserts that "he who knows God is freed from all fetters" (V. 13). The *Mundaka Upanishad* celebrates the latter when it asserts that "he, verily, who knows Supreme Brahman becomes Brahman himself" (III. 2.9). The relevant commandments are "Thou shalt make onto thyself no graven images" and "thou shalt make for thyself a god who shall go before thy face." The gods which men serve are not images of what has been, but forces which lead into what will be. Their function is always to go before men's faces, to lead them into or to reveal that by which they come to see what they previously have not seen. Religion, therefore, sometimes manifests itself as transgressing the social norm, as feasting, or as spending one's resources. Such behavior is prohibited for those who are tied down by convention or tradition, but it is permissible for those who are prepared to effect new visions, relationships, and values.

A good practical everyday example of religious activity doing this detaching and creating is prayer. Consider, for example, the hunter's association of today's ritualistic dancing and drumming with the success or failure of tomorrow's hunt, and the confidence of the devotee who knows that, as he prays or offers sacrifice, he has, in an incomprehensible way, an effect upon God. Each person knows that somehow he shapes what will be, that what he is doing is not a charade which merely affirms what already will be, but an efficacious activity which contributes to that future, even if it is only the individual's own. "As the spider moves upward by the thread, obtains free space, thus assuredly, indeed," so the *Maitri Upanishad* insists, "the meditator moving upward by the syllable *aum* obtains independence" (VI. 22).

Art too detaches and creates, as Picasso, for example, realized well. Alice B. Toklas reports, "After a little while I murmured to Picasso that I liked his portrait of Gertrude Stein. Yes, he said, everybody says that she does not look like it but that does not make any difference, she will, he said."[32] In one important context in which he uses the term *mimesis*, Aristotle agrees with this characteristic of art. That context involves, first, his denial of the existence of an ideal world apart from our natural, everyday world; second, his assertion that in its place there is only a concrete *ousia*, that which is common to individuals and which exists only in and through the individual species; third, his concept of the relation of *ousia* to activity (*energeia*), that kind of action in which the goals or ends are one with the action itself (*Metaphysics*, 1048b9ff; *Physics*, 199a12-19). In other words, though Aristotle postulates that art

imitates nature, it imitates a nature which is activity, which creates or produces something that has no place apart from the activity itself. By so acting, art and nature—and, we add, religion—change what is. The artist who, directly or indirectly, molds clay, chips marble, welds steel, casts bronze, or lays pigments onto a canvas, who, directly or indirectly, plans buildings, sings songs, plays instruments, enacts roles or dances, also, directly or indirectly, detaches us from old understandings, from old ways of seeing things, and creates new ones. Everybody now sees Gertrude Stein with the help of Picasso's portrait, including Picasso. As he said, for those who look, Stein comes to match the portrait.[33]

Aristotle's own examples are music and poetry. Consider the writing of a poem. Of course there is a motivating experience, which demands an expression in the form of a poem, but just as "Gertrude Stein before Picasso" and "Gertrude Stein after Picasso" are not the same, so the motivating experience and the expression of it in the form of a poem are not the same. Quite simply,

> A poem is never a put-up job so to speak. It begins as a lump in the throat, a sense of wrong, a homesickness, a lovesickness. It is never a thought to begin with . . . It finds its thought and succeeds, or doesn't find it and comes to nothing. It finds its thought or makes its thought . . . It finds the thought and the thought finds the words. Let's say again: A poem particularly must not begin with thought first.[34]

Note that the motivating experience of the lump in the throat and the rest limits the perfect freedom of the unwritten poem in it that it begins it, but the poem in finding its thought about that experience articulates it in such a way that the poet and we who pay attention to the poem come to understand the motivating experience differently. It is as if the poet has only a little idea of what he wishes to say until he says it; seemingly, the words themselves take on a life of their own and transport both audience and poet to a fuller understanding. It is as if what he wishes to say becomes clear only as the poem takes shape in his mind, even as clay takes shape in our hands. Thus, rather than constituting a technique to reinforce the fetters of the motivating experience, the poem comes to be its own end. For the poem to "succeed," the poet has to be willing to let go, or as Frost puts it, to let the poem "find its thought."

The most serious challenge to our assuming that art does detach and create in this manner will come from important painters such as Courbet who unemotionally depicted the activities of the common

man, and thereby earned the admiration of Zola, and from important propagandists such as Mao Tse-tung, who, in 1942 insisted that "we must . . . repudiate all works of literature and art expressing views in opposition to the nation, to science, to the masses and to the Communist Party."[35] In their diverse ways each conceives art as that which repeats or 'represents' the motivating experience. Their claim is that painting a picture or writing a poem is but putting down on paper an experience which the painter or the poet has already had (that is, Gertrude Stein, a lump in the throat, "reality," the ideals of the Communist party, even the lines of the unwritten poem). In one respect they are indeed correct; art does express forms which already exist in nature. This challenge to artistic creativity is effective, however, only if the representation they insist upon is naive; that is, if before the painter paints a portrait or the poet writes a poem, each knows and can state the specifications of the work he is to do in the same way the carpenter can state the specifications of the table that he is about to make.[36]

But artists have always hesitated to accept this naive view of representation, most clearly on the physical level. History supports their hesitation. If their activities were naive at their core it would be reasonable to expect that more naive, literal, pictorial representations —albeit with perspective distortions—would become evident as more and more paleolithic animal paintings were discovered, and that constant later modifications aimed toward perfecting these elementary expressions would be equally evident as artists became more capable. This is not in fact the way art has evolved. As Arnheim notes, "Representation started genetically with highly simplified geometric patterns, and realism was the late and laboriously accomplished product of such sophisticated cultures as Hellenism and the Renaissance."[37]

We also know that even before 1563 when certain groups of painters, scupltors, and architects broke away from their respective craftsman's guilds to form the first Academy of Art, Florence's *Academia del Disegno*, artists thought of themselves only as imitators in the Aristotelian sense just noted. This to say they understood their task to be the attempt to imitate a God who is pure act, a creator God who produced that meaning and structure which men come to understand through Scripture. They believed that through their artistic activity, also properly interpreted, men also could achieve a new understanding. Thus they too scorned naive attempts to represent things of the sense and insisted that the artist should never depict nature, the ordinary sensible nature, the theologically fallen physical world, but only what could be, and was, once upon a time: a divine order that was mirrored and interpreted in the classical and Boethian myths of the

Golden Age and that had existed in Eden before the Fall. The artist who designed the south transept window in Chartres Cathedral tried to express this outlook. The window tells us that along with him, men can experience this golden vision if they too but take their stand with Christ and look out from that great height occupied by the evangelists Matthew, Mark, Luke, and John, who in turn rest on the shoulders of the prophets Isaiah, Ezekiel, Daniel, and Jeremiah.

Ananda K. Coomaraswamy, writing about art theory in the East, also questions the existence of a tradition of a physical, naively representational art. He insists that the criteria for good art, as distinct from what he calls 'decadent' art, have always been its "degrees of vitality, unity, grace, and the like, never of illusion."[38] By the word 'illusion' he means, of course, the world of sense experience, *māyā*. Thus " 'Realistic' art must be regarded as 'decadent'," of interest only for those "civilizations that fear death."[39] He tells us that in India, for instance, only amateurs practice representational portraiture, and in China, Cambodia, and Java there have been no serious attempts to practice portraiture. The closest acceptable activity to this kind of representation is Chinese *fu shen*, "portraying the divine image in a man," that is, producing the "exemplary elements" or what sometimes is called, the glorified body.[40] Obviously, as in medieval Europe, there is little interest in copying or representing those individual physical characteristics by which men superficially recognize other men.

Whether artistic naiveté is as clearly questioned on the more sophisticated level of psychological representation is less obvious. Think, for example, of Duccio Di Bouninsegna's panel scene *Betrayal of Judas*. Jesus stands in the middle of the foreground, motionless. Judas embraces him, and the soldiers who are crowding about them obviously are about to arrest him. Jesus expresses pity. The Pharisees, in contrast, show a paralyzing concern. On the left, Peter is rushing, knife in hand, toward a soldier. On the right, the other disciples hurry away. The *Maestà* does make clear its separation from any intent of a naive pictorial representation by making the setting a dramatic constituent of the action, but it still attempts a psychological naiveté because it reinforces and plays on the subject matter's overwhelming cargo of prior associations. By so doing the *predella* naively represents or repeats those theological values it was commissioned to serve. This is something Duccio's contemporary, Giotto resisted.[41]

The existence of an obvious tradition of psychological representation therefore challenges my suggestion that art detaches and creates. Does this mean we should conclude the *Maestà* is not art, or that

my insistence that art detaches and creates is in error? Not necessarily, because there is an ambiguity in the challenge. What does it mean to say "Duccio expresses a psychological reality," or in fact to say that "Art expresses reality?" Consider the statement "I wish to express my disapproval of this assertion." The statement entails disapproval of the assertion, but it also entails a desire to communicate that sense of disapproval to whoever will pay attention. That which comes second, the communicating of the disapproval, is separated from the disapproval which the individual feels. Thus the actual act of expressing my disapproval has become an attempt to point out or to evoke, possibly even an attempt to reproduce or to reinforce my original sense of disapproval. To say that I wish to express my disapproval means that I wish to point out to whoever will listen that I disapprove, to make him aware that I disapprove, and even possibly to evoke in him that same disapproval.

Now if we apply this distinction to the challenge that art expresses reality, we must ask whether this means art is expressing a reality which already exists and which I may want to communicate to others, or whether it means art is actually expressing a reality in the first sense above, say, the way a cider press presses apples and ex-presses apple juice. The first meaning of express suggests that art evokes or naively represents that which man has already experienced; thus there is no detaching and creating. Along with the craftsman, the propagandist, and the illustrator, there is a service, perhaps to a blueprint, or to a political goal, or a commission. Each makes a call for recognition. The second implies that in art there is what the Platonists call a divine madness, that art is a power or force ex-pressing or pressing out what was not there before, transforming the old into the new. Consider the very powerful Piero della Francesca's *Madonna della Misericordia*, in which the Virgin Mary, an independent and monumental *magna mater*, spreads her cloak to shelter men and women who have sought her protection. Is the painting simply expressing the plea that Mary "pray for us sinners, now and at the hour of our death, amen," a plea from which it thereby derives its power, or is it moving beyond this reality to a new reality which it itself ex-presses? In the same way, is Duccio only expressing the already familiar theological and psychological values or does his *Maestà* move beyond this reality to a new reality which it ex-presses?

What we learn from this is that the assertion that art and religion introduce something that was not there before is not conspicuously vulnerable. Neither activity obviously repeats or naively represents

what already is the case. But this is not enough. I must cite evidence that art and religion do in fact detach and create. This is not to argue that they do not repeat or represent what already has been learned, it is to argue that they do not merely repeat or represent.

Consider the weighty tradition behind Elizabethan drama and the Kabuki stage to which I referred in a footnote above. Their culturally understood costuming, makeup, movement and gesture, together with their appeal to commonly experienced feelings and emotions certainly contributed to the "placing" of the literal scene being depicted, and as such constituted a representation of what already was the case. Through their exaggerated, stereotyped manner, however, these "placings" actually free the scene from its particular place, time, and character. In effect, the representational elements serve as the shared familiar communicable base from which the artist and his audience move. In Kabuki, the result was a totally new place. In the Elizabethan drama, the result was more apt to be a new understanding of an old place. Now the new place or the new understanding is related to the old place or to the old understanding and related as well to the theatrical production itself, but changed, only coming to exist in the mind of the artist as he works out his presentation, and in the mind of the audience as they watch it unfold.

Ballet and traditional music present an interesting variation on this theme. Here, too, that which is repeated or represented becomes a familiar communicable base which audience and artist share, but its original place is not drawn from the outside. It is inherent in the very art form itself. Our point that art and religion detach and create is in no way compromised, because these objective impositions constitute rules from which the artist deviates. Thus *Swan Lake* develops from the "authentic" Sergueyev version to a current production by the Bolshoi Ballet, and the cantata evolves from Schutz to Stockhausen. Take, for example, a composer composing a sonata. When he composes, he relies on the knowledgeable listener's taking the sonata form for granted in the same way that Pierre Boulez, in his compositions, seems to take for granted an audience steeped in Debussy, Stravinsky, and Berg. This assumed content is that with which the artist begins, but it is also that from which he intends to advance or deviate. The composer composing his sonata assumes that the knowledgeable listener will tend to interpret each single isolated sound stimulus of his sonata in terms of the culturally prevalent style system of what constitutes a sonata. He takes advantage of this expectation and understanding by presenting contextual ambiguities, irregularities or deviations. In so doing, he will

work out in the mind of the audience and in himself, a modified sonata—the old sonata plus the embellishments, cadenzas, and modifications which change the meaning or significance of the antecedent structure. Thus the sonata form moves forward from type to prototype, from Haydn to Beethoven, from Beethoven to Schumann. In the composing, as it was with the theatrical production, there is a doing that makes a difference, something new comes to exist in the mind of the artist as he works out his piece, and in the minds of the audience as they watch it unfold.[42]

Understanding the represented element in art as, at best, this shared familiar communicable base from which the artist and the audience can move, points up the significance of the commonly observed religious willingness to sacrifice thoughts of the self.

> O God! Why was Pharaoh
> Condemned to the flames
> For crying out
> I am God, and Hallāj
> Is rapt away to heaven
> For crying out the same words:
> I am God!—Then he heard
> A voice speaking:
> When Pharaoh spoke those words,
> He thought only himself,
> He had forgotten me,
> When Hallāj uttered them
> He had forgotten himself
> He thought only of me.
> Therefore the I am
> In Pharaoh's mouth was a curse to him;
> In Hallāj the I am
> Is the effect of my grace.[43]

The Pharaoh was "condemned to the flames" because he failed to let go of himself and allow his words to take wings of themselves. Hallāj on the other hand was "rapt away to heaven" because he "had forgotten himself" and thereby allowed his words to reach heaven. Only Hallāj was willing to detach himself from that which was before, and only he came into the new. He was freed from looking *at* his old motivating experiences and free to look *with* them, to consider them not so much as something which he must serve or defend, but as something of interest, something which might help him to come into a fuller understanding of himself.

Sancho Panza understands well this religious demand for a sacrifice of the ego. After Don Quixote has finished explaining that in accordance with the rules of chivalry, knights serve and render homage to their ladies "with no expectation of any reward for their many and praiseworthy endeavors," Sancho correctly observes that this "is the kind of love I have heard the preacher say we ought to give to our Lord, for Himself alone, without being moved by any hope of eternal glory or fear of Hell, but for my part, I prefer to love and serve Him for what He can do for me."[44] Like the Pharaoh, he too fails to let go of himself.

It is time to incorporate my findings. I have suggested that art and religion detach and create, and that it is this kind of doing which makes them be art and religion. But I have found that this does not mean they do not somehow represent that from which they detach themselves, it just means they do not merely copy or repeat. Sancho's failure is that he did wish to merely copy or repeat his experience as he currently understood it. He wanted to dictate to his activities rather than learn from them and become different. He is not willing to detach himself from himself, and so he is not willing to become anything other than what he is.

Paul Klee touches upon that quality which Sancho is missing when he writes, "I do not love animals and other creatures with an earthly heartiness. I neither stoop to them nor raise them to me. Rather, I first surrender myself to the whole and then feel that I stand upon a fraternal footing with all creatures of earth.[45] Only then Klee paints. There are affinities here with what actors or conductors do. They play the role or direct the composition another has prepared, and to this extent they sacrifice their own ego. But if what they do functions as art or religion they do not so much lose themselves as find something of themselves hidden within the work. They become more sensitive, and in turn contribute a new dimension to that role or composition.

In effect Klee's "surrender" consists of suspending his normal reaction, not reacting at once to the stimulus of his prearranged habitual pattern. The resultant "fraternal footing" is the new prototype of what is. Whereas the act of suspending reaction is first of all acknowledging the commandment "Thou shalt make unto thyself no graven images," the resulting new prototype is the "making for thyself a god who shall go before thy face." Perhaps the one word which best expresses this two-faceted activity is innocence. To suspend a habitual pattern and to effect a new prototype is to allow oneself to pay attention

to what one has previously ignored in the hitherto normal rush to react; it is to be at once open to the formerly "strange" and to respect it. Christ, and Nietzsche too, consider the model to be the child, whom, Nietzsche says "in innocence and forgetting, takes the freedom of the lion and makes a *new* world." A less ambiguous analogy is Abraham, who "went out, not knowing where he was to go" (Heb. 11:8). Rama-krishna, a contemporary model, reports that once, "while worshipping Shiva, I was about to offer a bel-leaf on the head of the image, when it was revealed to me that this Virat, this universe itself is Shiva . . . Another day, I had been plucking flowers . . . It was shown to me that each plant was a bouquet adorning the Universal Form of God . . . That was the end of my plucking flowers. I look on man in just the same way. When I see a man, I see that it is God Himself, who walks on earth, as it were, rocking to and fro, like a pillow floating on the waves."[46]

Jean-Paul Sartre provides us with a somewhat bizarre example of this innocence and surrender when he interprets an experience Giacometti had when the latter was "hit by a car while crossing the Place d'Italie. Though his leg was twisted, his first feeling, in the state of lucid swoon into which he had fallen, was a kind of joy! 'Something has happened to me at last!' " Sartre goes on,

> I know his radicalism: he expected the worst. The life which he so loved and which he would not have changed for any other was knocked out of joint, perhaps shattered, by the stupid violence of chance: "So," he thought to himself, "I wasn't meant to be a sculptor, not even to live. I wasn't meant for anything." What thrilled him was the menacing order of causes that was suddenly unmasked and the act of staring with the petrifying gaze of a cataclysm at the lights of the city, at human beings, at his own body, lying flat in the mud: for a sculptor, the mineral world is never far away.[47]

He finally comments, "I admire that will to welcome everything . . . if one likes surprises, one must like them to that degree, one must like even the rare flashes which reveal to devotees that the earth is not meant for them."[48]

These examples encompass all of the reasons emphasized in this chapter for suggesting that innocence is an appropriate term for describing the attitude of those who are engaged in artistic and religious activity. First, the examples each imply the artist or religious person has a sense of insufficiency or dissatisfaction with whatever constitutes a current understanding of what already is. Second, this leads to my suggestion the artist and religious person willingly detach themselves from these current understandings, either by sacrificing that ego con-

struct through which they understand the world or by suspending judgment. Third, I conclude that the artist or religious person each willingly creates or finds new understandings by incorporating experiences which they had previously ignored.

Fascination

"At Saint Anne's Psychiatric Clinic, a patient cried out in bed: 'I'm a prince! Arrest the Grand Duke!' Someone went up to him and whispered in his ear: 'Blow you nose!; and he blew his nose. He was asked: 'What's your occupation?' He answered quietly: 'Shoemaker,' and started shouting again. I imagine that we're all like that man."

Sartre

So far my exploration into artistic and religious activity has made us aware that it involves the artist's or religious person's detachment from the initial motivating experience—a moving beyond naive representation—as well as an attitude of innocence or openness which enables both to move into a new understanding of the world in which they function. This chapter will explore the nature of this process of detachment and the next chapter will explore creativity. Both chapters will build upon the first chapter's observation that although it would be a mistake to conceive of art and religion as naively 'representing' an inherited structure, a kind of representation does take place in which the represented structure serves as a common base of shared experience in order to make communication and development within art and religion possible. This inherited representational structure is the prior 'given' which confronts, limits, and nourishes.

This prior given is diverse. We already have considered it as people (Gertrude Stein), feelings (lumps in the throat), ideals (a divine order which existed before the Fall), common everyday gestures (Kabuki theater), even musical scores. It can be anything: naked bodies, mountains, colors or shapes. Debussy's triptych for orchestra, *Nocturnes*, attempts to represent an impressionist painting by using orchestral timbre contrasts, as Monet uses colors—to create perspective and to

27

give the illusion of foreground and distance. This given can even be a specific style. The Egyptian technique of representing the human body and funerary figures which go back to the Old Kingdom might have inspired the archaic Greek scupltors to attempt their often-repeated *kouros* model.

These same shared experiences can function as the religiously given as well. Appropriate examples would be sunsets, sounds, historical events, or certain experiences of a continuing historical community. David Hume speculates that "an anxious fear of future events" might well be the prior given which motivates all religion. Later in the same essay he asserts that "*ignorance is the mother of Devotion*: a maxim that is proverbial, and confirmed by general experience."[49]

A religious example somewhat akin to that of the Egyptian funerary figures, but one which is portentous for the development of this chapter, is the Indian caste system. In the *Rig-Veda*, where the caste divisions first appear in a religious context, we read:

> When they divided Purusha [the soul and original source of the universe], how many portions did they make?
> What do they call his mouth, his arms? What do they call his thighs and feet?
> The Brāhman was his mouth, of both his arms was the Rājanya [the second or kshatriya caste] made,
> His thighs became the Vaisya, from his feet the Sūdra was produced.

[X.90. 11-12]

Later, in the *Brahmanas*, where the divisions appear in their more developed form, we find mention of this as the ideal social community, an organic socio-religious structure functioning through the cooperation of all its divisions: the Brahmins or priests as the head of the body, the Kshatriyas or warriors as the arms, the Vaísyas, or farmers and merchants, as the trunk, and the Sūdras, or servants, as the feet.

Note that the priest is assigned the place of mouth or head. As such, he represents society and its tie to the wheel of reincarnation. He also embodies a force for expressing dissatisfaction with this tie and for bringing about change. Only the religious person, the head, the Brahman, can push into nirvana. Here is the detaching and creating of which I spoke in the previous chapter. By incorporating the priest with his obligation to transcend this system or this given, Hinduism witnesses to the previous chapter's discovery that religion continues to represent or work with a given, that is, the caste system, which at one and the same time, nourishes it and confronts it. The given nourishes

religion in much the way Tillich might insist the Christian symbol of God nourishes the faithful—as its mode of participating in the holy—and it confronts religion in much the same way Tillich insists the Christian symbol of a crucified God confronts the faithful—as a "broken" symbol of the holy which reminds men of its incompleteness and challenges them to transcend it.

There is more. Since the religious person (the Brahman or priest) represents both society and the forces which change that society, it seems that these inherited givens with which the world works are themselves related to previous religious activities. This is to say that the only meaningful way in which religion can be a force which reaffirms or represents society and dissolves society is if that society—and by implication all prior givens—are but a result of previous religious activity. Thus the given is more an interaction than a confrontation. What religious people do, and what artists do, contribute to it. They break it, create it, and represent it, all in one.

Van Gogh suggests something like this when he writes to his brother Theo that he

> can find no better definition of the word art than this, "l'art c'est l'homme ajouté à la nature" [art is man added to nature]—nature, reality, truth, but with a significance, a conception, a character, which the artist brings out in it, and to which he gives the expression, "qu'il dégage," which he disentangles, sets free and interprets.[50]

But in truth his comment only suggests because we can understand it in two ways. The first way softens the full impact of the suggestion that what is given, be it nature or society, or whatever, is but the result of previous artistic or religious activity. Perhaps Van Gogh only wanted to claim that that which the artist "brings out" and " to which he gives expression" is there in the given, something which the artist is especially prepared to see. If in fact he does only claim this, his "find" is no great discovery. Men have long been aware that their particular culture as well as their particular physiological system see the beauty of Venetian sunsets because he already had appreciated Titian's colors. Brueghel could appreciate the steep, isolated Alpine peaks because the tradition of his art provided him with visual symbols which made it possible for him to single them out. Bach could use the transverse flute and the F minor key to reinforce his solemn blood, guilt, and tears theme in the aria in the *St. John Passion* scored for soprano voice, two flutes, and one oboe d'amore because of the technical limitations of that instrument and because of the cultural sound associations with that particular key.

In fact Thomas Aquinas organized observations such as these into an argument. He tells us that because men respond only to that for which they culturally or physiologically are prepared, God therefore sets forth "intelligible things" in scripture under "sensible figures"— not because these "intelligible things" are themselves sensible, but because these "intelligible things may be understood" (*Summa Theologica* I. Q51. A3).

One religious doctrine which encapsulates this idea that men respond only to that for which they are prepared is the Christian affirmation of the necessity for prior grace. Another, related doctrine is the Muslim declaration that "there is no god but God." Each insists nothing can happen without the prior will of God; therefore He must stand behind men's will if they are to do his work. Religions differ not as to the presence of this prior preparation, only to the extent of its domination. For example, opposing Hindu Vaishnavite schools argue as to whether grace is administered by way of the "monkey offspring method" or by way of the "cat offspring method." According to the first claim, God leads men as the mother monkey leads her young; they need to make an effort themselves, though, of course, with her guidance. According to the second, God leads men as a cat leads her young; they are swept up and passively carried from "all this" into salvation. Whereas the latter method emphasizes the dominance of the prior cultural and physiological preparation for doing what art and religion do, the former emphasis finds room for a certain freedom independent of this priority which we have been calling the given.

It is this former idea which prepares us for a second way of interpreting Van Gogh's passage. It more forcefully suggests that givens are interactions, not confrontations. Perhaps Van Gogh is claiming that that which the artist "brings out" and to which he gives expression is truly "ajouté à la nature." His emphasis therefore would be not so much upon that which is there in the given as upon the artistic or religious bringing out or setting free.[51] Wallace Stevens clearly makes this switch. He writes that

> The validity of the poet . . . is wholly a matter of this, that he adds to life that without which life cannot be lived, or is not worth living, or is without savor, or in any case would be altogether different from what it is today.[52]

Both he and Van Gogh clearly agree that "art is man added to nature," or that "the . . . poet . . . adds to life." But whereas we could understand Van Gogh as claiming that art brings out something which is

already there in nature, thereby setting it free, Stevens more forcefully insists that art adds that which makes a difference, that without which life would not be life as we know it. Stevens is more emphatic in telling us that art looks upon the given not so much as something having a significance which the artist sets free, but as something which changes as the artist contributes his new sensitivities or new dimensions. Both men are aware that art adds to, and thereby leaves behind, the restrictive provinciality of the original given; but only Stevens's comment clearly stresses that the new resultant given, or "life" is not the given that we know unless it has interacted with artistic activity. Thus, whereas Hume observed,

> A young man, whose passions are warm, will be more sensibly touched with amours and tender images, than a man more advanced in years, who takes pleasure in wise, philosophical reflections concerning the conduct of life and moderation of the passions. At twenty, Ovid may be the favorite author, Horace at forty, and perhaps Tacitus at fifty.[53]

We now observe that not only must his young man be ready for Ovid but that insofar as he artistically responds to Ovid, he changes Ovid—insofar as Ovid constitutes part of that given which the next generation takes seriously.

The theory of knowledge implied here considers present discriminations, objects, and actions not as data which exist independently of men, but as data signifying what men did. As such, the worlds of art and religion are deliberately imposed worlds. That with which the artist and the religious person work is created by virtue of their and other people's activities. It is no more primitive, existing prior to or apart from artistic and religious activity, than are the Aristotelian metaphysical categories of substance and attribute or the commonsense world of things and their properties. All are projections—the former, aesthetic or religious; the latter two, logical. Whereas the Aristotelian categories flow from and exceed the Aristotelian logic of subject and predicate, and the commonsense categories flow from and exceed the commonsense logic embodied in our familiar parts of speech, the aesthetic and religious categories flow from and exceed the impositions of physiology and culture that the artist and the religious person have inherited or already have achieved. To think otherwise is, from this point of view, to commit the epistemological fallacy of making our own understanding the criterion of truth.

Leonardo's use of *sfumato*, his consciously adopting the indeterminate, even confused, form in order to stimulate the observer to

contribute his own bit of creativity to the given so that he is therefore no less an artist in this situation, is an excellent example of an artist implying present discriminations are data to which men have contributed. Pirandello's *Six Characters in Search of an Author* and Peter Weiss's *Marat/Sade* are broader efforts recognizing the same point. Each play tries to nullify the restrictive effects of the cultural dimensions of its given by trying to give its audience a role in the play's progression. But both attempts are artificial. Their so-called audience never frees itself from the playwright's domination and thus never really manages to contribute that fresh new addition which the observer of Leonardo's work is forced to contribute to it. More daring and somewhat more successful attempts are environmental theater and systems-oriented sculpture: one tries to incorporate the audience's response into the play, the other tries to enmesh the observer's movement within its movable parts.

Religious attempts to nullify the restrictive effects of the physiological and cultural dimensions of the individual's inherited given are often expressed in terms of sacrificing the ego, of surrendering, submitting, or being receptive to God. Unfortunately, the inherent ambiguity in what is meant by 'God' and the passivity of the recommended action encourages religion often to think of its creativity in the manner akin to our first interpretation of Van Gogh's passage: as expressing what has already been expressed, that is, in the mind of God. I will have more to say about this tendency in the next chapter; but it is important to emphasize that when religious spokesmen do make Stevens's switch from a concern with the prior preparation for doing to the doing itself, the same radical awareness is to be found in religion as in art namely, that all discriminations are projections and that what religion does is to impose a new understanding on these old givens, thereby changing them. For example, consider the following four religious cases: (1) the *Maitri Upanishad* directs men to "cleanse" their thoughts because "what a man thinks that he becomes, this is the eternal mystery" (VI. 34). (2) Ramakrishna reports that once

> there was a woodcutter who led a very miserable life with the small means he could procure by daily selling a load of wood brought from a neighboring forest. Once a Sannyâsin, who was passing that way, saw him at work and advised him to further move into the forest, saying, 'Move onward, my child, move onward.' The woodcutter obeyed the injunction and proceeded onward until he came to a sandalwood tree, and being much pleased, he took away with him as many sandal logs as he could carry, sold them in the market and derived much profit. Then he began to wonder within himself why

the good Sannyâsin, had not told him anything about the wood of
the sandaltree, but had simply advised him to move onward. So the
next day he went on beyond the place of the sandalwood until he
came upon a copper mine, and he took with him all the copper that
he could carry, and selling it in the market, got more money by it.
Next day, without stopping at the copper mine he proceeded
further still, as the Sadhu had advised him to do, and he came upon
a silver mine and took with him as much of it as he could carry, sold
it and got even more money, and so daily proceeding further and
further, he found gold mines and diamond mines and at last
became exceedingly rich.

and concludes "Such is also the case with the man who aspires after true
knowledge."[54] (3) Gregory of Nyssa observes that "to find God is to seek
Him without cease. For seeking is not one thing and finding another;
the profit of the quest is the quest itself."[55] (4) Finally, Isaac Singer's
father-in-law advises, "If you can't be a good Jew, act the good Jew,
because if you act something, you are it."[56]

Clearly, religion no less than art is committed to those radical
implications that grow out of an insistence that present worldly dis-
criminations are at least partially the result of previous artistic and
religious activity: (1) thinking is to become; (2) aspiring is to achieve; (3)
seeking is to find; (4) acting is to be. These pronouncements support
the reductionist analysis that talk about things is really disguised talk
about sense data. They also conflate the philosophically useful and
intuitively sound criteria-evidence distinction, that it is one thing for a
cognitive sentence to be meaningful (true or false) and another thing
for men to know that it is meaningful—in the sense that the meaning of
what it is to be, say a Jew, is made equivalent to the empirical expecta-
tion of what it is to be a Jew. In effect the artistic and religious world is
what artists and religious people make it be. True knowledge does
not lead to salvation, it is salvation. As John Dewey observed, "Works of
art . . . are literally pregnant with meaning," meaning thereby, they do
not carry a meaning as vehicles carry goods but as a mother carries a
baby when the baby is part of her own organism.[57] Like mothers, art
and religion literally bring what they have to show us into being. "The
fool who repeats again and again, 'I am bound, I am bound,' remains in
bondage. He who repeats day and night, 'I am a sinner, I am a sinner,'
becomes a sinner indeed."[58]

We conclude that the relevant literature in the arts and religion
make clear, at least in theory, that though these activities do represent a
given from which they receive nourishment, of which they are espe-
cially aware, and obligated to "bring out," it also makes clear, at least in

theory, that these activities also creatively transcend that given by adding to it that which does not exist independently of the activities themselves.

How comfortably these two responsibilities complement each other in practice is another matter. For example, Jerzy Grotowski correctly advises his actors "never in the performance to seek for spontaneity without a score." Why? because "no real spontaneity is possible without a score. It would only be an imitation of spontaneity since you would destroy your spontaneity by chaos."[59] In fact even during his required preliminary exercises before the performance he advises them "to improvise only within this framework of details." Yet at the same time, also correctly, he can insist that "art doesn't like rules. Masterpieces are always based on the transcendence of rules."[60]

In his classic study, *The Idea of the Holy*, Rudolf Otto reflects on these two responsibilities insofar as they effect religious consciousness. He calls man's religious interest in affirming his inherited structures the element of *fascinosum*, and his interest in transcending them the element of *tremendum*. The former stems from man's consciousness of the given as already created, whereas the latter stems from man's consciousness of the given as something to be created. Otto insists that they exist together and that both are important. Together they account for the security and the insecurity men find in religious activity.[61]

The first element, *fascinosum*, is directly related to the confidence which flows from men's experiencing an end which they serve. It "fascinates" because it provides direction. Moreover, it provides a release of tension, together with criteria for the resolution of conflicts in values. It is important to religion and, I suggest, to art as well, because, at its best, *facsinosum* represents the consolidation of an original creative push into new ground, a consolidation which is necessary before men can launch a new artistic or religious expression. It is important because it saves creative activity from chaos.

But alone, fascination with the results of previous creative artistic and religious activities constitutes a danger. If it dominates, then there is no energy or desire to move beyond the present consolidation. Religion then slips into apologetics and art into a kind of propaganda. A charming example is Ghirlandajo's portrait, *Giovanna Tornabuoni degli Albizzi*, commissioned by her wealthy Florentine banking family, in partnership at that time with the Medicis. Of course, under such circumstances it must have been easy to slip into doing propaganda, but the cost of such ease is propaganda nonetheless. To look at the portrait is to see a representation of sweet innocence, youth, and

intelligence—yet these qualities we and the Tornabuoni family already know. Instead of conveying a new dimension of insight into these already experienced and already appreciated qualities, Ghirlandajo's portrait borders on becoming only an example of that understanding of these qualities which exists independently and prior to the portrait itself. In traditional terms, what attracts us is Giovanna, the subject matter of the portrait, rather than the portrait's form. This flaw permits the accidents of our personal associations with innocence, youth, and intelligence, and those of the patron, Giovanni Tornabuoni, to become the direct bearers of the meaning communicated, rather than the portrait itself. Of course, Ghirlandajo may have intended all of this, but in any case, the portrait merely designates, it does not create or, as I sugggest in chapter 5, it does not perform. There is no tearing away from the old; there is only the luxury of indulging in emotions and memories of which the Tornabuoni family may wish to be reminded.

Now what breaks this fascination with what one already has seen, so that the artist or the religious person can move on to a new dimension, is what Otto calls the element of *tremendum*. If Ghirlandajo were to avoid leading men only to experiences which reminded them of previous ones, he should have given his portraiture a heightened sense of capacity, letting it serve not as a limit beyond which he and the audience cannot go, but as a start out from which they necessarily do go—as *terminus a quo*, not as *terminus ad quem*. To do for Giovanna what Picasso thought he did for Gertrude Stein, Ghirlandajo's work should have conveyed to others and to himself a realization of the significance of the qualities of the subject matter free from those enveloping memories which so sweetly unite men to their past. In a dramatic and far from sweet way Archibald MacLeish insists upon this very same point. "The poet's labor is to struggle with the meaninglessness and silence of the world until he can force it to mean: until he can make the silence answer and the non-Being Be."[62]

But Jacob Epstein is more sensitive to the sweet scent of inherited structures and in acknowledging their force he moves closer to the truth of the matter. Commenting upon the *Rima* for the W. H. Hudson memorial in Hyde Park he notes,

> Even had it been possible to know how Hudson thought of Rima, I could only create her sincerely as I myself conceived her in my particular medium in the particular space put at my disposal. You musn't make the mistake of thinking that I despise illustration. I don't at all. Most of the great artists have been illustrators. But the illustration must be of secondary interest.[63]

Certainly MacLeish is correct; the artist's labor does contribute to what will be, but Epstein reminds us inherited and given physiological and cultural dimensions, the marble which is chipped, the steel which is welded, the bronze which is cast, the pigments which are laid onto the canvas, even the poet's words which are made meaningful, all also contribute their share. Here is the full impact of Otto's *tremendum*. Michelangelo was called *terribile*, and Vasari and others attributed the character of *terribilità* to his works, first, because there is a terror in the awareness of the open-endedness or the perpetual incompleteness of the structures which men already know; second, because there is a terror in the awareness of man's own perpetual moving, via art and religion, into new structures which come to exist only because men like Michelangelo have created them; and now third, because there is a terror in realizing that with the *Pieta*, for example, and with all new understandings which art and religion carry and proclaim, there is no foothold or anchorage in reality apart from the unique combination of medium and activity conceived by men in a particular culture and with a particular physiology.

Epstein's comment about his *Rima* is also helpful to us in that it suggests the tension that exists between artistic and religious *tremendum* and artistic and religious *fascinosum*. The artistic and religious creative urges which force MacLeish's "non-Being" to "Be" are constrained by the limits of the particular situation. Nonbeing can only be in a particular way. Joyce Cary's colorful Gully Jimson calls this restriction "the curse of Adam":

> "I love starting, Nosy," I said, "but I don't like going on. The trouble with me is that I hate work, that's why I'm an artist. I never could stand work. But you can't get away from it in this fallen world. The curse of Adam."
>
> 'N-no, p-please, Mr. J-Jimson. You know you have s-sacrificed your whole life to art, and no one works harder. I've seen you myself working all day and never even s-stopping to eat."
>
> "I was probably altering something or taking something out, that's a way of starting new. But not a good way. It only leads to more trouble. More problems, more work. No, you want to start clear, with a clean canvas, and a bright new shining idea or vision or whatever you call the thing. A sort of coloured music in the mind."[64]

A more authentic example of the restriction at work is in Vollard's report,

> In my portrait there are two little spots of canvas on the hand which are not covered, I called Cezanne's attention to them. "If the copy

I'm making at the Louvre turns out well," he replied, "perhaps I will be able tomorrow to find the exact tone to cover up those spots. Don't you see, Monsieur Vollard, that if I put something there by guesswork, I might have to paint the whole canvas over, starting from that point?"[65]

Music provides a wholly different kind of example of Otto's two elements of *fascinosum* and *tremendum* existing together in tension, each nullifying the possible excesses of the other. In the first chapter I cited those tensions evident in musical composition. Now consider the tensions in musical performance—tensions in the relationship between the composer and the performer, a relationship which fluctuates not only from one type of music to another (for example, the constraint of the prior given which fascinates is generally more evident in classical music than it is in folk music or jazz), but also within a type of music. While dominant seventeenth and eighteenth-century practice was to merely sketch in what performers should do (for example, Handel's *Messiah*) or even of noting in ornamentation and diversions (for example, Bach's *Italian Concerto*), in the nineteenth century a limit was placed upon the performer's freedom, a limit which negates Otto's *tremendum*. For example, in the scoring of the first act of *Die Walküre*, where Wagner attempts to present a vocal dialogue, a trialogue, and occasionally a monologue, with orchestral commentary, he marks out not only the basic pulse but each deviation from that pulse. The result is a total closing off of room for creativity on the performer's part, or, as the jazz enthusiast might put it, the denial of exuberance. Obviously, so long as Wagner's example dominated, there was little sympathy for ornamentation or delay by embellishment. The composer thought of the performer only as a musical craftsman, someone playing a score, but never contributing to it.

In jazz and folk music the musical styles have moved mostly in the other directions. By their nature they are largely improvisatory with only the basic plan of a piece written down. The realization of that plan is left to the creative ability of the composer-performer whom the listeners evaluate almost solely on his or her ability to improvise or embellish: in effect, to alter the traditional notation by remolding and weaving together fresh combinations of more or less familiar patterns. This makes the music "hot," but it is interesting to note that even here, when the music is at its hottest, the performer still considers his creativity as only a "break" or a "riff," that is, an ornamentation to a score. It is this awareness which prevents the embellishments from becoming simply exuberance, an absence of inhibition, or what in another medium might be called "chaos," the breakdown between the formal and

the material elements in an artistic activity. In other words, here, too, the tension remains. Jazz and folk music are not mere exuberance any more than classical opera is mere repetition. Both types of performers are artists. Each shapes and molds the abstract scheme which the composer furnishes him. Through his own sensitivity and insight, each performer brings "life" to the score with which he works. Each is creative, yet each creates within the confines of a score which already exists.[66]

Before concluding with a philosophical recapitulation, I will cite two religious examples of *tremendum* and *fascinosum* functioning together in tension. The first religious example is the classical one of Dionysus and Apollo existing side by side in Greek society. Pausanias reports that he can look at the images on the altar in front of him and see "wrought in relief . . . Zeus and Hermes . . . talking together; and near them conversing Dionysus and Semele and near Semele Ino.[67] Even more striking than Greece finding room for each side by side, is that each finds room within itself for the other. First there is Dionysus, who represents the abandoned enthusiasm of the force of creativity and participation, to whom

> our own
> Wives, our own sisters, from their hearths are flown
> To wild and secret rites; and cluster there
> High on the shadowy hills with dance and prayer
> To adore this new-made God, this Dionyse
> What'er he be![68]

[Euripides, *Bacchae* V 215-220]

He reveals his receptivity to restrictions placed upon his creativity in two ways. The first way has to do with his acceptance of the performance of Greek drama as an expression of ritual worship. The dramatists created the choral dithyramb especially to honor him. This was a sort of passion play expressing the passionate sufferings man undergoes, but by its very production as a play, Dionysus, the god of tragic participation, becomes the god of the *form* of tragic participation, the form of Greek tragedy.

Second, there is Apollo, who represents restriction of abandon and creativity; the god whose temple is inscribed with such constraining precepts as Curb thy spirit, Observe the limit, Hate hybris, Keep a reverent tongue, Fear authority, Bow before the divine, Glory not in strength, Keep women under rule. He reveals his receptivity to creativity by using Delphi actually to participate in the everyday administrative decisions pertaining to law and order. Incidentally, it is in reference to

the temple at Delphi that we note the second way that Dionysus reveals his receptivity to the restrictions upon creativity. Plutarch tells us that "Bacchus also . . . has no less to do with Delphi than Apollo himself." In the winter months Apollo left Delphi to spend his time among the Hyperboreans, thereby allowing the people "for three months to invoke Bacchus instead of Apollo, . . . to . . . sing dithyrambic verses, full of passions and change, joined with a certain wandering and agitation backwards and forwards." He also notes this form of song and praise was in sharp contrast to that song sung the other nine months of the year, for "to Apollo they sing the well ordered paean and discrete song."[69]

Theology provides a second religious example. Here the two elements of *fascinosum* and *tremendum* exist together in tension, each nullifying the dangers of the other in a wholly different way. Consider Norman Pittenger's assertion that theology

> sprang from the continuing experience of the living Christ; it was concerned to find ways in which the grounds of that experience could more satisfactorily be stated; and it had for its final purpose the protection of the experience from an interpretation which would endanger its validity and undermine its assurances.[70]

Here in one sentence he hints that theology does more than defend and evoke certain experiences of the past while almost simultaneously, denying it. First, there is the consideration of theology as a religious force working toward a better and fuller understanding, implied by the emphasis upon the "continuing experience of the living Christ." Second, there is the consideration of theology as a consolidation and reaffirmation of old understandings, implied by the emphasis upon "protection" as "its final purpose."[71] But even here within the context of this part of the passage which seems to be totally concerned with *fascinosum*, ambiguity remains. What does theology protect? If its final purpose is to protect the "continuing experience of the *living* Christ" so that it may continue to be a "living" experience, that is one thing, but if its final purpose is to protect the already encountered experience of the *previously* continuing experience of the living Christ, and thereby attempt to assert certain definitive interpretations and assurances, then that is something else entirely. It is only with this latter interpretation that theology finally and decisively fails to contain the tension found in artistic and religious activity, fails to be an instrument of vision, a vehicle by which and through which men press forward towards a fuller knowledge of an open-ended future. Only then has the theologian sacrificed "the continuing experience" for "the protection of the

(past) experience." Only then would its summary creedal statements with their third-person references be a thinking and a talking *about* a God whom others have encountered and whom *others* know. As such, these statements then would have little in common with the first- and second-person cast of the psalms, or the hymns, or the prayers, which seem to be not so much a thinking and talking about a God as a thinking and talking *to* a God.[72]

If our author's understanding of theology is no more confused than most—and he does express an ambiguity present within the theological tradition—this may well account for the difficulty philosophers have in classifying that discipline. Nevertheless there should be no confusion as to what is at issue. If theology only speaks of *tremendum* but of itself has none it is to religion no more than counterpoint exercises are to music. Its role in religion, then, would be akin to that of the art patron who offers his influential support to advance not the interests of aesthetic insight, but his own tastes.

My philosophical recapitulation begins with considering a short article entitled "Classicism as an Evangel," in which John Dewey speculates about the possible reactions different individuals could have to the sentence, "The knowledge of what is possible is the beginning of happiness."[73] He insists that there are two such reactions. The first would be to think in terms of human possibilities and to derive the lesson of limitation and check upon aspiration and desire. If man only knew his own limits or his own possibilities, Dewey's argument goes, he would obtain happiness. He would not ask for more than his due. The world is by its nature structured. It establishes limits to the restless flow of life, and measure, order, proportion, and limit reveal its ultimate character. The role of reason in this case would be to perceive, to adopt, and to serve this limiting structure as the rule of life.

The second possible reaction to the sentence would be to think in terms of the possibilities of things and to consider the world as open to change and transformation. If man would only concentrate on changing the world, he could obtain his happiness. The world would be his instrument of happiness, for it stands open to his suggestions. Its very nature is changing and flowing; and our suggestions, as well as our hopes and desires, are part of its process and can affect its flow. Nature without these suggestions, hopes and desires, is uncertain; and the role of reason would be to direct nature's flow toward the hoped-for re-creation leading to happiness. To apply reason in this dynamic, instrumental sense would be the rule of life.

Elsewhere Dewey carries his analysis further and concludes that it is the extent to which the individual allows "the craving for the fixed and the sure" to dominate, that determines which of these two possible reactions he would have. This craving exists in all of us, but when it rules, we hypostatize our present discriminations into ultimate laws which we believe transcend the uncertainties of everyday happenings. In effect, this indicates a retreat into the certain, the traditional, and the accepted. It is equivalent to choosing the first possible reaction, looking at nature's structure in order to obtain happiness. On the other hand, when we refuse to allow the craving for the fixed and the certain to dominate, we align and unite our philosophy with life. Since there is now no ultimate law transcending the present uncertainties, we must courageously face the open universe with its plural and unfinished directions, its hazards, its novelties, and its adjusted crosscurrents. This is equivalent to choosing the second possible reaction, looking at nature's possibilities in order to obtain happiness.[74]

Now consider these two reactions in conjunction with the religious question, "Is it possible to emulate the divine?" Here again a dichotomy is evident. The first possible type of reaction is to think in terms of limitation and check upon aspiration and desire. Man must know his limits. It is not for him to equal the gods. The gods are of such a nature as to stand apart from man, and they insist upon his recognition of the limits beyond which he cannot go. Man cannot emulate the divine. Such a viewpoint assumes that the world is a structured whole in which each segment fits in place. Measure, order, proportion, and limit are its ultimate characteristics. Reason is the voluntary perception and intellectual adoption of this structure or measure as the rule of life. The other possible reaction to the question is to think in terms of open possibilities and human potentiality. The gods are of such a nature as to be involved with man, and this means he is related to the powers of the universe. Man can emulate the divine. The gods listen to his prayers and respond to his needs. Such a viewpoint assumes that the changeable and flowing world is significant and responsive to man's power. Reason is the voluntary instrument he applies to accomplish the hoped-for result. The rule of life is to live so as to be in touch with the divine, with the powers of the world.

Obviously these reactions are amplifications of the two elements which I have been claiming constitute the essential tension in both art and religion. Together with Otto's reflections, and my analysis of the implications of Hinduism's assigning the Brahman the dual task of representing society and destroying it, I can conclude the following: (1)

The nature of the given to which art and religion are sensitive is created in part by artistic and religious activities in the past. (2) It is also created in part by a further interaction with artistic and religious activities in the present. (3) The defensive kind of reaction of which Dewey speaks is a fascination with the given as it is already established. It is that reaction in which men learn to know their limit, not to emulate the gods, and to contribute measure and order to the world. It is an acknowledgment of the boundaries of the world which men take seriously. (4) The aggressive kind of reaction which Dewey describes constitutes a confrontation with the previously established given. It is that reaction in which men learn to know their possibilities, to emulate the gods, and to consider all givens as fetters or bubbles which men eventually break. Whereas the defensive reaction is symbolized by the tiger, the aggressive reaction assumes the power of the dragon—the ancient Chinese symbol depicting the infinite, change, and the terrifying responsibility to move into that which is not yet. (5) Though art and religion must reconicle and harmonize these two reactions, it is no easy matter.

Distance

"Though Charles XII was in reality no better than a prisoner honorably treated in Turkey, he yet formed the design of arming the Ottoman Empire against his enemies . . . By way of amusement, he sometimes played at chess; and as the characters of men are often discovered by the most trifling incidents, it may not be improper to observe that he always advanced the King first at that game, and made greater use of him than any of the other men, by which he was always a loser."

<div align="center">Voltaire</div>

We have come to see that art and religion teach "unaccustomed movements" to men who are interested in them. In innocence all who are appropriately involved begin with a given which they neither repeat nor serve but from which they move out, and by doing so, they contribute something new. But whereas the first two chapters emphasized the "innocent" creating as dutifully qualified by and related to the given, this chapter focuses on artistic and religious distancing from these old understandings. In essence, it emphasizes that a necessary and permanent withdrawing accompanies art's and religion's openness to creating or finding the yet-to-be. In essence it generalizes from that rather dry passage in the *Dhaniyasutta* quoted in chapter 1, and from this more familiar but less direct passage from the *Majjhima Nikaya,*

Suppose that a man, coming upon a long journey, finds in his way a great broad water . . . Accordingly, disciples, suppose this man to gather together reeds and twigs and leaves and branches and bind them all together into a raft, and launching forth upon it and laboring with hands and feet, attain in safety the other shore. And now, the flood crossed, the further shore attained, suppose the man should say, "Very serviceable indeed has this my raft been to me. Supported by this raft and working with hands and feet, I am safely

crossed to this other shore; how now if I lift the raft up on my head
or lade it upon my shoulder, and so proceed whithersoever I wish!"
What think ye, monks?

(I. 22. 169)

Of course the answer is to think of him negatively for "there is no
(further) use for a raft." The man must leave the raft or his old
understandings behind him.

Another example of the willingness to withdraw from old under-
standings is the way religion uses the word 'God'. Whatever present
discriminations the word is assigned, religion always considers it to be
less than ontologically complete. It expresses this in two ways. First, it
declares the divine nature to be inscrutable or incomprehensible (*Na-
tura divina est imperscrutabilis*), God's reality is always more than any
religious person's current understanding of Him. When the religious
person asserts that God has chosen the Jews for no reason, or that God
has created the world *ex nihilo*, or that God makes things good simply by
declaring them to be good, his primary point is not to make grammati-
cal or logical sense, but rather to say first, as far as God is concerned,
everything is possible. Things are good simply because God says they
are good. God made the people Israel a holy people simply because he
wanted to make the people Israel holy. As the world has come into
existence by means of God's almighty will, so meaninglessness and chaos
are overcome simply by means of his fiat. Second, as far as man is
concerned, God is beyond all human structures. Man's knowledge of
God is doomed to be perpetually incomplete. God chose the Jews for
no reason that men can fathom, he created the world and good-
ness out of a nothing—which puts the act beyond man's com-
prehension. In words more religiously familiar, the religious person
who seems to be making statements here about God is really making a
confession of faith in God as Lord Almighty, and making a confession
of his own intellectual and psychical incompleteness and dependence.
But it is knowledge nevertheless. The *Kena Upanishad* declares "I do
not think that I know it well; nor do I think that I do not know it. He
who among us knows it, knows it and he, too, does not know that he
does not know" (II. 2). That is, he who knows that he does not know
God well, knows something of God, as contrasted to he who simply
says, "I do not know God."

As a corollary, when religious people do attempt to define God's
nature, they think in terms of what God is not; that is, something to be
expressed in terms of God occupying a level "beyond" men's presently
established understanding. Thus Saint Paul declares that in order to

know God one must look "not at the things which are seen, but at things which are not seen." Anaximander declares that God is the "limitless;" Anaximenes, that He is the "air." Aquinas points out that to say that God is one is not to say how many gods there are but to say that God is not among those things that are countable. The Chinese Buddhist asks, "Is the Buddha-nature in this dog?" and his answer is *Nyes*—either yes or no or neither yes or no. And so it is with Brahman, the ultimate of Indian nondualism. Brahman is the principle that lives immanently in all changes of birth, growth, and dissolution, yet at the same time Brahman is transcendent, knowing no phases and is detached from the living and the dead. This makes very little intellectual sense; [75] but by asserting it, the religious person reminds us once again that it is not his intellectual grasp of God that is of paramount concern to him, but his own intellectual and psychical incompleteness. Only the fanatic insists that 'God' is equal to God, that religious concepts are equal to what is.

Thoughts such as these account for the development of the Christian doctrine of the Trinity and quite specifically for the Cappadocian Fathers' resistance to the Western church's introduction of the *filioque* clause. The Cappadocians argued that "God, who is overall, alone has, as one special mark of His own hypostasis, His being Father and His deriving His hypostasis from no cause, and through this mark He is peculiarly known."[76] Thus they insisted that the monarchy of the Father, the one fountain head of the deity, the God beyond 'God,' was the sole original source and cause of all things created and uncreated. He, God the Father, therefore always must be more (in the sense of order and logical priority) than man's understanding of him as God the Son. As God the Father he is the *principium* and source of the whole Godhead.

The Cappadocians' resistance to the *filioque* clause—which describes the Spirit, the third person in the Christian Trinity, as proceeding from the Father *and* Son—stemmed from its blurring the distinction between the Father and the Son and tending to equate God (the Father) with man's present understanding, which is the revelation of God (the Son). There seems to be some validity to this objection. For instance, when Augustine attempts in his *De Trinitate* to explain why, with the *filioque* clause, there is a distinction of Father and Son in the Godhead, he can only say, "The Word who is God, the Father's only begotten Son, in all things like and equal to the Father, God of God, Light of Light, Wisdom of Wisdom, Essence of Essence—that Word is entirely what the Father is though he yet is not the Father since this is Son and that is Father" (15. 14. 23). It is this kind of conflation which

produced the almost impossible so-called Athanasian Creed, but more importantly, eliminated the reason for these distinctions in the first place. The Spirit flows not from the source alone, but equally from man's current understanding of that source. The result is that Western Christianity's *filioque* undercuts the Christian attempt to establish a theological underpinning for the religious awareness that a God revealed is less than God.

The second way religion expresses its consideration of 'God' as less than ontologically complete is that it understands its religious assertions about God as at best contextual, as equal only to particular manifestations, revelations, or understandings. In other words, just as a painter distinguishes between an inquiry into the nature of the physical world itself and his own inquiry into the nature of man's reaction to the physical world, or between an inquiry into the causes of certain effects he wishes to produce and an inquiry into the mechanism of the effects themselves, so religious people distinguish between an inquiry into the nature of God himself and an inquiry into the nature of God revealed, or between an inquiry into the causes of this revelation and an inquiry into the obligations stemming from it. An instance of this latter distinction at work is that vast Talmudic literature in which there is little speculation as to why the Jews are God's chosen people (perhaps that they were good and deserved that designation, and so forth) but much speculation on the obligations incumbent upon being so chosen. The implication is that this is the best that men can do: inquire into the obligations stemming from what they know, and ignore what they don't know.

As might be expected, examples of the former distinction are related to the previously recognized confession of one's intellectual and psychical incompleteness and dependence. In his chief dogmatic work, Schleiermacher reminds his readers, "Any proclamation of God which is to be operative upon and within us can only express God in His relation to us; and this is not an infra-human ignorance concerning God, but the essence of human limitedness in relation to Him."[77] John Calvin rather forcefully asks, "Who is so devoid of intellect as not to understand that God, in so speaking, lisps with us as nurses are wont to do with little children?" and then continues, "Such modes of expression, therefore, do not so much express what kind of a being God is, as accommodate the knowledge of him to our feebleness. In doing so, he must of course stoop far below his proper height."[78] John Colet also thinks in terms of God's "accommodation" to men. In keeping with the old Scholastic saying that the final cause operates not according to its

real being, but according to its being as that is known (*causa finalis movet non secundum suum esse reale, sed secundum esse cognitum*), he writes,

> It was thus [in the spirit of "accommodation"] that Moses taught the truth and justice of God, as it was brought down to the level of sensible things, and diluted for the ancient Hebrews. It was thus that Christ taught to the disciples what they were able to bear. It was thus, lastly, that Paul, both gently and sparingly gave to the Corinthians, as it were, milk instead of meat.[79]

A non-Christian example of this same insistence is the Islamic Shiite belief that the Eternal Imām comes *to* the situation but not *into* it, that is, his epiphany, or his making himself visible in the form in which he is contemplated, does not reveal his essence, but rather the need and capacity of the one who contemplates it. Thus the Imām can be at once father and son, a youth or an old man, depending upon the situation. This is very much in keeping with the Hindu understanding of the incarnations or avatars of Vishnu, as shown, for example, in the *Bhagavadgita*: "Whensoever the law fails and lawlessness uprises, . . . then do I bring myself to bodied birth. To guard the righteous, to destroy evildoers, to establish the law, I come into birth age after age" (IV. 7).

But now we must raise an obvious question. We may agree with the previously quoted passage in the *Kena Upanishad* that to know one does not know God well is to know something about God, but what is this something not known? Is it equivalent to knowing that we do not know, in effect knowing nothing? Can we not say this 'God' which we do not know well is not only ontologically incomplete, He is ontologically insignificant? If in fact God benignly reveals himself to men in order to lighten their heavy burden of being in the world, and if in fact this revelation is not of Himself as He is, but a lisping expression or a diluting of that self, an adjustment to what men can bear, can religion speak of objective knowledge, of truth? Feuerbach suggests the problem when he observes that "what he [God] is to me is to me all that he is."[80] In other words, if religious hypostatizations are responses to human needs they are not only human categories but they are categories valid only for those particular human needs. It seems not only are there different gods "age after age," but also different gods within the same age, each answering a different need. The nomads who live off the herds, which in turn live off pasture land, which in turn is dependent upon the rains from the sky for growth, might conceive of their gods as heavenly fathers; the farmers, who live off the products of the soil, might conceive of their gods as earthly mothers; finally the hunters, who live off the success of the hunt, might conceive of their gods as

lords of the animals. Thus with Santayana, "the great use of the gods" is not that they lead us to truth, but "that they interpret the human heart to us, and help us, while we conceive them, to discover our inmost ambition and, while we emulate them, to pursue it."[81] There is no objective knowledge so far as God is concerned.

But there are gaps in this presentation. This contextual relevance does not entail that religious hypostatizations (that is, 'God') lack objectivity. That the gods interpret the human heart does not necessarily mean they are dependent upon the human heart. For such an entailment there must be a chronological sequence of first, man; second, needs; and third, the answers to these needs. This ordering, religion need not necessarily grant. Appealing to the simple principle that if a pattern recurs frequently enough it must have some validity—or to put it more technically, that there is a relationship between man's theories of knowledge and his theories of nature—religion might well claim that the obvious lesson is that the relationship between man's needs and the answers to these needs is rather an all-at-onceness. Think of the need for food, or the need for speech; there is not first a need which creates the organs and manipulates the circumstances in order to realize the need; rather, the need comes from the all-at-onceness of having the organs in a network of interrelationships composing the right circumstance. Or think of the need to solve the world's vast engineering and scientific problems and the mathematical and scientific formulations which answer these needs. There is not first the world with its problems and then the responding mathematical and scientific formulation, but rather an all-at-onceness of man in the world who now both projects and reflects its structures, needs, and solutions. Thus, the argument would proceed, just as there exist all at once, appetites, digestive systems, and food to digest; thoughts, and words to express those thoughts; mathematical and scientific projections, and external reality which reflects and corresponds to those projections; so there may exist, all at once, man enmeshed in his own situation, and religious constructs which answer the particular needs flowing from that situation. Therefore, to answer the question "What does religion know?" the religious person may well reply with Augustine that he knows that "Thou has made us for Thyself and our hearts are restless until they find their rest in Thee."

Up to this point, this chapter has cited an extended way in which religion affirms its necessary and permanent withdrawal from the already known, while at the same time noting how it possibly draws from the already known a knowledge that transcends the tentative and

temporary character of the relationship. Like all religious people, Arjuna sees God, but only enough of Him to know that God is of such a nature that he wants to see more. The *Bhagavadgita* records his desire in pictorial terms. On the strength of a faith previously confessed, Arjuna asks, "I am fain, O supreme lord, to look upon thy sovran form . . . show to me thy changeless self, sovran of the Rule," but when shown he becomes "smitten with amazement, with hair standing on end" and finds that he must ask again: "Relate to me who thou art in this grim form." In the end he learns only to say "be gracious" and once again declares that he "would fain see thee . . . O thousand-armed, universal-bodied being" (XI. 3-46).

Now it is more difficult to find extended or generally applicable instances which make clear art's necessary and permanent withdrawing from the already known. But there are a few. Lessing, in his essay *Laokoon*, theorized that if an artist wishes to present action in sculpture and in painting, he must present that action not at its climax, but at a point a few minutes before the zenith, thereby affording room for more than what is already given.[82] Worringer argues his way into another example, but in his case when he applies his theory to concrete examples, something goes wrong. Initially, he correctly assumes that art distances, that is, has no intention to represent literally. The artist changes. Something emerges from his efforts which was not there before, something that he and his audience previously had been unable to see. In other words, by their actions artists form, they make what is, come to be. Second, Worringer evaluates architectural forms accordingly. He insists architecture comes of artistic age with the Gothic because whereas Greek architecture is "applied construction," a means to a practical end, attaining its expression through its material, Gothic architecture is "pure construction," "an end in itself" attaining its expression in spite of the stone.[83] His point is that whereas Greek architecture considers the practical purpose of the building and the limitations of the stone as essential impositions on architectural design, Gothic architecture considers them only as temporary impositions, impositions which the architect must consider but from which he must distance himself. Thus it is only in the Gothic form of construction that we have an artistic expression, an expression "carried for its own sake far beyond its practical aim." Architecture becomes an art form only the moment it ceases to employ its material merely as the means to represent or achieve some other end or aim. True art withdraws from the mere utility of the given material so that it might initiate a new understanding.

What has gone wrong is not merely Worringer's evaluation of Greek architectural forms. For example, the Doric order is not a building which the Greeks built solely for economy or for strength or for any reason of which we can think. Rather, it is an end in itself which we should appreciate in itself. Its architects carried it to a point far beyond any "practical aim." The columns provide a support immeasurably in excess of what the building requires. Thus according to his standard, we must consider it too as "pure construction," as aesthetic and not "applied." No, what has gone wrong goes deeper than this. It has to do with his slighting the collaboration between the artist and his material of which I spoke in the previous chapter. In defending the idea that the architect must resist the imposition of the demands of his material, Worringer overlooked the qualifying effect of old understandings and old materials. As a result he probably would have depreciated such architectural attempts to balance representation and distance as Nervi's exhibition hall in Turin or his Pallazzetto dello Sport in Rome, and would have had too great an appreciation for such monuments to architectural "ends in themselves" as the Empire Mall in Albany, New York, and say, the State University in that same city.[84]

Perhaps such examples, where theory dominates at the expense of conflicting sensitivities of which artists themselves are well aware, make clear why there is an artistic hesitance to theorize about the need to withdraw from the already known and to remain instead with individual observation. In place of theory Flaubert writes to a correspondent that "the idleness in which I have lived for some time gives me the cutting desire to transform through art all that is 'myself,' all that I have felt. I feel no need of writing my memoirs; my personality even repels me."[85] In a similar vein Keats remarks, "A poet is the most un-poetical of anything in existence; because he has no Identity—he is continually in for—and filling some other Body—the Sun, the Moon, the Sea."[86] Finally, in the most personal observation of all, Robert Frost writes,

> My poems—I should suppose everybody's poems—are all set to trip the reader head foremost into the boundless. Ever since infancy I have had the habit of leaving my blocks carts chairs and such like ordinaries where people would be pretty sure to fall forward over them in the dark.[87]

These examples are valuable because their concreteness suggests certain associated characteristics which artistic and religious distancing implies but which are sometimes lost in generalized theory. Two characteristics in particular demand our attention. The first is the

persistence of that sense of contingency to which we alluded at the very end of chapter 1 and which is very much part of Otto's *tremendum*. We are reminded that art and religion are marked by a falling "head foremost into the boundless" and Frost adds, "Forward, you understand, *and* in the dark." This particular characteristic is especially evident in certain concrete religious examples. Tradition records that when the Buddha attained nirvana, the faithful disciple Ananda uttered this verse:

> Then was a terrifying awe,
> Then was a horrifying dread,
> When he of all the marks possessed,
> The Enlightened, had Nirvana reached.[88]

What this utterance makes clear and what we might, possibly lose awareness of in, say, the psalmist's generalization that the fear of God is the beginning of knowledge or in Petronius' declaration that "fear was the first origin of the belief in Gods," is that artistic and religious terror or fear of falling "head foremost into the boundless . . . dark" is due not only to knowing some particular happening might or might not occur, or even to not knowing *what* particular happening might or might not occur, but rather to knowing that whatever does occur, it need not necessarily have occurred. It is knowing everything is contingent, an accident, or as the man who repaired my stove put it, it is knowing that "we are *all* terminal, just some sooner than others." So far as artists and religious people are concerned it is the awareness that the world in which they function is an accommodation, perhaps by God whom they really do not know, or perhaps by them to a previous moment, and that writing and listening to poetry, like attaining nirvana, is equally a falling forward out of that accommodation into what is now not yet, but nevertheless will be the new world.

This is a very important point for religion. Its distinction between faith (*fides*) and belief(*credo*) is an example of this. According to the *Chandogya Upanishad*, "when one has faith, then he thinks. One who has not faith does not think. Only he who has faith thinks" (VII. 19. 1). Immediately preceding this observation is the assertion, "When one thinks, then he understands. One who does not think does not understand. Only he who thinks understands" (VII. 18. 1). Together the two statements tell us that it is the man of faith who thinks and who, thereby, comes into understanding. It is the man of faith, who by thinking, falls forward into the dark, moving into a state where he has not been previously. In this sense we can understand the claim that the

man of faith has faith, not in things he has seen, but in those things he shall see, if he has faith. So understanding, hope, too, become a part of faith.[89]

The contrast and counterpart to faith is belief, *credo*. Whereas faith hovers in *tremendum*, always on the brink of the yet-to-be, belief holds forth and idolizes, in *fascinare*, in what religion has already established. Here there is no sense of contingency, no falling forward into the dark, no need for hope. To use an analogy from painting, faith is akin to the painter's use of light when that light gives existence to the things the painter paints. When the light goes out, the objects disappear. When faith goes away or grows weary, its objects too disappear. On the other hand belief is akin to chiaroscuro, that technique so marked in the works of Caravaggio and Rembrandt whereby light becomes a theatrical lighting of objects out there, bestowing clarity on what was previously obscure. In the latter case, when the light is removed or the belief departs, the objects remain. They are merely in the dark.

This analogy suggests the second characteristic which specific and concrete examples tend to make clear about the nature of art and religion. It is that these two activities are marked by that kind of work which creates new things, which brings about new discriminations. It is not by accident that Hesiod's *Works and Days* covers religion, agriculture, and ethics. Each area involves that kind of work which brings into the light that which did not previously exist. So does art.[90] Van Gogh, while thinking of painting, notes that

> making beautiful things costs trouble and disappointment and perservance . . . It is working through an invisible iron wall that seems to stand between what one *feels* and what one *can do*. How is one to get through that wall—since pounding against it is of no use? One must undermine the wall and drill through it slowly and patiently, in my opinion . . . I consider it of very positive and great value that one must try to develop one's power of reflection and will.[91]

To "develop one's power of reflection and will" so that one might work "through an invisible iron wall" or so that one might "imagine himself God," as Paul Klee once put it, is but to affirm man's artistic and religious obligation to distance himself from that which he originally encounters, and to stretch his understanding to newly encountered dimensions, as against the more typical willingness to cut down these dimensions to a previously established understanding. This is what is necessary: in terror, to distance from old understandings; and to work

to bring into existence that which has no existence. In activities of this sort "the sun does not shine on good and evil alike; for here . . . only he who works has bread, only he who is troubled finds rest, only he who descends into the netherworld rescues the beloved, only he who draws the knife obtains Isaac."[92] For art and religion men must work, otherwise there is only darkness. There are no molds. There is no rest in the knowledge of what one already knows, even the knowledge of God. There is only that continuous activity which keeps men always on the brink of the yet-to-be.

An important confirmation of this second point is the religious use of the Indian word and doctrine *karma*. It literally refers to that special kind of work which brings new structures into the old world; that is, it fixes a person's total self in future existences. The word is connected to the Sanskrit root *KRI*, (or KR) to do or make, which in turn is related to the English word 'create.' Thus *karma* is that kind of work which creates future existences. In effect it creates life. Without *karma* man has no life. It is by way of previous *karma* that he is what he is in this existence. It is by way of new *karma* that he escapes from the fetters of what he is in this existence and puts on a new self.

A more general religious example is the rite of initiation. First the men of the tribe may inflict upon the adolescent candidate physical and mental suffering by torture, by terrorizing, by beatings and/or by forcing the candidate to drink a narcotic brew. As it is with a monk's voluntary withdrawal from the world or the involuntary beating which the Zen master administers to his pupils, the men intend this harsh treatment to stimulate the necessary rejection and distancing which will precede the required working into a rebirth or redirection. The assumption is that it is necessary to die to the old and to the profane before the candidate can be born into the new and the holy. As for the rebirth itself, or the venturing forth into the yet-to-be, this may not come for many years. But when it does come, a new wisdom marks it and the adoption of a new name and the assignment of a new place in society usually accompanies it. The family weeps and laments because what they had, they no longer have. Their child is not the child they once knew. He has become another.

Notice something else about this kind of work. Human initiative marks these examples. This too is related to that artistic and religious openness or innocence discussed in chapter 1. There I quoted T. S. Eliot's *Burnt Norton*:

> "Words strain,
> Crack and sometimes break under the burden,
> Under the tension."

Now, although this is so, there is added the observation that

> "each venture Is a new beginning, a raid on the inarticulate"[93]

> (*East Coker*, Section V, lines 7-8)

Herein lies the distinction between prophet and soothsayer. Both work, but it is only the prophet who takes the initiative and raids the inarticulate. Only he accepts the responsibility to forward a message that at most is a promise of things to come *if* men, including himself, will do such and such. He accepts the challenge to raid that which awaits his work, that which will remain inarticulate but for man's actions. This is why the archangel Gabriel could not answer the prophet Muhammad's question. Muhammad tells us that first Gabriel said,

> "O Muhammad, I am Gabriel, and thou art Allah's Apostle." Then he said to me: "Recite!" but I answered: "What should I recite?"; whereat he seized me and grievously treated me three times, till he wore me out. Then he said: "Recite, in the name of thy Lord who has created" (Sūra XCVI. 1). So I recited it and then went to Khadīja, to whom I said: "I am worried about myself." Then I told her the whole story.[94]

Obviously what Muhammad had to recite was not there waiting like a ripe apple to be picked. It was inarticulate until Muhammad himself articulated it. The doing creates; the saying articulates. In this instance, to recite is to articulate. F. Scott Fitzgerald points up this connection when he tells his daughter,

> Nobody ever became a writer just by wanting to be one. If you have anything to say, anything you feel nobody has ever said before, you have got to feel it so desperately that you will find some way to say it that nobody has ever found before, so that the thing you have to say and the way of saying it blend as one matter—as indissolubly as if they were conceived together.[95]

For the soothsayer none of this is true. He foretells a future that will come regardless of human actions. This future has no relationship to these actions, including his own. For him there is no inarticulate. The future is decreed. It is known, completed and finished. What needs to be said already has been said. There is no responsibility, no initiating. If the soothsayer raids anything, it is the already articulate, that which already is, those structures men already know.

Religious activity no less than artistic activity raids the inarticulate, it too improvises or initiates. Interestingly, a good store of evidence comes from those religious acts performed as death approaches—that most decisive area where what finally occurs requires little initiation on man's part. When the Buddha knew he was going to die,

the Blessed One laid himself down on his right side, with one leg resting on the other and he was mindful and self-possessed . . . He gave Ananda a few instructions and called his monks together. Did any of them have in their minds any doubts or perplexities concerning the Doctrine or the discipline? Let them hurry and state them before it was too late! After urging them for the third time and receiving silence in answer, the Blessed One said: "Behold now, brethren, I exhort you, saying, 'Decay is inherent in all composite things! Work out your salvation with diligence!'" These were the Tathagata's last words. Already the death struggle had begun . . . From the peak of ecstacy he passed slowly through the series as a natural transition into the supreme and ineffable state of final Nirvana.[96]

It was no different with Jesus Christ. When,

Jesus knew that his hour had come to depart out of this world to the Father . . . during supper, . . . Jesus, knowing that the Father had given all things into his hands, that he had come from God and was going to God, rose from supper, laid aside his garments, and girded himself with a towel. Then he poured water into a basin, and began to wash the disciples' feet and to wipe them with the towel . . . He came to Simon Peter and Peter said to him, "Lord do you wash my feet?" Jesus answered him, "What am I doing you do not know now, but afterwards you will understand." Peter said to him, "You shall never wash my feet." Jesus answered him, "If I do not wash you, you have no part in me."

[John 13: 1-8]

When religious spokesmen, representing the collective group, sanction the tribal killings of priests and kings, the aged and the sick, they too are trying to maintain the initiative. They wish to cause a death rather than to witness it passively. Causing the death is also their way of affirming their role—albeit in a futile way—of determining what shall be the new world of the tribe. Tribal killing is a way to affirm what Bhartrhari declares in the *Vakyapadiya*, that "all this universe is but the result of a sound," (I. 24); that is, man's sound, the sounds that come from his art and his religion.[97]

Significantly, religion explicitly relates these findings about the nature of artistic and religious work to God, this chapter's original example of religious distancing. Since God is always more than what men can make of Him, this religious raiding of the inarticulate is also a moving toward God, nay, even more. The *Mundaka Upanishad* bluntly reports that "He who knows the Supreme Brahman becomes Brahman himself" (III. 2. 9). Clement of Alexandria softens this last step but he affirms the connection. "It is . . . the greatest of all lessons to know one's self. For if one knows himself, he will know God; and knowing

God, he will be made like God, not by wearing gold or long robes, but by well doing, and by requiring as few things as possible."[98] This also reminds us of the connection of this chapter to the previous two chapters. Clement tells us first, that religious work begins with a knowledge of one's self, and second, that such work eventuates in the religious person's being "made like God." The necessary ingredients are self-knowledge (the given, in fascination), work (or what Clement calls "well doing"—distancing, in terror), and becoming like God (a God not previously known).

Now Clement's observation can be true, and in fact understood, only if he already has distinguished that kind of work and self-knowledge which the soothsayer holds from that kind of work and self knowledge which we insist the artist and the religious person hold. This is to say, Clement's observation, and that of the author of the *Mundaka Upanishad*—that the religious person begins with what he is and works toward what he will be—can be valid and can make sense only if the kind of work which the religious person does is that kind which distances from things already done, is that kind which takes the initiative to bring about new things, and is that kind in which the self-knowledge with which the religious person begins is a knowledge of the self which now is, and yet at the same time is not yet because of religious work still to be done. Religion speaks of this as a "supreme knowledge" because it includes the "knowledge" of what is not the self as well as what is the self, when men know themselves as finished objects in this or that place and in this or that time. It is "supreme" because it is a knowledge of the self from which men must distance themselves and a knowledge of the self which will be.

Schopenhauer helps to make this point clearer. He reflects on the meaning of the Christian prayer, "Lead us not into temptation," and concludes that it means "Let me not see who I am."[99] The impact of these comments about work is that the "who I am" to which Schopenhauer refers is the knowledge of the self which the soothsayer holds, the knowledge of "who I am" here and now. Thus Schopenhauer's analysis of the prayer is that it is telling men that they must not be tempted into being content with these structures which they already know; rather they must press on to relate with the not-yet, with the appearing with God. He does not deny the "who I am"; he is saying only that the religious person—and we add, the artist—cannot rest content with it, or say, "Hold fast." In effect the soothsayer's "who I am" can only be that functional place *from which* the artist and the religious person assume the initiative and move into the future. To use

Clement's terms again, we continue to note a threefold logical distinction. First, there is the knowledge of themselves which tells men who they are. This is the "who I am" with which they hopefully pray they will not be tempted to rest content but from which they will be allowed to distance themselves. Second, there is the knowledge of themselves which is receptive or open to what in the first instance, they are not, but perhaps might become. When this self-knowledge becomes a part of what they are, they have knowledge of God. Third, there is the "well-doing," the work, the act of initiating new discriminations which move men from self-knowledge in the sense of "who I am" to self-knowledge in the sense of "made like God."[100]

The particular advantage of the term 'distance' is that it theoretically allows for what is implied in the observation that to initiate a new discrimination is not to create something out of nothing. Although both art and religion are aggressive in maintaining this threefold distinction of which I have just spoken, we must remind ourselves that the given limits which discriminations individual artistic and religious acts can initiate. I spoke of this in the first chapter commencing with the example of Duccio's *predella* scene which psychologically represented those theological values it was commissioned to serve. Duccio represented these familiar communicable values as a base from which he and his audience moved, somewhat the way Beethoven represented Haydn's sonata form: to present, to bend, and eventually to extend it.

In that chapter I also implied that some artistic works did this extending more completely than others, for example Giotto's pictures in the Arena chapel at Padua more completely than Duccio's *Maestà*. In this chapter I noted that Worringer insisted Gothic architecture did it more completely than did Greek architecture. But the important thing is to recognize this variance of completeness, not necessarily to agree with the examples. We must recognize the fact that although all artistic and religious works extend the given beyond its previously accepted limits and associations, some works or expressions do it more decisively or more completely than do others. We might say they effect a more definitive distancing between what they have to say and what they had previously understood. Religion provides its examples. On the one hand we have Jesus' harsh insistence that "if any one comes to me and does not hate his own father and mother, and wife and children, and brothers and sisters, yes, and even his own life, he cannot be my disciple" (Luke 14:26), and on the other hand those warnings of dire consequences which accrue to those who do not work in this manner, as in the *Koran's* vivid elaboration:

> The righteous shall surely dwell in bliss. But the wicked shall burn
> in Hell-fire upon the judgement-Day: they shall not escape.

> Would that you knew what the Day of Judgement is! Oh, would that
> you knew what the Day of Judgement is! It is the day when every
> soul will stand alone and Allah will reign supreme (LXXXII. 4).[101]

This latter passage less decisively breaks with the past because in attempting to motivate a religious activity which does distance, it appeals to associations already established in that past. Whereas Duccio appeals to psychological and social values supported by the ecclesiastical authorities who commissioned his work, the author of the *Koran* appeals to individual fears of experiencing the pain of a hell-fire in which the hardened sinner who denies the truth shall burn. As such, these works or pronouncements are less decisive in bringing a new world or a new understanding to be; but they are still art or religion insofar as they preserve some semblance of distance and do stretch into the future. Duccio, as we noted, made the setting a dramatic constituent of the action, Islam stimulated its followers into assuming new behavioral patterns which heralded a new future. Alongside its appeals to the fear of blazing fire it also insists that only those so-called good works which are distanced from this fear will actually achieve what religious activities are meant to achieve, namely, free the sinner from the fire. He "who offereth not favours to any one for the sake of recompense, but only as seeking the face of his Lord the Most High . . . surely in the end he shall be well content" (*Sura* XCII. 3).

This is the lesson of Job, also clearly found in the *Bhagavadgita*. The religious person must distance himself even from the fruits of his good works—in this case, the desire for deliverance from hell. Man cannot direct his religious acts toward any known understanding.[102] His religious work must be valuable in itself; done for itself, for what it may initiate in the future, not in order to free him from fears already conceived or to affirm hopes or visions which he already has established in the past. We are reminded of this chapter's original finding that certain artistic and religious discriminations are less than ontologically significant. Only he who, like Abraham, draws the knife on *everything* builds the new. There are no artistic or religious structures that deem it otherwise, only temporary impositions. Even "unsteady, verily, are these boats of the eighteen sacrificial forms, which are said to be inferior karma. The deluded who delight in this as leading to good, fall again into old age and death" (*Mundaka Upanishad* I. 2. 7).

In essence 'distance' is a useful term because it accounts for this fact that works of art and religion initiate new discriminations which

vary in their degree of newness. So far as a work does function as art or religion it must evince some distancing from old understandings. This in turn suggests something of which we shall be sensitive in chapter 7: instead of evaluating specific artistic and religious acts with the severe, cleanly-cut, value-oriented words 'good', or 'bad', or 'poor', or even 'major' or 'minor', we should think of art and religion in terms of more or less, in terms of 'diminish'. Those acts which appeal to associations already established compromise this withdrawing or distancing and as such they have diminished their artistic and religious force. But, of course, insofar as they only diminished this force, and have not extinguished it, they remain artistic or religious. Art has a word for such dimunition, 'mannerist', denoting works "in the manner of" or with features strongly analogous to the characteristics of the style of the preceding, or primary, period. Occasionally such mannerism has even dominated a total mode of artistic expression, as European (especially Italian) art, say, from 1525 to 1600, may demonstrate. These works have compromised distance, thereby diminishing their force so that they contribute at best an embellishment to a world seen elsewhere.

Nevertheless, it would be rash to assume dimunition entails poorer. A less decisive distancing does not automatically compromise artistic and religious force in the sense that such art or religion is poorer than the art or religion which goes in the other direction and possibly abandons all limits to distance. As we learned from chapter 2, this would be to ignore the presence in these activities of that which restricts distance, that which fascinates; that is, victories men have already won or structures they have already seen. It also would ignore the lesson learned from Worringer's insensitivity to the in-fact presence of a compromised distance between the architect and his material. However the facts do suggest that *to a degree* dimunition implies 'poor', 'bad' or 'minor', art or religion. Consider our example of mannerism. So far as it is identified with a period of style in Italian art, no matter how that style is variously interpreted—whether as a bridge between High Renaissance and Baroque, or as the beginning of that which culminates in El Greco, or even as a manifestation of the "eternal Gothic spirit"—in no case of which I am familiar are its particular expressions considered to be anything other than minor. They are bridges, beginnings, or manifestations; doings in or through a style which at best find their artistic significance in preparing for that style, enlarging it or embellishing upon it. In the language of the example from the *Koran* which started this discussion, they are similar to those actions which are in response to human needs or fears, but which at the same time transcend them insofar as they are art.

There is another aspect to this reason why 'distance' is useful. It allows for the differing capacities and fluctuating moods of persons who function in artistic and religious situations. Not only do artistic and religious activities variously work in and through the limits of their given situations, but people differ from one another regarding what constitutes their functional minimal and maximal capacity to distance, and also regarding their ability to maintain that habitual capacity in different moods, with different objects, and during different activities. Traditionally, the Christian church recognizes these personal variations and fluctuations by its insistence that it is a "mother" and not a "virgin," and so does Zen with Rinzai's acceptance of certain riddles, technically called koans, as aids for meditation and with Sōtō's inclination to think of these koans as compromises to religious distancing. In practice, musical appreciation is no different. For some people knowledge that Mahler was influenced by Jean Jacques Rousseau's longing for a closeness with nature contributes to their appreciation of his symphonic pastoral movements, whereas for others it is aesthetically irrelevant, something from which to distance themselves. Obviously a rigid insistence that only the latter examples are valid actions of religion or art is a view which has no room for these variations and fluctuations.

This second aspect of why 'distance' is a useful term for understanding art and religion also has its ramification. There is evidence to suggest the individual capacity to distance more or less successfully is, at least partially, socially induced. Think of the responses of various periods to the Elgin marbles and to African sculpture, or the attitudes of various societies toward the veneration of relics. In the ancient Buddhist Pali text, *The Questions of King Milinda*, we read,

> Venerable Nâgasena, the Tathâgata said: "Hinder not yourselves, Ânanda, by honouring the remains of the Tathâgata." And on the other hand he said:
>
> "Honour that relic of him who is worthy of honour,
> Acting in that way you go from this world to heaven."
>
> Now if the first injunction was right the second must be wrong, and if the second is right the first must be wrong. This too is a double-edged problem now put to you, and you have to solve it.
>
> Both the passages you quote were spoken by the Blessed One. But it was not to all men, it was to the sons of the Conqueror that it was said: "Hinder not yourselves, Ânanda, by honouring the remains of the Tathâgata. Paying reverence is not the work of the sons of the Conqueror, but rather the grasping of the true nature of all com-

pounded things, the practice of thought, contemplation in accordance with the rules of Satipatthana, the seizing of the real essence of all objects of thought, the struggle against evil, and devotion to their own [spiritual] good. These are things which the sons of the Conqueror ought to do, leaving to others, whether gods or men, the paying of reverence.

(IV. 3. 24, 25)[103]

At its charitable best our reaction at this moment in the twentieth century may well be similar to that in John Evelyn's report:

> Keeping on our way, we come to St. Croce of Jerusalem, built by Constantine over the demolition of the Temple of Venus and Cupid, which he threw down; and it was here, they report, he deposited the wood of the true Cross, found by his mother, Helena; in honor whereof this church was built, and in memory of his victory over Maxentius when that holy sign appeared to him . . . Here is a chapel dedicated to St. Helena, the floor whereof is of earth brought from Jerusalem; the walls are of fair mosaic, in which they suffer no women to enter, save once a year. Under the high altar of the Church is buried St. Anastasius, in Lydian marble, and Benedict VII; and they show a number of relics, exposed at our request; with a phial of our blessed Saviour's blood; two thorns of his crown; three chips of the real cross; one of the nails, wanting a point; St. Thomas's doubting finger; and a fragment of the title (put on the cross), being part of a thin board; some of Judas's pieces of silver and many more.

Evelyn quickly adds, "if one had faith to believe it."[104]

To recognize that this varying and fluctuating ability to have "faith to believe" is partially a social product prevents men from turning inward and thinking of art and religion "as some internal spiritual act, of which the words then are to be the report," perhaps as some psychological commitment which occurs prior to the actual painting or praying. The turning inward goes something like this. First, there is the legitimate awareness that art and religion work in and through the limits of a given situation while at the same time transcending it. But the given is narrowly defined. We are variously told art and religion must express "emotions different from and transcending the emotions of life, . . . not actual feelings but ideas of feelings." They must render lust and superstition into that which is "innocent and interesting," and thereby become "free from all encumbrances with the 'otherness' of empirical sensuous existence and of sensuous images and representations." Second, there is the recognition that it is the connoisseur, the artist and the religious person who turns these emotions or feelings

into those kinds of emotions or feelings which transcend life. Perhaps the most famous move in this direction is Wordsworth's often quoted Preface to the *Lyrical Ballads* in which he declares,

> Poetry is the spontaneous overflow of powerful feelings; it takes its origin from emotion recollected in tranquility: the emotion is contemplated till, by a species of reaction, the tranquility gradually disappears, and an emotion, kindred to that which was before the subject of contemplation, is gradually produced, and does itself actually exist in the mind. In this mood successful composition generally begins, and in a mood similar to this this it is carried on.[105]

First comes the emotion itself and the individual recollecting it in tranquility, until, finally the tranquility disappears and the emotion is produced once again, this time in the mind. The process of introversion is almost complete. Poetry is the spontaneous overflow of powerful feelings, not as they are but as they are recollected in tranquility. Art and religion are no longer acts done on canvas or in temples but they are the ideas of those acts. They are no longer expressions of emotions, but, as Collingwood insists, "the experience of expressing one's emotions."[106]

Edward Bullough provides us with the final step of confirmation with his influential 1912 article "Psychical Distance as a Factor in Art and on Aesthetic Principle." He argues that although artists and connoisseurs do make an inward move to put the original emotion "out of gear with our practical, actual self," this

> does not imply an impersonal, purely intellectually interested relation . . . On the contrary, it describes a *personal* relation, often highly emotionally coloured, but *of a peculiar character*. Its peculiarity lies in that the personal character of the relation has been, so to speak, filtered. It has been cleared of the practical, concrete nature of its appeal, without, however, thereby losing its original constitution.[107]

My quarrel then is not with Bullough's conclusion that art (and religion) are "filterings," or distancings, or withdrawings, from an original given, but with his insistence on an inward psychical act which explains or is the phenomenon of distancing. To think of distancing as an at least partially social product is to neutralize the need for a prior individual psychological act that brings about or is this artistic and religious distancing, and to suggest there is only the doing of certain activities—of painting and of praying which function in society in such a way they effect a certain filtering or distancing from old givens.

There is a third and final aspect to this usefulness of 'distance' in understanding art and religion. It allows us to incorporate the fact that the new knowledge to which art and religion introduce men isn't necessarily a bursting, complete and revolutionary, all-of-a-sudden insight akin to the literal at-once knowledge one has of a fact or of a new proposition. Rinzai's efforts to achieve a sudden illumination are the exception. Most of the time artistic and religious illuminations are like the growing into a knowledge of this or that person, a kind of knowledge which gradually means new understanding, but which may, nevertheless, continue to fluctuate from day to day very much like private moods.[108]

It is for these three reasons, each rooted in ways in which art and religion actually function, that 'distance' is useful. In spite of the association of 'distance' with a psychologism which suggests evidence for understanding of art and religion is merely a contingent generalization about the way certain people happen to think or feel, it is useful to suggest that so far as a work functions as art or religion it evinces some distancing from old understandings. In fact I shall argue in the next chapter that this characteristic of art and religion allows us to distinguish art from craft, religion from magic. Whereas the craftsman and the magician subsist with discoveries man has achieved and desire the results man already knows, the artist and the religious person show an eternal, never-to-be-consummated, heuristic initiative which satisfies, if anything at all, their craving to solve the not-yet-solved, to create the uncreated. It is this same appetite which is related to the craving for a "supreme wisdom" which I noted, if man's understanding of himself includes the knowledge of what he is not as well as what he is.

All of this, though, is a matter of degree. For instance, literary gossip has it that Faulkner rated Wolfe higher than Hemingway because Wolfe tried again and again to do the "impossible" while Hemingway stayed within the style he knew and did so well. It was this same awareness that later led Faulkner to depreciate his own *As I Lay Dying*, once his favorite, as he put it, because "it gave me no trouble." Yet *As I Lay Dying* is art, and Hemingway's *The Sun Also Rises* likewise is art. The interesting question then—for which 'distance' provides the theoretical context—is, When does the style of an artist become a practiced technique inherited from previous understandings? When do later works in a particular style become merely examples of craft? The answer is, When they no longer effect a distancing from what previous activities in that style have already achieved.

Thus I conclude that 'distancing' best captures this fluctuating process of growing-into-a-new-understanding, in which we observe art and religion to be participating—that is, that process which begins with a context and is sensitive to it, but which nevertheless then assumes the initiative and effectively moves out from it, thereby altering it. Only by so acknowledging this process can we incorporate endeavors such as Aristide Maillol's innumerable efforts to construct subtle variations of three-dimensional plastic form with the female nude, or Fouquet's *Diptych of Melun*, in which the Virgin is said to be the portrait of King Charles VII's mistress, Agnès Sorel. In the latter case, without the idea of distancing, Renaissance man could only have judged the piece to be "crude" or "sacrilegious"!

Craft and Magic

To the wardrobe there very merry with my Lady, and after dinner I
went for the pictures thither, and mine is well liked; but she is much
offended with my wife's and I am of her opinion, that it do much
wrong her; but I will have it altered . . . With my wife to the payn-
ter's where we staid very late to have picture mended, which at last
is come to be very like her, and I think well done . . .

To church, and heard a good sermon of Mr. Gifford's . . . upon
"Seek ye first the kingdom of Heaven and its righteousness, and all
things shall be added to you." A very excellent and persuasive, good
and moral sermon. He showed, like a wise man, that righteousness
is a surer moral way of being rich, than sin and villainy.

<div align="center">Pepys</div>

Following a lead from the discussion of the distinction between
prophet and soothsayer, the next stage of my argument will point up
the usefulness of 'distance' in allowing us to distinguish art from craft,
religion from magic.

Because Dewitt Parker insists upon a Freudian interpretation of
art—one which understands both art and religion very much in terms
of what I will call craft and magic—his conclusion provides a fruitful
point of entry for my analysis: "Through art we secure an imaginative
realization of interests and latent tendencies to act and think and feel
which, because they are contradictory among themselves or at variance
with the conditions of our existence, cannot find free play within our
experience."[109] First, he observes that each individual person is a
fragment, only one possibility among the many that he might have
been. Second, he theorizes that no matter which of the lives an indi-
vidual chooses for himself or fate forces upon him, the individual

always retains a longing for all of the other possibilities that will go by unfulfilled. Third, he concludes that it is the function of art to serve this longing for what each person will not become.

The conception is very much like a Surrealistic theory of art which understands art to be the recapturing of man's dreams by resolving them into a reality-absolute or a surreality. Realizing what Parker calls "latent tendencies" is the artistic act. It makes the longed-for reality come to be, a reality which might have been, but which certainly is not yet. At its best, art hereby allows the fragmented individual, first, to recognize his fragmented nature by purging himself of his self-containment, and, second, to find himself as he really is: a fragment plus a longed-for reality which does not yet exist.

Now this could sound very much like Clement of Alexandria's insistence that the true knowledge of oneself leads to the knowledge of God; what men dream, through art and religion, is herein resolved into a reality-absolute. But the two positions are quite different. As I pointed out in chapter 3, men can come into Clement's divine knowledge only if they incorporate into their knowledge of themselves a knowledge of what they previously were not. This comes from that innocent openness discussed in chapter 10. Thus the related aesthetic is in harmony more with a conceptual realism in which 'real' means a freeing from certain realities than a conceptual realism in which 'real' means a serving of certain realities.[110] In the latter depiction, the psychological understanding of art which I have identified with Parker, individuals take in only that knowledge of themselves which already is: the longed-for reality of what they might have been or what they already potentially are. This means there is no distancing from understandings they already grasp. There is no taking in what they already are not; there is only a taking in of what they already are, in longing or in potential. In this scheme of things, art and religion become activities which only transfer already existing thoughts, objects, and needs from one kind of existence to another. To say that art and religion are the recapturing of dreams or the imaginative realization of the selves which we are not, but long to be, is to say that they are the projection of images from the unconscious to the conscious, serving gods or visions which are already functioning.

My distinction then is between activities which incorporate only knowledge which they do not already have and activities which incorporate only knowledge which they do have. An example where both types of activities are present and clearly distinct is man's theorizings about the nature of love. First, following Aristophanes' discourse in

Plato's *Symposium* 189-193, it is possible to think of the longing to fulfill what Parker called "interests and latent tendencies," love. Empedocles provides the cosmological setting. "In strife all things are endued with form and separate from each other but they come together in Love and are desired by each other"(Fragment 96). Thus men desire that from which they have been separated, that which they once were. In the *Symposium* 211-212, Plato even suggests that this can explain man's longing to be God, and in the *Theaetetus* 176, he has Socrates exhort man to "become like a god, so far as he is able to."

But second, in the *Bhagavadgita* we find a further development. Krishna, the divine incarnation of Vishnu, tells Arjuna,

> Not for the Vedas, not for mortifications, not for alms-giving, and not for sacrifice may I be seen in such guise as thou hast seen me.But through undivided devotion, Arjuna, I may be known and seen in verity, and entered, O affrighter of the foe.
>
> He who does my work, who is given over to me, who is devoted to me, void of attachment, without hatred to any born being, O son of Pāndu, comes to me.
>
> [XI. 53-55]

He who does God's work, in devotion, *void of attachment*, comes to Him. Here is the necessary prerequisite to that kind of doing which incorporates knowledge that individuals do not already have. Krishna asks for a love rooted in a longing for something *other* than one's already established "interests and latent tendencies." Plato shows us how it is done. In the *Phaedrus* 254, he depicts the charioteer and his two steeds who behold the vision of love. Whereas the good steed refrains from leaping on the beloved and falls back in adoration, the bad steed draws the charioteer and the good steed to the beloved, desiring to overcome her. Both steeds behold the vision of love, but only the good steed acknowledges distance and falls back, thereby allowing the other (that from which he is separated) to be. Here Empedocles' desire has been checked and that form previously endued by strife, at first a fragment or latent tendency of oneself, is now recognized as something valuable in itself. Love has moved from being an egotistical force, a longing to fulfill one's own "interests and latent tendencies," to a force which recognizes that that for which one longs exists independently of one's longing, and that which makes it desirable nevertheless is its value in itself, not in satisfying one's previously established interests and latent tendencies.

It is this kind of love that is related to religion.[111] Sometimes we are told that God is love, and we remember the familiar first commandment of the Decalogue, "Thou shalt love thy Lord they God with all thy heart, with all thy soul, and with all thy mind," and the imperative "Love God and thy neighbor as thyself." Clearly men are not hereby enjoined to have an inner feeling of affection, because affection cannot be enjoined, only invoked. Instead, what is being enjoined is to practice a certain freedom and openness which it is hoped will create new understandings or new relationships; further, to practice that kind of objectivity which might possibly succeed in incorporating into the self a knowledge of what is not the self. Love, as exemplified by the good steed, is the desire so to incorporate, by recognizing distance. This does not mean that the love affair is never consummated, or that one never knows God; simply that the beloved, God, or the love itself, is never consumed by love's passion. The object is never possessed.

The first of two important entailments from so understanding love and religion, and art, too, is continuing fragmentation, a reminder of that sense of contingency of which I spoke in the last chapter. Unamuno relates it to suffering.

> There is no true love save in suffering, and in this world we have to choose either love which is suffering, or happiness. And love leads us to no other happiness than that of love itself and its tragic consolation of uncertain hope. The moment love becomes happy and satisfied, it no longer desires and it is no longer love.[112]

Rainer Maria Rilke actually writes of

> loving the distance . . . once the realization is accepted that even between the closest human beings infinite distances continue to exist, a wonderful living side by side can grow up, if they succeed in loving the distance between them which makes it possible for each to see the other whole and against a wide sky.[113]

Religion recognizes the fragmentation in various ways. Madhva's insistence that in the Great Release differences will remain, is very much in harmony with Jewish, Christian, and Muslim speculation on the nature of the messianic age or of heaven. The more traditional Eastern way is first to insist that the Great Release means complete absorption but then, because of the this very fact, personally to reject it. The Bodhisattva, "one whose essence is perfected wisdom," is the familiar example. So is the Hindu Tantric initiate who asks, "Who seeks nirvana? What is gained by moksa?" and then boldly comments, "Water mingles with water." A less familiar example is Jñanesvar, who when commenting on his Vaishnavite brothers, declares,

"So dear the path of the bhakti, they despise
The Great Release."

Tukaram, also a Mārātha Vaishnavite, pleads:

Hear, o god, my supplication—
Do not grant me Liberation.

'Tis what men so much desire;
Yet how much this joy is higher!

Home of every Vaishnavite,
See, with glow of love alight!

By their door with folded hands
Full Attainment waiting stands

Heavenly joy is not for me,
For it passeth speedily;

But that name how strangely dear
That in songs of praise we hear!

Yea, thou, dark as clouds that lower,
Knowest not thine own name's power.

Ah, says Tuka, it is this
Makes our lives so full of bliss[114]

A passage which tries to express an affinity with Madhva's insistence upon ontological differences and to accept as well the traditional understanding of nirvana, is the following one from the ninth-century Tantric text *Sarah Dohakosha*:

He who clings to the Void
and neglects compassion,
Does not reach the highest stage
But he who practices only Compassion
Does not gain release from toils of existence.
He, however, who is strong in practice of both,
Remains in neither Samsara nor in Nirvana.[115]

In effect, it affirms a new place, of the world but not in the world, a place where men can compassionately acknowledge the divisions of the world but somehow at the same time transcend them. It affirms for the religious sphere the eternity of the other which can never be reduced to Parker's "latent tendency."[116]

In the realm of art, Paul Klee recognizes continuing fragmentation while answering the question, "Does the artist have to deal with microscopy? History? Paleontology? He insists,

Only by way of comparison, only by way of gaining greater scope,
not so that he has to be ready to prove his fidelity to nature! The

main thing is freedom, a freedom which does not necessarily re-
trace the course of evolution, or project what forms nature will
some day display, or which we may someday discover on other
planets; rather a freedom which insists on its right to be just as
inventive as nature in her grandeur is inventive. The artist must
proceed from the type to the prototype![117]

In the terms of an analogy once used by Robert Frost, the artist and the
religious person are like the person who goes into the field to pull
carrots. Although he is sensitive to the form which each carrot already
suggests, he refuses to leave them as they are, and keeps

> on pulling them patiently enough until he finds a carrot that
> suggests something else to him. It is not shaped like other carrots.
> He takes out his knife and notches it here and there, until the
> pronged roots become legs and the carrot takes on something of
> the semblance of a man.[118]

A kind of evolution takes place, not toward a formal explication of
latent tendencies but in a succession of steps, away from them. There is
no rest, no peace, no fulfillment. New forms quickly become old forms
from which our puller of carrots now in turn distances himself. Forms
assert their validity, but as bases to be acknowledged, incorporated,
and finally to be left behind.

John Herman Randall, Jr., suggests that such activities as these
function symbolically, but they do so in the peculiar way of what he
almost calls a representative symbol.[119] By making 'representative' the
adjective we could thereby acknowledge the artistic and religious need
to begin with understandings and latent tendencies which already
exist, and by putting it in combination with the noun 'symbol' we could
acknowledge the distinctive artistic and religious need to move beyond
them and into a knowledge of what is not yet known. Art and religion
are representative symbolic activities—continually fragmented, always
distancing themselves from things and tendencies signified, named,
pointed to, evoked or announced—but never abandoning them.

Literary examples are easily cited in support. Think of the rela-
tionship between the 'I' in a poem and the 'I' who is writing the poem;
Emily Dickinson's "I'm nobody! Who are you? Are you nobody, too?"
for instance. The poetic 'I' represents the 'I' who is writing the poem or
the 'I's' who could write the poem, and it symbolizes those 'I's' which are
distancing themselves from the represented 'I' by becoming that vehi-
cle by which these 'I's' move into a new understanding of what it means
to be an 'I.' The poet's voice is the voice of an 'I' coming into a new
understanding but at the same time, one which relates to old
understandings.

So it is with Dante *poeta* (the author of *The Divine Comedy*) and Dante *personaggio* (the character in the poem). The *poeta* is moving into a new visionary experience in which his will will be at one with God's, but at the same time he is related to the *personaggio* who feels anguish (*pietade*) toward the sinners in Hell. Certainly the Miller and the Wife of Bath are original characters, not at all interchangeable; each is very much him or herself, and yet somehow both are recognizably Chaucerian. Bishop Blougram and Andrea del Sarto are also distinct yet, at the same time, Browningesque. So it is with Richard Cory and Miniver Cheevy, each distinct, but still, patently, creations of Edward Arlington Robinson. It fares the same with a painter's portraits—all different, yet with a family likeness. The common element, the family resemblance, stems from those traditions, feelings, needs, and subconscious associations which the artist assumes. These assumptions provide both the obstacles to and the necessary resources for the artist's attainment of his new vision. They supply the conditions, the interests and latent tendencies, which the artist must take into account, and in doing so suggest a style. This is the extent, however, of their legitimate authority; though they suggest a style, they do not command it. Though a Khmer head represents centuries of Buddhist tradition, what makes it art is its distance from and its creative extension of that tradition, leading viewers to an altered and expanded understanding.

Here lies the aesthetic value of the sinopie, those full-scale preparatory underdrawings (as distinct from the full-scale preparatory drawings on paper) by which thirteenth-, fourteenth-, and fifteenth-century artists played with the total impact which they wished to achieve in their finished frescoes. In a period marked by strong representational loyalties, these underdrawings are examples of a full and free expression of an experimental distancing from those rigid designs and formulas which preceded the artist's own work, and to which the artists partly returned in their own finished masterpieces.

Two related religious examples of how 'representative symbol' can contribute a functional understanding, are Christianity's Crucifixion and Resurrection. In the Christian understanding of these acts, their representational aspect lies in their being a response to man's needs, so that the obstacles as well as the necessary resources for Jesus' symbolic act are provided. As such, the Christian sees Jesus as a surrogate representing mankind beause he identified with its needs. But these acts are symbolic too, because the Christian understands them to be the necessary condition for bringing about a new man, one not only free from sin and mortality, but enlightened as well.[120]

'Representative symbol' also allows us to understand the final theological working out of the Christian iconoclastic controversy. In 787 the Second Council of Nicea forbade "actual worship" of images (*alethine latreia*) but encouraged "salutation" or "tribute of an embrace" (*aspasmes*) and "reverent honor" (*timetike proskunesis*), because in these instances "the honor paid to the images passes to its original . . . [while] he that adores an image adores in it the person depicted thereby.[121] The image as adored or worshiped represents an understanding of the person depicted, but in its religious context as honored, it not only represents him as he is currently understood but contributes to an understanding as well. The same orientation prevails with the veneration of relics and the recitation of religious names or prayers, even by mechanical means. These identify not with the depiction, the captured understanding therein presented, but with a person who is always more than that which is depicted. Relics and prayers serve that to which they draw religious attention, but they extend it as well, with the honor passing to the original whom they represent.

There is still that danger of which the council was well aware. If images, relics, or the like are too lifelike, it is possible that the honor paid to them no longer passes on the the person depicted, thereby contributing a new understanding, but remains with the depiction itself, with the old understanding. Icons are attempts to prevent this, but if they in turn become a mere copying of traditional styles and associations, they also fix old understandings, and nothing passes on to contribute new knowledge. In such cases the symbolic dimension is destroyed. So great is the danger that attempts by such groups as the German Mystics of the Middle Ages, the Quietists of eighteenth-century Europe, the Sufis, and the disciples of Zen, to banish images, even names and ideas, so that religion will not renege on its responsibility to preserve distance and to push beyond whatever it already knows, are understandable.[122]

This chapter's thesis should now be clear. That activity which employs religious language but which affects only the single responsibility of protecting or expositing, I shall henceforth denote as 'magic.' That parallel activity which thus uses the language of art, I shall denote as 'craft.' If we consider Augustine's phrase, "faith seeking to understand itself," it is tempting to say that the distinction between religion and magic is caught in the simple shift of emphasis from to "understand" to "itself." If an appropriate action leads to a new understanding it is religious, if it leads to an understanding of itself of a faith already revealed, it is magic. This categorization is akin to the distinction in art between what a craftsman does with his blueprints and what Parker

insists an artist does with his interests and latent tendencies. We can also cite the distinction between Clement's understanding of the self, which includes that into which the self is coming to be, and the soothsayer's understanding of the self, which includes only what one already is. The soothsayer, and the sorcerer too, practice magic to serve themselves, as an expression of their need for protection or for furtherance of their particular interests.[123]

By definition, then, if an activity neither distances nor creates, it is magic or craft. If it simply distances from old understandings but does not lead into new understandings it is nonsense, chaos, or noise; in any case it is a private experience which fails to provide material for the future—or as Kandinsky puts it, it fails to be "the mother of our emotions." It then dies of its own weight, in obscurity and loneliness. Finally, if an activity actually does distance from old understandings and leads or stretches men into new understandings, it is artistic or religious.

These distinctions provide the basis for Roger Fry's criticism of Brueghel. Fry calls Brueghel "essentially an illustrator rather than an artist" because "he does not speak to the mind directly through visible harmonies but, by the associations which his images call up, by their references to actual life.[124] His criticism is simply that Brueghel's pictures derive their meaning and appeal from releasing what man already has experienced rather than by adding to an understanding. Brueghel's skill resides not in providing an experience but in providing the occasion for reliving an experience. If Fry is correct in his evaluation, Brueghel's works are but means to an end; their production is classified as a skill, and Brueghel as a craftsman. In harmony with Aquinas's definition of a craftsman, Brueghel "is moved to action by the end, which is the thing wrought, for instance a chest or a bed."[125] Before he began his "action" he knew the end for which he worked and he had no need or room for the contribution of "the thing wrought" other than bringing it into being.

Although it might be difficult for us to accept this evaluation of Brueghel as "essentially an illustrator,"[126] especially in an age which so readily tries to accept as artists such confessed illustrators as Aubrey Beardsley whose drawings graced the *Yellow Book*, and Gustav Doré, who illustrated the prison yard for Herrold's *London*, nevertheless we should not lose the point at issue, namely that insofar as certain activities serve only the past, insofar as they only draw men's attention, for example, to children's games played long ago, they are but artifacts, works of craft. Their value lies in turning the focus of attention away

from the particular work in front of them to the activity of filling lacunae in their prestructured understanding. This function is no different from fulfilling expectations, hopes, or needs. What men look for determines what they find. Their affinities lie with the forbidden "worshiping" of images, with works that prejudge and crystallize prejudices into stereotypes. They all reduce the empirical to the a priori. Canned expectations or reactions replace open responses. The objects involved are directed *ad hominem*, arrangements to suit the man; they are simply recognitions—things subordinated to emotions or memories or needs, but not to perceptions. They please, not *qua* object, but according to the quality of the scene, memory, or incident they illustrate. They appeal, as Whistler once put it, to a people who

> have acquired the habit of looking, as who should say, not *at* a picture, but *through* it, at some human fact, that shall, or shall not, from a social point of view, better their mental or moral state. So we have come to hear of the painting that elevates, and of the duty of the painter—of the picture that is full of thought and of the panel that merely decorates.[127]

For these Sancho Panzas, the inn is preferable to the road. Their kinship remains with those dissections done with the intention not to do research but to teach and illustrate the truths originally set forth by Galen; with those Christian stories about Jesus written and told not to recount the facts but to awaken a belief in him as the Messiah; with illustrations painted in order to sell a car or a can of beer; with those Dutch still lifes which men appreciate because their depicted objects excite the appetite; with those crusaders who murdered the Turks in the Promised Land in order to earn a place in heaven; with that Soviet literature which cultivates in the Soviet people a richness and versatility of Socialist reality, and which exposes all which hinders the progress of that society; and finally with those ecclesiastical authorities who declared, "The composition of religious imagery is not left to the initiative of artists, but is formed upon principles laid down by the Catholic Church and by religious tradition . . . The execution alone belongs to the painter, the selection and arrangement of subject belong to the Fathers."[128] They are craftsmen or magicians all, Gepettos or sculptor— Kings of Cyprus, who by their actions aim to bring to life their own favorite Pinnochio or beloved Galatea. Intending to evoke old experiences rather than to move on to new experiences, they wish only the security of possessing or controlling the past, to release again or reaffirm what is already there. None of them have room in their work for what that work might add. None relate to the open future, none save

themselves "for a certain abandon later on, for discoveries made as the work advances."

At the root of this definite distinction lies distance. What Archibald MacLeish says on behalf of the poet in his "Invocation to the Social Muse" is in truth spoken for all artists and religious people.

> We are
> Whores, Fräulein: poets, Fräulein, are persons of
>
> Known vocation following troops: they must sleep with
> Stragglers from either prince and of both views.
> The rules permit them to further the business of neither.
>
> It is also strictly forbidden to mix in maneuvers.
> Those that infringe are inflated with praise on the plazas
> Their bones are resultantly afterwards found under newspapers.[129]
>
> [lines 10-16]

Artists and religious people are whores, every one. They have time for all, but they further the business of none. They begin with what they have gained from their particular hour and from their particular place, but quickly move on to bring into focus or to manifest a new understanding, a new relationship. And though whores might tend to take their customers lightly, the customers cannot reciprocate because the "Supreme Teaching" ordains that "as a man acts and walks in the path of life so he becomes." The *Maitri Upanishad* also tells us, "What a man thinks, that he becomes." (VI. 34). Thus it seems that once men submit to art or religion, they are never the same; they come to understand all of their experiences, old ones as well as new, in terms of what they now have learned. Like the whores they are, art and religion are homebreakers. Their calling is to create new relationships, not to service old ones, to dictate the nature of future visions and to rupture the earlier ones. Hegel agrees. He asserts that "artistic production"—and we would add, religious production—is "an activity . . . constrained to work out of its own wealth, and to bring before the mind's eye a wholly other and far richer content, and a more embracing and unique creation than ever can be thus prescribed."[130] Once men "know" that "wholly other and far richer content," yesterday as well as tomorrow will be changed because men will no longer see and understand only that which is consistent with their previous expectations. They will begin to evaluate and change these expectations so as to abide with that "content" which they now have been taught to see.

Now for the craftsman or for the magician, none of the foregoing relationships apply. Here there is no whoring about, no distancing

from experiences gone by. What for art and religion might have been called *technē*, a disclosing knowledge, knowledge at work, knowledge which makes the present appear, with craft and magic, becomes *diké*, a containing knowledge which objectifies what has previously appeared. Knowledge as *technē* creates and therefore doesn't know what it is to disclose until it discloses. In contrast, knowledge as *diké* serves what it wishes to objectify and therefore does know what it must disclose.[131]

We are now prepared for my second important entailment: craftsmen and magicians work in a confidence of control that is foreign to artists and religious people. This entailment is related to the earlier one of artistic and religious fragmentation. For example, consider the difference between the magician who casts a spell and the religious person who recites a prayer. First, the magician intends to bring about what he wishes and since he knows what it is that he wishes, he is, at least in theory, in charge. But second, he also believes that he can bring about what he wishes because he assumes that there is a power which men can channel, control, and direct if they have the proper "know-how." It is having this know-how that makes the magician effective. Herein lies his security—not especially in the assurance of the sufficiency of his particular know-how, which he may well share with the artist and the religious person—but first, in knowing that there is a power which he can control and manipulate for his purposes. In those words previously quoted from the *Vakyapadiya*, his security lies in knowing that "all this universe is but the result of sound," but in this instance what we mean is not the sounds artists and religious people make in order to maintain the initiative, but the sounds craftsmen and magicians can manipulate. For this reason, many primitive societies forbid unauthorized people to mention certain animals or people by name. They, too, believe that the universe is but the result of the sounds magicians manipulate, and that the sounding of a prohibited name releases or generates that magical power, which they fear the unauthorized individual might not have sufficient know-how to control. Though they doubt the sufficiency of this or that individual's know-how, they do not doubt the greater security of knowing that men can make demands and can generate a magic to satisfy these demands. There is no doubt that men, that is, magicians, can be in charge.[132]

With religion, there is no such security. Whereas the magician uses sounds which he can manipulate in order to serve his prior goals, the religious person creates according to the sounds themselves. The first uses sounds, and the sounds become a means to a far away end, the second makes sounds, and the sounds become the end in themselves.

The sounds themselves determine what this universe shall be. It is this second kind of sounds which the Yogin uttered and which, tradition has it, thereby created the gods. They were religious sounds because they carried their meanings within themselves. The gods did not exist before they were so created. The sounds themselves determined what was to be.[133]

Note the lack of assurance built in. The religious person possesses no prior knowledge of what he wishes to bring about, nor does he have access to a power which he can control and manipulate. Only the sounds themselves have being, and they determine what the universe shall be. As far as the religious person's sounds of prayer are concerned, there is at best petition, supplication or entreaty, never control of cause and effect. Man is not in charge. In fact the religious person also comes to exist in his particular way only through the religious act of sounding forth, and thus he too must await the act's outcome. Once the sounding begins, his prior purposes for acting are no longer 'purposes.'[134]

In a most interesting way, this artistic and religious lack of assurance is reflected in the transitoriness of what functions as 'art' or 'religion.' Since the sounds which men make determine the sounds' own fulfillment, what they actually do in society determines whether they are artistic or religious. That is, if they do stir men's attention, are distanced, and do create new universes, then they are accepted as holy or as masterpieces; they do then disclose a knowledge which allows men to participate in the future. On these works men do bestow their applause. Thus the people of Siena enthusiastically carried Duccio's *Maestà* from his studio to the cathedral—because the panels gave them their world. Not to listen to the sounds of the panels is not to participate in their world. This is the meaning of that passage in the *Taittiriya Upanishad* which reads, "Non-existent, verily does one become, if he knows *Brahman* as non-being. If no one knows that *Brahman* is, such a one people know as existent." (II.6). To know God as non-real is to say one has no *mana*, no knowledge which allows one to participate in the future; to know God as real is to say one has *mana*, that knowledge which does allow one to participate in the future. The ancient Egyptians also said as much when they asserted that in opposing *Maat*, the order of what will be, one dies.

The lack of assurance arises from the awareness that these panels may not continue to show men their world. It is legitimate to say that Constable is a master because his work has taught men how to see the clouds. It is not legitimate to say that he is a master because his work will

continually teach men how to see the clouds.[135] Whereas the former statement permits Constable's works themselves in their new context to determine how they will function, the latter assertion attempts here and now to decide for that future how these works will function. In fact as far as the people of the future ever do submit to this canonical decision, they engage in sentimentality, that is, they willingly reaffirm what was previously artistically and religiously true without themselves actually maintaining the initiative and working into it. Their actions are akin to evoking an emotion previously earned without now participating in the entailments of which it is ostensibly a part. It is like having the fruits of a friendship without actually taking part in the relationship. Actions like these are using rather than participating, they certainly offer representation but no symbolism. There is no distancing, nor is there any creating. It is the death of art and religion.

Despite some proclivity toward sentimentality in its escape literature, in its pastorals, and in its romanticism, art willingly acknowledges that its masterworks must continually show men their world. Modern art's creation of all sorts of theatrical situations in which familiar art 'signals' are either avoided or radically reversed, is just such an attempt to clear the way for new experiences and new insights, and thereby help keep art contributing to the future. The 1960s procession from action painting to 'happenings' to an aesthetics of impermanence, which considers a work of art as a transitory event in the life of the artist and his audience, is of the same genre. Marcel Duchamp insists that art continually lead the way into new experiences. His criticism of the way his *Nude Descending a Staircase* functions in that society which comes after his painting, is that this society no longer responds to the painting but only to the knowledge which it already has learned from the painting, thereby no longer allowing the painting itself to herald a future, but only to defend a past.

Religion is less vehement. In fact, it seems seriously to compromise our observation that its holy wares as they were experienced in former times are not forever holy and therefore are not necessarily valid for those who have yet to experience their value. In the name of religion wavering pilgrims often absolutize previously experienced revelations, hoping thereby to guarantee their particular future. A typical example is Hiuen-Tsiang, the Chinese Buddhist pilgrim who used the short *Sutra of the Heart of Perfect Wisdom (Prajña-pâramîtahridaya Sutra)*, which the Chinese regarded as a mantra or charm, to help him cross the Gobi desert. His biographer, Hwui-Li, reports that in the Gobi desert Hiuen-Tsiang

encountered all sorts of demon shapes and strange goblins, which
seemed to surround him behind and before. Although he invoked
the name of Kwan-Yin he could not drive them all away; but when
he recited this Sutra, at the sounds of the words they all disap-
peared in a moment. Whenever he was in danger, it was to this
alone that he trusted for his safety and deliverance.[136]

Here and throughout the *Life* we cannot help but conclude that Hiuen-
Tsiang conceived of religion in terms of a confidence appropriate only
for the magician. Hiuen-Tsiang clearly does believe in the existence of a
power which he aims to control and manipulate for his purpose of
crossing the desert.

But if we look deeper into the background of the situation, of
which Hiuen-Tsiang may or may not have been aware, we find that
Hiuen-Tsiang seemingly was in charge of his situation not because he
controlled the power of the sounds of the words of the sutra, but
because he was indirectly invoking the aid of Kwan-Yin who first had
sounded the sutra. In effect, he was putting himself at the mercy of
Kwan-Yin, certainly a far cry from those assured acts of the magician. It
was up to Kwan-Yin, not Hiuen-Tsiang, to decide the outcome of the
situation on the basis of her activity. The first chapter of the *Maha-
Vairocana Sutra* makes this quite clear: "Thanks to the original vow of
the Buddhas and the Bodhisathvas, a miraculous force resides in the
mantras." Later we read that "success in our plans through mantras is
due to their consecration by the Buddha which exerts upon them a
deep and inconceivable influence."

What this means is that even in those forms of Buddhism which
seemingly are most determined to find assurance in a mantra or in an
incantation which when uttered will control some power or some force,
the "miraculous force" which does become evident does not come from
continually sounding for manipulative purposes but only from the
sounds themselves as they originally sounded, and continue to sound,
in a religious act. The holy mantra continues to be holy only in so far as
its sounds continue to sound forth as they originally did, that is, as
vehicles into new universes.

Unfortunately there is a circularity here, but it is intended. Holy
vehicles exert their "miraculous force" and help men move into new
universes only insofar as they are performed by men who, in innocence
and with a sense of distance, do move into new universes. Holy vehicles
are holy only insofar as they do what holy vehicles do, but in order for
them to do what holy vehicles do they must be sounded by holy people.
In effect, holy vehicles are holy only for holy people. The religious

counterpoint to magical guarantees of paths of "safety and deliverance," to guaranteed claims of the sacramental presence of the holy in concrete actions or things, or to the presence of holy people or places which ensure automatic communion with the divine, is to say that these holy issues are effective only for those who already are religious, that is for those who *already* are in communion with them. When Christ refers to the "kingdom of heaven" as "a treasure," he wants us to remember that a treasure is only a treasure for those who live in a universe where the thing discovered is valuable and who therefore are prepared to recognize it as a treasure. This is the same thing as saying that only those people of Siena who already had elevated Duccio's panels in their minds bothered to carry them to the cathedral. That preceding act of openness and the resultant creativity are continuously necessary for religion to function as religion and, of course, for art to function as art. For the others—those who never have distanced themselves from the familiar or the profane, those therefore who never were open to the new and therefore who never were stretched into communion with it—that new or holy or sacred place is a strange place, having no "miraculous force" at all.

We see then that despite its hesitancy vehemently to declare its position, religion does acknowledge that its masterworks must continually show men their world; and by doing so, it also affirms that it, too, like art, functions in an atmosphere of uncertainty. An individual may be sure that he is reciting the mantra correctly, but he cannot be sure that he is in communion with the Buddha by whom it was first sounded and with whom it created its world.

This uncertainty is further reflected in theological speculation. One example has to do with Christianity's uncertainty regarding the religious status of its own ordained leaders. Uncertainty in this area has resulted in making a distinction between the validity of the sacraments and their efficaciousness. This historical need for the distinction came to the fore in the fourth century, when a faction in the church called the Donatists asserted that the validity of the holy vehicles, the sacraments, depended on the worthiness of the minister, and that the church ceased to be holy when it tolerated unworthy bishops and other officers in its ranks, particularly those who had surrendered copies of the Scriptures to the civil authorities during Diocletian's persecution in 303. Presupposed in the Donatist attitude was the conception of the church as a society which was *de facto* holy, consisting exclusively of religious men and women. This in turn presupposed that it was possible to tell who was religious, or at the very least, that one could tell whether oneself were religious.

The Western church's reaction to the Donatist assertion was to claim in turn that it is God or Jesus Christ that is the principal agent and that the priest or minister is merely God's instrument. This assertion would imply that the force or grace contained in the sacraments is God's gift and has nothing to do with the officiant as such. Closely related to this was the church's idea that the production of sacramental grace was tied to the divinely prescribed formula or sounds which the priest or minister uttered. The church used this latter idea to reinforce its anti-Donatist decision by prescribing prearranged stereotyped gestures, special vestments, and perhaps even masks. These ritual measures further depersonalized the claims and status of that *particular* minister standing before the congregation. The doctrinal affirmations which permanently sealed these two ideas into the mainstream of Christian thought were, first, the affirmation that sacraments function *ex opere operato*, that is, that they are signs which actually and automatically release the grace which they signify, and second, the affirmation that they impart a permanent character (*dominicus character*) which can be lost no more than a tattoo could, or a mark branded on a cow.

So much then for the sacrament's validity. No matter how unworthy the minister may be, the institution guarantees, through the religious act of Jesus Christ, the technical administration of its holy force. In fact, it dares to assert *extra ecclesiam nulla salus*. Christ performed the efficacious religious act. Here in His church, it is guaranteed that men can participate in that universe which these acts bring about. But once again, there is no certainty that, in effect, men do so participate, that is, there is no absolute certainty of saving grace upon an individual's reception of the valid sacrament. Its efficaciousness depends upon the individual's prior state of grace, just as the efficaciousness of the sutra depended upon Hiuen-Tsiang's prior relationship with Kwan-Yin. On unholy men holy wares have no effect. A sacrament can possess technical validity without its recipient obtaining the grace a Christian expects. Augustine provides the classic statement:

> Accordingly neither without, any more than within, can any one who is of the devil's party, either in himself or in any other person stain the sacrament which is of Christ . . . when baptism is given in the words of the gospel, however great be the perverseness of understanding on the part either of him through whom, or of him to whom it is given, the sacrament itself is holy in itself on account of Him whose sacrament it is. And if any one, receiving it at the hands of a misguided man, yet does not receive the perversity of the minister, but only the holiness of the mystery, being closely bound to the unity of the Church in good faith and hope and charity, he receives remission of his sins, . . . But if the recipient himself be

misguided, on the one hand, what is given is of no avail for the salvation of the misguided man; and yet, on the other hand, that which is received remains holy in the recipient, and is not renewed to him if he be brought to the right way.[137]

By making statements akin to this at the Council of Arles in 314 and at the Council of Nicea in 325, the early church preserved the religious character of efficacious participation in the sacraments while acknowledging the fact of religious uncertainty for the individual. To summarize, it did this, first, by insisting that the church's holiness lies in its openness to and participation in that new universe heralded by Christ's saving precepts and sacraments; second, by insisting that these holy things, now freed from depending for their holiness upon the at times questionable holiness of this or that administrator, are efficacious only for people who themselves are holy.

A further theological example which expresses this religious uncertainty is that talk of a God beyond god of which I took note in the beginning of the last chapter. In addition to the knowledge of God which God shows men, the Christian claim is that there is always more to know, a side of Him which will remain forever dark. This is that Godhead to which the Father and the Son and the Holy Ghost point, that which is presupposed in the very notion of the Incarnation—the ground antecedent to it, *anarches arche*, the source without other source than itself, uncreated. It is the beginning and the cause of all, from which all incarnations derive their being. In Hinduism it is Brahma, he who is "altogether the beginning of gods and saints:"

> . . . all this universe is strung upon me,
> as rows of gems upon a thread
> I am the taste in water . . . I am the light in
> moon and sun, the Om in all the Vedas, sound in
> the Ether, manhood in men.
> The pure scent in earth am I, and the light in
> fire; the life in all born beings am I, and the
> mortification of them that mortify the flesh.
> . . . I am the understanding of them that understand
> the splendor of the splendid.
> The mighty of the mighty am I.
>
> (*Bhagavadgita* VII. 7-11)

This dark side of God means that 'God' as He is in himself is beyond men's understanding of the law, not bound by good and evil. In fact His acts become good, not because they are good, but because He does them. In popular Christian theology Mary, the Virgin Mother of

God, comes to personify this dimension of God's transcendence. There are many examples, and I shall refer to some of them in chapter 6, but for one, on the inner west wall of the twelfth-century abbey church of Souillac there is told in sculpture-relief the story of the apostasy of Theophilus, who, though he had entered into a legally binding feudal contract with the Devil, solicits the intercession of Mary, who of course hears his petition and rescues him from his deserved, but ill fate. In the words of Fulbert of Chartres:

> She [Mary] consoled the grieving man, promising him indulgence: and that he should not doubt her promise, she tore the charter from the devil and returned it to the captive as a token of his liberty. When, upon awakening, he found it on his breast, what joy he felt, with what pious feeling he uttered sounds of exultation and confession![138]

This is also Job's lesson. In such a world the saved are saved because God wills it, not because they deserve it. He wills it and it is so, because he is God.[139]

Thus this chapter's thesis and its entailments appear to hold. Unlike craft and magic, which merely exposit or protect what men already know, art and religion distance from what they know and create in its place new understandings. This means they operate in a state of continuing fragmentation and insecurity. But there is a final question: practically speaking, how much will this help us to distinguish art from craft, religion from magic? For example, consider the theoretically clear distinction between a painting of a nude and a painting of a naked woman. According to my thesis, the painting of a naked woman is the work of a craftsman because it represents perceptions and appetites we already know, whereas the nude is a representative symbol having a life and value of its own independent from the naked person represented. But which is which? Labels are of no help because they are applied after the decision has been made. Kenneth Clark adds to the difficulty in politely reminding us of what he calls man's desire to grasp and be united with the female body and then commenting, that while

> no doubt an artist can achieve a greater degree of detachment than the profane might suppose . . . does this not involve a certain callosity or dimness of response? To scrutinize a naked girl as if she were a loaf of bread or a piece of rustic pottery is surely to exclude one of the human emotions of which a work of art is composed.[140]

Of course he is right. For this reason, in the previous chapter of the term 'distance' was preferred to the more definitive all-or-nothing

terms. But what does this do to our distinction between art and craft, religion and magic?

Odilon Redon proposes a solution. He tells us that if the painter, having painted a naked woman, leaves in our minds the impression that she is going to get dressed right away, then he has resolved the tension toward appetites already experienced and his work is craft. On the other hand, if the painter shows her to us in a nudity that is reassuring because she does not hide it, then the tension has been resolved on the side of the symbolic and his work is art.

> Thus without shame, she remains in an Eden for glances that are not ours, but those of a cerebral world, an imaginary world created by the painter, where moves and has its being a beauty that never gives birth to impurity, but on the contrary lends to all nudity a pure attraction that does not demean us. The nudes of Puvis de Chavannes never get dressed, nor do many others belonging to the charming gynaceum of Giorgione and Corregio.[141]

He betrays the usefulness of his solution, however, by his examples. It is certainly not the nudes of Puvis that are at issue—more the likes of Balthus' *Katia Reading*. Certainly Katia is without shame, but is not this the very quality that gives the painting its erotic undertone and prevents the viewer from finding room for the new associations necessary for art?

Redon's solution fails. I must switch tactics from overarching theories to in-fact observations. I must turn away from trying to determine whether a particular work is properly acknowledging the correct distance from that which it represents, to trying to determine when a representational symbolic activity is actually taking place. That is to say, if attention is being given to a particular work under investigation, and not to what it represents, then the question to be asked is whether that work provides growth into the future. Does it demand attention on its own account and pass its creative vitality on to our understanding of what it represents, or does attention devoted to it stay with itself, forcing it to function merely as "a child of its time?" If the latter is the case, the history of art goes around, rather than through the work. The work contributes nothing to the future; therefore it is an artifact—at best, an example of good craftsmanship, but not art.

Consider Van Meergeren, the declared forger of Vermeer. My first move might well be to think in terms of a properly acknowledged distance and to say that since we find that Van Meergeren's work demands attention only as Vermeer's, since it affirms only what men understand Vermeer already to have affirmed or else affirms nothing,

it is craft, not art. There is no distance. The appreciation of Van Meergeren's work exists only to the extent that it reaffirms that art community's expectations of Vermeer's established style and insight, somewhat as a religious community's appreciation of a theologian's speculations is limited by the necessity of harmony with that community's already established understanding. Each community accepts these works very much as a department store accepts the evaluations of its own Bureau of Standards, as the giver of "seals of approval" to standards which they already have established and which are in harmony with products which they already are manufacturing and offering for sale.[142]

But my in-fact observation points out that this is too simple. Van Meergeren painted *original* works in the style of the master which in fact elaborated on that style. An analogy from religion would be a competent but obscure theologian's advanced speculation on, say, Aquinas's Scholasticism. Van Meergeren's works done in the style of Vermeer did not only affirm what art historians expected, but also extended it and in effect contributed to a "better" understanding of it. When the community of art connoisseurs first considered that first unidentified Van Meergeren, the majority of them attempted to fit it into the then existent category 'Vermeeer.' This was possible especially because of a peculiarity of Vermeer's life and work. Very few documented facts are known about him and scholarship is based upon the evidence of his paintings. More important, connoisseurs are familiar with an early style and a late style but the pictures of his middle period were lost. Thus there is ample room for a Van Meergeren pastiche and its acceptance sufficiently modified that original category 'Vermeer' so as to make it easier for the art community to accept the next Van Meergeren; and this cycle was repeated. Thus the Van Meergerens not only fit, but elaborated and developed the holistic concept of what constituted 'Vermeer.'

My partial in-fact observation is that the Van Meergerens are art. They do achieve distance, and they have contributed to a new understanding of 'Vermeer.' But there is one more fact to take into account, and it will change my conclusion: Van Meergeren confessed. As a result, a new category, 'Van Meergeren,' has been established, with its own demarcation. The original category 'Vermeer' has regained its previously defined limits and it resumes its working place in art history; the Van Meergerens are no longer relevant to anything outside themselves and no longer provide any growth into the future.

There are questions still to be answered. But I shall carry forward into the next chapter this suggestion that the only valid label as to

whether this or that activity is religious or magical, art or craft, is that one which is currently being earned, the one which comes during the fact of, or lack of, a distancing which works into new understandings. It is a working suggestion which is currently being worked. In much the same practical manner, patent law distinguishes a discovery from an invention. A discovery makes an addition to men's knowledge of nature, whereas an invention establishes a new operational principle which serves some previously acknowledge objective. Thus discovery, along with art and religion, points out or creates what men do not know; and invention, along with craft and magic, ingeniously turns what they do already know to an unexpected advantage. Robert Browning criticizes Andrea del Sarto because he does not point out or discover anything; because his works do not create that by which men see. Del Sarto disappoints as an artist because his works primarily show off his craftsmanship, his talent to ingeniously turn Raphael's classical style to unexpected advantage. If this is correct his kinship is clearly with those artificers who attempt to conjure up and utilize tantric deities to achieve their own already established goals, not with those worshipers who implore these same deities (in *bhakti*) for help. What they all lack—the magician, the craftsman, and the inventor—is freedom from the urge to control, willingness to let go of their expectations, and willingness to absorb whatever discoveries may come.

Coalescence

But whatever his weight in pounds, shillings and ounces,
He always seems bigger because of his bounces.

"And that's the whole poem," he said, "Do you like it, Piglet?"
"All except the shillings," said Piglet, "I don't think they ought to
　be there."
"They wanted to come in after the pounds," explained Pooh, "so
　I let them. It is the best way to write poetry, letting things come."
"Oh I didn't know," said Piglet.

<div style="text-align:center">Milne</div>

The previous chapter's analysis has drawn boundaries between craft and magic, on one level, and art and religion, on another. By and large it did so by carrying forward the ideas of distance and creativity; that which affects only the single responsibility of protecting or expositing what is already clearly known is craft or magic; that which leads men into new understandings is artistic or religious. The craftsman and the magician affirm that "all this universe is but the result of sound," meaning the sounds which they sound in order to manipulate their universe. The artist and the religious person affirm this same statement, but with a significant alteration; the sounds themselves, once sounded, have an effect of their own independent of human intentions, even though human initiative creates those sounds.

If we analyze what this distinction means so far as the nature of the artistic and religious sounds is concerned, I suggest it most forcefully tells us these sounds make rather than shape. This reminds us of the discussion in chapter 3 in which I concluded that a kind of human initiative which brings into existence that which has no existence marks artistic and religious work. But now I wish to further my analysis, not in

the direction of noting the artistic and religious lack of security which stems from the fact that artists and religious people do not shape their universe with acts done in accordance with agreed upon rules, laws, or objectives, but rather in the direction of noting the consequent nature of artistic and religious sounds themselves. Toward this end, two elements are worth noting: first, that artists and religious people sound their sounds in such a special way that, second, they come into a new understanding. The *Maitri Upanishad* brings both factors into focus in its comment, "As the spider moves upward by the thread, obtains free space, thus assuredly . . . the mediator moving upward by the syllable *aum* obtains independence" (VI. 22). Wallace Stevens also shows the interplay of both elements in his observation that "poetry and painting, have in common a laborious element, which when it is exercised, is not only a labor but a consummation as well."[143]

Religion has a tendency to express its awareness that it must make its sounds in a special way by applying negative injunctions to the sounds themselves. For example, the *Koran* exhorts its followers to "bestow not favours that thou mayest receive again with increase" (LXXIV). The overtly expressed purpose of this prohibition is that "the people of the Book may know that they have no control over aught of the favours of God, and that these gifts are in the hands of God, and that He vouchsafeth them to whom he will" (LVII). Of course, the point is that to seek increase or to weigh advantages is to subvert the religious sounds and actions to prior appetites and understandings, instead of letting them have their own effect. The religious message is for men to follow the Way, to sound their sounds, and to have no thought of tomorrow. "If it is the will of Heaven that the Way shall prevail, then the Way will prevail. But if it is the will of heaven that the Way should perish, then it must needs perish" (*Analects* XIV. 38). The doctrine of *karma*, discussed above, is a generalization from negative exhortations such as these. "Good" *karma*, the kind which sets the individual free, consists of that kind of labor or activity which men carry out with minds disinterested and disassociated from previous understandings, and free alike from thoughts of cause and effect and thoughts of gain.[144]

To express this positively is simply to say that the sounds of art and religion must be sounded in such a way that they constitute ends, not means. Their activities have no end or aim—no prior or extrinsic purpose—beyond the doing of the acts themselves. For example, Hegel asserts that "artistic activity is no means to an essentially ulterior result, but an end which at once is rounded in itself by virtue of its own execution."[145] And Malinowski observes,

This difference will serve us as a *prima facie* distinction between magic and religion. While in the magical act, the underlying idea and aim is always clear, striaghtforward, and definite, in the religious ceremony there is no purpose directed toward a subsequent event.[146]

Daisetz Suzuki explicitly relates art and religion on this very point. He insists that to be

free from all conditioning rules or concepts . . . is the essence of the religious life. When we are conscious of any purpose whatever in our movements, we are not free. To be free means purposelessness . . . When teleology enters into our life we cease to be religious, we become moral beings. So with art. When purpose is too much in evidence in a work of art, so called, art is no longer there, it becomes a machine or an advertisement . . . In this, art approaches religion.[147]

Now this awareness that artists and religious people must do their activity in that special way free from prior understandings, as ends and not means, has three important philosophical ramifications. First, it means the artist and the religious person not only have no a priori model for their action, but also have no yardstick for deciding when they have completed their activity.[148] To predict what they do would be to produce it before it is produced. Further, to know what constitutes the completion of what they are doing would be to know what they are doing before they do it. Herein is the truth in Luther's "Give your gifts freely and for nothing"[149] and the philosophical significance of Kafka's "Hunger Artist," who wanted to be a hunger artist only as long as he did not yet know for how many days he could actually go without food. His eagerness to use his art to come into an understanding is akin to Hokusai's, who we are told wrote at seventy-five, "When I am eighty I shall know more; at ninety I shall have got to the heart of things; at a hundred I shall be a marvel; at a hundred and ten every line, every blot of my brush will be alive!" On his death bed he sighed: "If Heaven had given me ten more years . . . five more years, and I should have indeed become a painter!"[150] Rodin is a prime example of an artist's not submitting to an a priori yardstick arbitrarily determining when his work is complete. By all standards external to his work, his sculptured pieces would seem to be still in a rough, not quite finished state. Yet they are finished. For another example, one in the tradition of Cezanne's presenting finished reworkings of the same scene, consider Picasso's *Variations* series. Now most artists have always approached their work with a series of experiments which begin by taking seriously some tradition, formula, or

ready-made phrase which previous artists have codified into a "style." They generally develop, modify, and expand this conventional style until they arrive, by a series of adjustments, at a finished work. Of course, this progress toward a final work of art always has been arbitrary; artists never have been able to justify decisively their answers to such questions as when and in which direction to develop and modify their approach, or when and where to begin and end the experiment. But now, Picasso, with his *Variations*, heightens our awareness of this arbitrariness by breaking with the traditional idea of presenting only the end product of a slow development toward a workable resolution of an original frustration; instead, he displays a panoply of modifications, all equally finished. In this manner, he has dramatically shifted the emphasis from art work as a solution, to art work as a doing. And it is also clear the Picasso simply completed the *Variations* when his movement stopped. That is all there is to it.

The second ramification is that what religious and artistic people do becomes clear only as the prayer takes shape in their minds, or the clay in their fingers. The Buddhist Middle Path for example is "middle" not only because it shuns excess, but also because it points out that the validity of a religious act or concept is always relative to one's position along the road of progress from ignorance to Buddhahood. Absolute evaluative assertions belong only to those who are attached to a particular place along the path or to those who invest their loyalty in the past or in the present; in essence, to those who are still on the hither side of the bank of ignorance. Pico della Mirandola's God, in speaking to man, makes it quite clear the luxury of stability is not the human lot.

> Neither a fixed abode nor a form that is thine alone nor any function peculiar to thyself have we given thee, Adam, to the end that according to thy longing and according to thy judgment thou mayest have and possess what abode, what form, and what functions thou thyself shalt desire. The nature of all other beings is limited and constrained within the bounds of laws prescribed by Us. Thou, constrained by no limits, in accordance with thine own free will, in whose hand We have place thee, shalt ordain for thyself the limits of thy nature.[151]

Thus if there are no absolutes, only concepts and states relative to where the artist and the religious person are at any moment, and if artists and religious people themselves have no special dwelling place, then there is what we might call an artistic and religious at-one-ness—a unity and attunement of artist, activity, idea, and material.

O chestnut tree, great rooted blossomer,
Are you the leaf, the blossom or the bole?
O body swayed to music, O brightening glance,
How can we know the dancer from the dance?[152]

[W. B. Yeats, "Among School Children,"
Section VIII, lines 5-8]

O the wonder of joy!
I am the food of life, and I am he who eats the food of life: I am the
two in One.

(*Taittiriya Upanishad* III.10.6)

In the preceding chapter I noted that at-one-ness of the priest's stereo-
typed gestures with the holy power which he administers, and the
at-one-ness of the icon with "the person depicted thereby."

The third philosophical ramification is that artists and religious
people have no fixed or predetermined essence. Not only do they have
no definite dwelling place but they can choose to be what they will. The
Platform Sutra of the Sixth Patriarch offers one clear perspective on this
inner freedom from definition, and thus from limitation:

Good friends, in this teaching of mine, from ancient times up to the
present, all have set up no-thought as the main doctrine, non-form
as the substance, and non-abiding as the basis. Non-form is to be
separated from form even when associated with form. No-thought
is not to think even when involved in thought. Non-abiding is the
original nature of man.

Successive thoughts do not stop; prior thoughts, present thoughts,
and future thoughts follow one after the other without cessation. If
one instant of thought is cut off, the Dharma body separates from
the physical body, and in the midst of successive thoughts there will
be no place for attachment to anything. If one instant of thought
clings, then successive thoughts cling; this is known as being fet-
tered. If in all things successive thoughts do not cling, then you are
unfettered. Therefore, non-abiding is made the basis.

Good friends, being outwardly separated from all forms, this is
non-form. When you are separated from form, the substance of
your nature is pure. Therefore, non-form is made the substance.[153]

This unfettered nonabiding nature is necessary in order to be
able to act without a preordained purpose or plan, in such a way that
what one is doing does become clear only as the work progresses. Such
a mode of existence demands a willingness to let go of one's previous
motivations, a willingness to be liberated or enlightened. What comes
to mind are those religious pronouncements which insist that one's

duty is to relate to what is not; that the religious goal is to achieve the identity of yes and no, or the totality of all things, which both includes and excludes each individual thing.

Again, this type of inner realization can be expressed negatively, as John Foxe, thinking upon one John Glover, thus depicts with earnest rhetoric:

> Though he suffered not the pains of outward fire . . . yet if we consider what in spirit and mind this man suffered, he may well be counted . . . for a martyr. For . . . this saint of God, . . . what boiling heats of the fire of hell inwardly he felt, no speech is able to express. I remember I was once or twice with him, who I perceived to be so worn and consumed that neither any pleasure of life and almost no kind of senses was left in him . . . But *this we see common among holy and blessed men; the more devout and godly they are, the more mistrust they have of themselves* [Italics added].[154]

Schumann presents us with a more subtle example. In the text of his choral work *Paradies und die Peri*, he notes that neither the Peri's gift of the last drop of blood that a hero has shed for liberty, nor her gift of the last sigh of a pure self-effacing love can help her regain paradise. At bottom, both acts are only reaffirmations of, or forms of service to, loyalties which the hero or lover, respectively, has already given. What finally does help the Peri is the first tear of repentence a redeemed sinner sheds. It alone signifies the turning aside from all previous understandings and deeds. By acknowledging its value and offering it as the necessary gift, the Peri wins freedom and heaven.[155]

I shall carry forward these three ramifications of my observation that artists and religious people sound their sounds in a special way, but to do so I must also relate them to that second noteworthy element mentioned above; that these sounds are what Wallace Stevens called "a consummation as well." That is, the sounds of art and religion are not simply that purposeless freedom of which Suzuki spoke; in addition, their freedom is charged with a force by which men come into new understandings. The sounds of art and religion impose themselves. "Women pass in the street, different from what they used to be, because they are Renoirs . . . The carriages, too, are Renoirs and the water and the sky."[156]

Kenneth Clark's historical treatment of the nude makes it clear that the nude is not a mechanical illustration of the naked body, but rather a shape which the artist imposes. His overarching observation is that "the nude makes its first appearance in art theory at the very moment when painters begin to claim that their art is an intellectual,

not a mechanical activity."[157] For my purpose this is his key insight—
that the nude appears "at the very moment" when art becomes art, or
what Clark defines as an intellectual activity. Just as there is no a priori
referential, no memories of deep pine forests or ideas of goodness to
which Hans Christian Andersen's nightingale must refer, so there is no
prior referential to which the nude must refer. There is only the artists'
activity itself and the nude which is the consummation of that activity.

I suspect that this is the point behind Roger Fry's and Clive Bell's
phrase "significant form."[158] Art and religion are endowed with signi-
ficant form because they encourage men to direct their attention away
from the references or motives behind the artist's and the religious
person's doing what they do, toward that which they do. A significant
form is a form which is forceful enough to direct men's attention
toward itself, toward that which is significant, toward the shapes, col-
ors, words, actions, and line which now speak their own language. To
put it another way, a significant form is one which is forceful enough to
deliver a content. Saying it this way preserves the obvious importance
of the content of a work of art, say as it is dramatically portrayed in such
works as Rembrandt's etching *The Hundred-Guilder Print*, which repre-
sents scenes described in Matthew XIX, and Giotto's fresco in Padua,
Lives of the Virgin and Christ. Their significance or forceful delivery
make them events in themselves, even though they may point to events
outside themselves.[159]

In any case, this second noteworthy element explains why the
actual artistic and religious objects themselves are so important, why
society shields them behind screens, puts them up on pedestals, in
frames, or into special buildings. (In ancient days, when theater was
high ritual, tragic actors performed in high wooden shoes and from
behind great masks.) Artistic and religious objects and actions are the
consummations of understandings which exist nowhere else except in
those objects or actions. They are invested with significance; they
deliver their own meaning or content. It is not a case of art plus
meaning, or religion plus meaning: the works of art and religion
themselves are meaningful. I reiterate here that the artist and the
religious person have no a priori model for their actions; each action
must be free and forceful to be truly creative. But whereas earlier I
pointed out the artist and the religious person act in freedom, here I
insist their activity results in work which is its own meaning. Whereas
earlier I pointed out there is no external yardstick to determine when a
work of art is complete, here I further conclude there is no external
yardstick to determine what it means. The answer to the question

"What does it mean?" is to point to what the artist has done. This is why Jacob Epstein, for example, insists, "I certainly will not explain my work. The explanation lies in the work itself. It is my last word."[160] Paul Klee gives his pictures titles that, instead of giving his audience an expected explanation of the objects on the canvas by indicating some common and already experienced frame of reference, simply repeat the picture's components. His re-enumerating in print what he already has set down in drawing of course frees him from explaining his work by relating it to experiences outside of the work itself. This device also compels the observer to supply his own unifying meaning from his experience of looking at the picture.

Religion is no less emphatic about significance than is art. Religion insists that it too, is a laborious consummation, that it points to itself and delivers its own content. This is most clearly seen when religion reflects upon God's acts:

> There is naught in the three worlds, O son of Prithā, that I must needs do, naught that I have not gotten or that I shall not get; Yet do I abide in work. For if I should not abide ever unwearying in work, O son of Prithā, men would altogether follow in my way; These worlds would perish, if I should not do works; I should make confusion, and bring these beings to harm.
>
> (*Bhagavadgita* III. 22-24)

But it is also evident when religion reflects upon man's acts. Men act as God acts. In fact they are enjoined to do so. "You shall be holy, for I the Lord your God am holy." (Lev. 19:2) Christianity asserts that God is love and Christ insists that all who follow him should love their neighbors as themselves. The commandment does not stipulate to feel what is not now felt or to intend to feel what is not now felt. Such a requirement would doom men always to fall short. Instead the commandment is to act and by so doing make the unholy holy, the unlovable lovable (Lev. 19:18, 34). "The thoughtless man, even if he can recite a large portion [of the law], but is not a doer of it, has no share in the priesthood, but is like a cowherd counting the cows of others.[161]

Seeing a kinship here with the group recitation of a creed, or the individual living out his life according to a caste, we note that what matters, in order to be religious, is the act of public reciting or the living of one's life in community—not the historical or personal accuracy of what is being recited or the social efficiency of the way one lives. By participating in a group recital or by living in a community, the religious person places himself in the ranks of those who are open to these

categories of understanding and who are willing to use them as a means to become whatever they will become—holy perhaps, lovable perhaps, but in any case, to become. This is not to say that there are no cows for cowherds to count, or creeds to recite, any more than it is to say there were no subjects for Rembrandt to etch; the past sees to that. But it *is* to say that art and religion insist these subjects should not belong to others. Somewhat as mimes, jazz players, bards and itinerant preachers improvise on themes familiar to their hearers, so those who do art and religion partly improvise on certain works, or take them seriously, and thereby deliver something new. Their doing is thereby significant.

Art and religion deliver their content. This is a very important phenomenon indeed. Worlds perish and come into being by what the artist and the religious person do. Ramakrishna's approving tale about Vyâsa (the author of the *bhasya* or the *Yoga sutras* upon which Śankara commented) illustrates this point splendidly. It seems that Vyâsa was about to cross the Jamunâ River when the Gopis or shepherdesses, arrived to do likewise. But there was no ferryboat.

> They asked Vyâsa, "Lord what shall we do?" Vyâsa replied: "Do not worry, I will get you across the river: but I am very hungry. Can you give me something to eat?" The Gopis had with them a quantity of milk, cream and fresh butter. He consumed them all. The Gopis then asked, "What about crossing the river?" Vyâsa stood near the edge of the water and prayed: "O Jamunâ! as I have not eaten anything today, by that virtue I ask thee to divide the waters, so that we can walk across Thy bed and reach the other side." No sooner did he utter these words than the waters parted and the dry bed was laid bare. The Gopis were amazed. They thought: "How could he say, 'as I have not eaten anything today,' when just now he has eaten so much?"[162]

By any external standard, this act most certainly smacks of gross mendacity. Vyâsa's boldness bordering on chicanery, his willful flouting of the laws of sensible behavior and of the very meaning of intelligible discourse, are striking. Nevertheless not only does Ramakrishna approve of Vyâsa's behavior—otherwise Ramakrishna would not have repeated the story in such an affirmative context—but seemingly God also approves; otherwise the waters never would have parted. What are we to make of this? One possible conclusion is that Vyâsa's standards must come from within the context of the act itself—that it is a religious act done for its own sake and, like all religious acts, calls new standards, new worlds into being. Ramakrishna agrees. He comments that the failure of the Gopis was that they didn't see that Vyâsa's prayer "was a proof of firm faith; that Vyâsa had the faith that he did not eat anything."

The incredible facts are these: Vyâsa ate. Vyâsa had faith that he did not eat. Vyâsa had faith that he did not eat, and he did not eat. Vyâsa had faith and so it was according to that faith. Vyâsa prayed that the waters be divided and so it was according to that prayer. The waters parted. Thus Vyâsa's act has established a new world in which previous rational limits and moralities are cast aside.

Virginia Woolf points to some of this in answering her own question "What is meant by reality?"

> It would seem to be something very erratic, very undependable—now to be found in a dusty road, now in a scrap of newspaper in the street, now in a daffodil in the sun. It lights up a group in a room and stamps some casual saying. It overwhelms one walking home beneath the stars and makes the silent world more real than the world of speech—and then there it is again in an omnibus in the roar of Piccadilly. Sometimes, too, it seems to dwell in shapes too far away for us to discern what their nature is. But whatever it touches, it fixes and makes permanent. That is what remains over when the skin of the day has been cast into the hedge; that is what is left of the past time and of our loves and hates. Now the writer, as I think, has the chance to live more than other people in the presence of this reality. It is his business to find it and communicate it to the rest of us. So at least I infer from reading *Lear* or *Emma* or *La Recherche du Temps Perdu*. For the reading of these books seems to perform a curious crouching operation on the senses; one sees more intensely afterwards; the world seems bared of its covering and given an intenser life.[163]

Clearly her answer suggests that artistic activities, too, are "forces, not transparencies." They do something rather than merely mirror something. But the Vyâsa story is more radical and more accurate. Not only do artistic and religious activities (sounds) perform that "curious crouching operation in which one sees more intensely afterwards," but the seeing itself is actually a kind of projection. It delivers. Seeing *is* imposing. If there is a difference between them, where art and religion are concerned, it is one of degree, certainly not of kind.

An example which incorporates Vyâsa's projection into Woolf's seeing is that of the editor Neville Rogers, who insists that genuine editorial activity involves interpreting texts so as to give them a form approximating as closely as possible what the author intended, and one which is in relation to the ideas which animate the text. He even extends his responsiblity to altering material which was published in the author's own lifetime.[164] In such a world, what becomes 'classic' or 'reality' is a learned imposition which society takes for granted and which it requires for further editorializing. That reality no more fills

primitive molds which exist apart from those acts which established it than does the commonsense logic embodies in our familiar parts of speech. Each is a 'transcendental,' a new projection—the first, aesthetic, the second, logical. To think otherwise—that is, for men to consider them to be literal or primitive—is to commit an epistemological fallacy, to make men's present understandings the criterion of truth, or to make "tender-minded" stabs at hypostatizing local distinctions. It is to fall into what John Dewey called the philosophical fallacy, the ignoring of the fact that objects are achievements or functional distinctions, not gifts[165]

Heidegger's explication of Pindar's assertion that to glorify is the essence of poetry rather neatly affirms the full impact of what we are saying.[166] He first points out that for Pindar the word does not derive its energy from what is already complete in itself. In that event men would only be glorifying what is already glorious, what already has the power to impress them. At best, the word then would denote an acknowledgment, or a confession of being impressed. Instead, Heidegger insists, 'glorify' denotes the power to make appear, or to cause a place to be extolled. When Heraclitus says, for instance, "For the very best choose one thing before all others, immortal glory among mortals" (Fragment 3), he is extolling a choice that will raise one to glory. When men glorify, they bring that new relationship into being. They bring into being a commitment, and possibly an attitude. So it is with the artist and the religious person or—to stay with Pindar—the poet. In deciding to glorify, he decides what is glorious. He prescribes or reveals. He places in the light; and for the Greeks at least, this means he endows with permanence, with being. To glorify is thus to act in a special way. It is the establishing, the extolling, or the appearing of a place. As such, to glorify is *to give* glory among men: not to acknowledge that place, but to create that place. If this interpretation is correct, Pindar is correct: To glorify *is* the essence of poetry, and of all art and religion.

There is one more thing that I must make clear about artistic and religious activity. It, too, is related to Wallace Steven's insistence that art is "a consummation as well." For those people who pay them their proper attention, the sounds of art and religion will not only impose new understandings but at the same time will coalesce with those new understandings. By 'coalesce' I mean two things, the first of which I already have been stressing with the Vyâsa story when I discussed the full impact of 'impose': what art and religion impose, is necessarily related to their activities or their sounds. Without artistic and religious

doing and without the proper attention, there can be no imposition, because then what is imposed does not even exist. It is not that art and religion show men what men had previously missed seeing; rather, art and religion show what did not exist prior to their showing it to men. Artistic and religious activities give glory among men; not to acknowledge a place, but to create that place.

But now I wish to add a second point. By 'coalesce' I wish also to assert that what artists and religious people impose, imposes itself back onto what they have done and are doing. Art and religion are what artists and religious people make; and what they make affects them and their understanding of the nature of art and religion. Naum Gabo is particularly sensitive to this second direction, as he avows, "It has always been my principle to let my work speak for itself, following the maxim that a work of art does not need to be explained by its author, that it is rather the other way around, it is the author who is explained by his work of art."[167] It is the second part of the maxim that is important for us now: "It is the author who is explained by his work of art." In recognizing it Gabo goes further than did Epstein in that passage of his quoted earlier. In this regard, artistic and religious activities are like those occasional storms of argument through which men pass, in which, though they argue well, they are destroying their own foundation—because whether they like it or not, the give-and-take exchange has brought to light new grounds for a fresh understanding of old positions.

The circularity here is apparent: artists and religious people impose a glory; and that glory, once imposed, imposes itself back onto them. Their activities are vehicles or instruments making it possible to discern what we or they never would have discerned without those activities. At the same time, these vehicles contain their own meaning and incorporate new discernment into their own process, thereby simultaneously conveying a new understanding and being the concrete experience of it. This is why, for instance, the Aurignacian or the Magdalenian, who painted in uninhabited and often inaccessible locations, out of the public view, can still be an artist, and why the worshiper who prays in the privacy of his 'closet' can still be religious. The creation or imposition which is essential to the artistic or religious act might well be only on oneself. Montaigne asks, "If no one reads me, have I wasted my time, entertaining myself for so many idle hours with such useful and agreeable thoughts?" His is the truly artistic or religious answer:

> In modeling this figure upon myself, I have had to fashion and compose myself so often to bring myself out, that the model itself

has to some extent grown firm and taken shape. Painting myself for others, I have painted my inward self with colors clearer than my original ones. I have no more made my book than my book has made me—a book consubstantial, with its author, concerned with my own self, an integral part of my life.[168]

There are numerous ways that this reciprocal or circular coalescence comes into practice. Think, for example, of the contemporary understanding and appreciation of Bach's cantatas. Music lovers in the twentieth century understand and appreciate these cantatas the way that they do because since 1950 or so, the cantatas have been widely available through long-playing records and because listeners have also been exposed to Monteverdi's works. Appreciating Monteverdi is an integral component of their appreciating Bach. Of course, it is true that they play, listen to, and appreciate Monteverdi because he *is* part of the history of baroque music leading up to Bach, but it is also true that in so playing, listening to, and appreciating Monteverdi, they come to understand and appreciate Bach in such a way that Monteverdi becomes a part of that history leading up to Bach.

There is also the example of the literary and philosophical *Kritik* so important in German writing from Lessing to Marx. It not only criticizes and appreciates a literature that already exists but it establishes accurate texts and relates these texts to larger wholes. It therefore selects and orders a canon, and by so doing the *Kritik* becomes not just an analysis or a preservation but a restoration, a construction, and finally a production of that which has not yet been formed.[169] It is similar to the situation when people gather from time to time in the basement of their community church, in order to do religious work; they not only act out their faith but grow into it as well.

In the same spirit, there is the story of an old Chinese woman who heard that a friend of hers was going on a journey to India and asked him to bring her back one of the Buddha's teeth. He went to India but forgot all about the old woman's request until he was nearly home. Fortunately at that moment he saw a dead dog lying alongside the road. Taking out one of the dog's teeth, he gave it to the old woman as a present from India. The old woman was overjoyed. She built a shrine for it, and she and her friends worshiped in it daily. After a time the tooth became radiant, and emitted a strange light. So strong was the faith and devotion of this old woman that the phenomenon persisted even after the traveler had finally revealed the true provenance of the tooth.[170] Obviously the woman's faith determined the manner of her

devotion; but reciprocally that devotion determined the nature of her faith. It is as if the already established style or faith determined what should be done and once the artist and the religious person began to do what they must, the doing affected or changed that motivating style or faith.

A further, and far more suggestive example is the frequently made assertion that works of art—and, we add, religion—are slices of life rather than representations of life. That is, their activities possess a life, a reality, a meaning of their own. It was in defense of this aspect of art that Jackson Pollock felt it was necessary to lay his canvas out flat on the floor and to walk around it in order to get *into* it, thus preventing the painting from becoming a mere exteriorization or a projection of a feeling already existent. Essentially his objective was no different from those of the earlier geometric abstractionists who had attempted to attain what they called 'a perceptive space,' a quality of space which did not precede the form of the painting, but which came into being with that form. Though more radically suggestive perhaps, his understanding of art in this regard is actually no different from the understanding of religion which Paul VI and Athenagoras II manifested in their declaration to "remove from memory the sentences of excommunication [between Eastern and Western Christianity] . . . and . . . commit these excommunications to oblivion."[171] For them, the declaration was equal to the doing. It too was a 'slice of life' and not a representation of a life elsewhere. The hanafi system of law which obtains in the greater part of the Muslim world reveals similar features. It contains, for example, the proviso that "a divorce uttered in jest and not meant seriously is just as binding as a deliberate utterance . . . Even a divorce spoken when a man is drunk is valid if he was culpably drunk and so, too, is a divorce uttered under compulsion."[172] What all these examples imply in common is a coalescence of action and fulfillment, a simultaneous manifestation of the doing with the effect which it brings about and the effect which it brings about in turn effecting the original doing.

Herein lies the full impact of what I wish to say. Art and religion not only impose a world; the world also imposes upon art and religion, and this coalescing process of imposing and being imposed upon is the necessary means to that new world. It is only when the genuinely artistic and religious sentiment abates that this coalescence breaks down and the dualism of act and purpose reasserts itself; for example, the notion reappears that man acts religiously in order to gain salvation or that the artist creates in order to understand himself more clearly.

There is a hint of what is meant by this depletion in Theodore Gaster's study, "The Religion of the Canaanites," where he notes what he calls the "punctual" and the "durative" levels of religious expression—levels which, incidentally, he believes exist in all primitive religions. His theory is that "all that obtains in the immediate here and now is but the punctual realization of something which is in essence durative and sempiternal."[173] By this he means that the religious activities of a primitive society are accepted as religious only insofar as primitive man has understood them to be the immediate here and now expression of an action which also occurs *eo ipso* on a permanent "ideal" level. For example the actions of human kings would have religious, that is, "permanent," validity only insofar as they are understood to be in tune, or to coalesce, with the actions of the gods. The former would thus be the punctual immanent expression of that which is valid on the "ideal," transcendent, durative level. Incidentally, to take a contrasting example, Bronislaw Malinowski finds this same insistence of a coalescence of human act with permanent fulfillment in his study of the "primitive" religions of the Melanesians. After observing examples of initiation and mourning, and noting that in each "the ceremony and its purpose are one" and that each is "an end in itself,"[174] he concludes, "Here . . . we find self-contained acts, the aim of which is achieved in their very performance."[175]

Notably, each interpreter observes a coalescence: Gaster in terms of a punctual action fulfilled on some "ideal" durative level, Malinowski in terms of an active ceremony at one with an achieved purpose or aim. Also, each interpreter preserves the attribution of creative initiative for this religious activity. Gaster almost commits 'the philosophical fallacy' and comes close to denying this latter point by his suggestion that there is another action which the gods perform on the durative level. Nevertheless, he stays clear of actually doing so by insisting that the religious act itself "is in essence durative," that is, there may appear to be two acts, but 'essentially'—where it really counts—there is but one. Malinowski is obviously more definite here. He simply refuses to speak of a second level of operation. He notes that religious actions contain within themselves their own purpose or aim. That is enough. They do, they are fulfilled, in their performance.

In the light of the different emphases in Western and Eastern religious theory, Gaster's more philosophically burdened and potentially dangerous interpretation may be considered the one especially attractive to the West. Serge Bulgakov, the nineteenth-century, Rus-

sian Orthodox lay theologian, provides us with a particularly good example. For instance, when he deals with the problem of how the Christian church is infallible, he is quick to distinguish

> between the *proclamation* of the truth, which belongs to the supreme ecclesiastical authority, and the *possession* of the truth which belongs to the entire body of the Church, in its catholicity and its infallibility. The latter is reality itself; the former is only a *judgment* passed on reality.[176]

In this context the "entire body of the Church" is akin to Gaster's durative level while Bulgakov's "supreme ecclesiastical authority" is akin to Gaster's punctual level of activity. The judgments or dogmas of the latter insofar as they are only decisions of pragmatic expediency—that is, responses to questions raised by heretics or doubters—are not in essence durative, or as Gaster would say, religious. Religious action can occur only when these judgments or dogmas express the truth which the church contains or, in terms of Gaster's distinctions, only when "the immediate here and now is . . . the punctual realization of something which is in essence durative." Bulgakov's conclusion regarding the problem of the church's infallibility, then, is that the "church is infallible, not because it expresses the truth correctly from the point of view of practical expediency, but because it contains the truth. The Church, truth, infallibility, these are synonyms."[177] Borrowing Gaster's terms, what he is saying is the church can be considered to act infallibly only when its acts are "the punctual realization" of the truth "which is in essence durative," in effect, only when its acts are cosmologically in tune or coalescing with the truth which it embodies.

The parallel with Malinowski's simple affirmation that religious actions coalesce their activity and their fulfillment within themselves and not through some other transcendent agent is the Hindu Brahma-Atman identification. Here is an affirmation which simply absorbs all dualisms.

> There are two unborn ones, the knowing and the unknowing, the one all powerful, the other powerless. Indeed there is (another) one who is unborn, connected with the enjoyer and the objects of enjoyment. And there is the infinite self, of universal form, non-active. When one finds out this triad, that is *Brahman*.
>
> (*Svetesvetara Upanishad* I. 9)

In general it seems that the religious person is bidden to act in keeping with his understanding, as if there were only this life—or more specifically, as if there were only this act which he is to perform. He is bidden

to act as if there were only reconciling knowledge, as if the external world and his knowledge of the external world were one. The result, the religious act (*fides qua creditur*), and the world which the religious person acquires by this act (*fides quae creditur*), are one. The faith which he finds and *the* faith are one. This knowledge of Brahman also becomes a reconciling or a saving knowledge, that is, salvation comes with being religious; the reward *is* at one with the doing. There is no duality of subject and object; their autonomous existence is an illusion.

A simple example of a breakdown of this coalescence, and one which supplies a contrasting example of coalescence in force, begins with the famous story about Solon, questioned why he was weeping for the death of his son "thus, if weeping avails nothing." He answered, "Precisely for that reason—because it does not avail." Now, just as one might think incrementally of religion *plus* salvation or of art *plus* clearer understanding, so Solon and his questioner made a conceptual distinction between tears and something to attain which exists and has a life apart from those tears. On the contrary, if Solon's weeping is the same kind as that which Malinowski observed in the mourning rites he witnessed, or which one might observe in the communal singing of the *Miserere*, there exist, integrally, only Solon's tears and that which coalesces with them. Tears do avail, as Schmuh's guests find when they visit his onion cellar:

> The host handed them a little chopping board—pig or fish—a paring knife for eighty pfennings, and for twelve marks an ordinary field,—garden—, and kitchen-variety onion, and induced them to cut their onions smaller and smaller until the juice—what did the onion juice do? It did what the world and the sorrows of the world could not do: it brought forth a round, human tear. It made them cry. At last they were able to cry again. To cry properly, without restraint, to cry like the mad. The tears flowed and washed everything away. The rain came. The dew. Oskar has a vision of floodgates opening. Of dams bursting in the spring floods.[178]

Here is the coalescence of which we speak. Again we can refer to Heidegger, who elaborates on this point:

> The writing of poetry is not primarily a cause of joy to the poet, rather the writing of poetry *is* joy, is serenification, because it is in writing that the prinicipal return home consists. The elegy "Homecoming" is not a poem about homecoming; rather the elegy itself, taken as the very poetry of which it is comprised, is the actual homecoming—a homecoming which is continually being enacted so long as its message sounds out like a bell in the speech of German people.[179]

The elegy "Homecoming" is no more a poem *about* homecoming than the Christian sacramental eating of the consecrated bread and wine is *about* being with God or Soto Zen is *about* enlightenment. As the elegy itself *is* the actual homecoming, so partaking of the Christian sacrament *is* the reception of grace sufficient for salvation and to practice Soto *is* enlightenment. They are no more the result of a prior arrangement which their subjects suggest than is that dam bursting in Günter Grass's passage above a prior arrangement which the tears suggest. Perhaps this is what Croce is defending in those difficult to understand assertions of his that "intuition is expression" or better, "intuitive activity possess intuitions to the extent that it expresses them,"[180] or what Augustine wants to say with his equally difficult insistence "that the knowledge of the Son is not one thing and the Son himself another; nor one thing His seeing, Himself another; but that the seeing itself is the Son, and the knowledge as well as the wisdom of the Father is the Son" (*Tractates on the Gospel According to St. John* XXI. 5).

This then is the full impact of the coalescence of which I speak. To do art or religion *is* to impose on the world and back onto itself. Art and religion simply do not exist prior to the imposing, to determine what that imposition shall be. There are only art and religion, imposing and being imposed on. Nietzsche is correct; in art and religion, the deed *is* everything.

> Just as the popular mind separates the lightning from its flash and takes the latter for an *action*, for the operation of a subject called lightning, so popular morality also separates strength from expressions of strength, as if there were a neutral substratum behind the strong man, which was *free* to express strength or not to do so. But there is no substratum; there is no 'being' behind doing, effecting, becoming; 'the doer' is merely a fiction added to the deed—the deed is everything.[181]

It will now be interesting to place this analysis of coalescence in relation to other human activities, more specifically to point out coalescence's affinity as an artistic and religious dimension to the language form designated by J. L. Austin as the "performative utterance." Austin pointed out effectively that an utterance might well be, in its "appropriate circumstance," an activity which performs an action, that is, which makes a difference in the way things are.[182] It was his observation—always "subject to revision"—that there is a language form which intends not merely to say something in order to evoke emotions already felt, or to describe facts already finished, but to *do* something. He calls it "performative" because in its particular place in

history, under its "appropriate circumstances," it performs actions which intervene, which make a difference in the world. Starting with preliminary examples such as "I do" as uttered in the course of the marriage ceremony, "I name this ship the Queen Elizabeth," as uttered when smashing the bottle against the bow, "I give and bequeath my watch to my brother," as occurring in a will; and finally, "I bet you six-pence it will rain tomorrow," he observes that

> in these examples it seems clear that to utter the sentence (in, of course, the appropriate circumstances) is not to *describe* my doing of what I should be said in so uttering to be doing or to state that I am doing it: it is to do it . . . To name the ship *is* to say (in the appropriate circumstances) the words 'I name, etc.' When I say, before the registrar or altar, etc., 'I do', I am not reporting on a marriage: I am indulging in it.[183]

I have called activities such as these 'coalescing' ones rather than 'performing' ones, and my examples, in the main, have been taken solely from art and religion; but I too have observed the same phenomenon; that certain utterances or activities can of themselves—"in, of course, the appropriate circumstances"—create and bring about new worlds. In the field of art, Van Gogh is correct: "One ends by calmly creating from one's palette, and nature agrees with it, and follows."[184] Bonhoffer, in religion, provides us with a traditional Christian example:

> When the name of Christ is spoken over the candidate, he becomes a partaker in this name, and is baptized '*into* Jesus Christ' (Rom. 6.3; Gal. 3.27; Matt. 28.19). From that moment he belongs to Jesus Christ. He is wrested from the dominion of the world, and passes into the ownership of Christ.[185]

The fruitfulness of so placing art and religion is enormous. For one thing, affinities with other human activities open up. Consider the ancient Roman act of manumission, by which a Roman citizen— instantly, automatically, and seemingly without any apparent external inducement—could change a slave into a free man, a noncitizen into a citizen, a legal nonperson into a legal person; or one of Boswell's conversations with Samuel Johnson, in which Boswell asks, "But what do you think of supporting a cause which you know to be bad?" and Johnson typically replies:

> Sir, you do not know it to be good or bad till the Judge determines it. I have said that you are to state facts fairly; so that your thinking, or what you call knowing, a cause to be bad, must be from reasoning must be from your supposing your arguments to be weak and inconclusive. But Sir, that is not enough. An argument which does

> not convince yourself may convince the Judge to whom you urge it; and if it does convince him, why, then, Sir, you are wrong and he is right. It is his business to judge; and you are not to be confident in your own opinion that a cause is bad, but to say all that you can for your client, and then hear the Judge's opinion.[186]

Both types of utterance indulge, or reciprocally impose; and there are parallels here with those practical judgments which sponsor, lead to, or establish standards of valuation, because the judging process contributes to, or coalesces with, the standard achieved. In these cases it is true that the judging process is already defined to the extent that its thought categories and language constructs already mean what they say, neither more nor less, like numbers men use in counting; but in another and more complete sense, each specific judgment contributes to what is already defined because it extends that to which these thought categories or language constructs apply. The practical judgment of what is applicable determines that to which the judgment applies by reshaping it or modifying it. To say, for instance, 'This act is justified', a statement which ostensibly says something about the act in front of me, is also to say something new about the term 'justified', thereby extending or modifying its meaning. This is another example of that reciprocal or circular dimension of coalescence of which I earlier spoke.

In each of these instances there is a going beyond a previously established understanding and a bringing about of a new situation. The Roman citizen's act of manumission actually makes a man free, just as the judge's decision actually establishes legal culpability. In each instance the act is one with its fulfillment, just as "I do" is one with being married and "I baptize the . . . " is one with being "wrested from the dominion of the world." In none of these examples is there merely a pointing to a situation, but rather there is a participating in it, a being intrinsically related to it, in fact an actually making it be *that* particular situation.

There is yet another valuable advantage of associating art and religion with Austin's performative. That connection allows us to latch on to his observation that it is a mistake to think of the performative—and we now include art and religion— as "some internal spiritual act, of which the words then are to be the report."[187] Art and religion are thus free from psychologism, the doctrine according to which the laws of logic, evidence, and morality, for example, are contingent generalizations about the way particular individuals think or feel. This is not to say that artists and religious people have no feelings or have no reasons motivating them to act as they do, but rather to make clear that it is the

acts themselves which they do—not the motivating feelings or reasons —which make the difference. With the acts themselves something really happens, or as John Wisdom expresses it, with each action "a game is lost and won and a game with very heavy stakes."[188]

The significance of this move is that instead of thinking of art and religion as that which certain people happen to think or feel after doing, or that which certain people happen to think or feel before doing, we must insist art and religion are the doing itself—more specifically, that kind of doing with which a game is won or lost, an imposition is made with what Austin calls a "force," a term I have used earlier.[189] The reference to "game" is not misplaced. Consider, for instance, the football referee's signal denoting a touchdown or a penalty. In most instances, actions quite similar but carried out unofficially, would only be descriptive, for example, an acknowledgment that in fact the ball carrier has crossed the goal line or a player has committed an infraction of the rules. But because of certain appropriate circumstances (that is, the nature of the game and of the referee's designated authority within that context), his actions now carry a force which goes beyond the standard acknowledgment of what has taken place already, which is analogous to the force of the judge's decision establishing legal culpability or the slave owner's act of manumission legally establishing freeman's status for the former slave.

I conclude that art and religion, like all performatives, are activities with a certain force, a force determined by their appropriate circumstances. Whereas the appropriate circumstance is the necessary condition, or the one which supplies the context of preconditions without which art and religion *could not* perform, the actual doing of art and religion is the sufficient condition, that which activates the context without which nothing *would* be changed.

Roderick Chisolm makes clear just how closely related these two conditions are. He begins by noting that clearly our saying 'I know' is not a performative in the "strict" sense of the term, that is, we do not perform an act by saying 'I know' in the same way we might by uttering 'I request', 'I promise', 'I order', 'I guarantee', or 'I baptize'. "To say 'I promise that', at least under certain circumstances, *is* to promise that *p*; but to *say* 'I know that *p*' is not itself to know that *p*. (One might say 'I hereby promise', but not 'I hereby know'.)"[190] 'I know' comes after the fact, sort of a confession to you that I already am more familiar with the situation than you thought, or perhaps a boast to you that I already understand.

But now Chisholm goes on to point out that 'I know' just as well might serve as a guarantee to you; and by so serving, accomplish what the strict performative might accomplish. 'I know that this car will run', said under the proper circumstances (with the proper intention and with the proper authority), could be the determinative reinforcement to a previous 'I promise or I guarantee that this car will run', and thereby be the vehicle by which you move into a new understanding. Chisholm calls this usage of 'I know' "a performative utterance in an *extended* sense of the latter expression," and he suggests that any ignorance of this extended sense of the performative utterance and the related assumption that nonperformative functions are inconsistent with the simultaneous performance of performative functions, might well be "an example of the performative fallacy."[191]

In effect, what he has made clear is that what separates the extended, but nevertheless *de facto*, performative utterance 'I *know* that this car will run' from the nonperformative utterance 'I know that this car will run' is its permitted force—permitted by the appropriate circumstance. The former re-in-*forces*; and as such it functions in the same way the referee's signal might be said (although not necessarily), to re-in-*force* what our eyes have told us. In any case, it is now obvious that what Austin calls the appropriate circumstance is crucial in determining whether an activity functions artistically or religiously. Therefore I must subject it to further analysis, which will be the burden of the next chapter.

Truth-To

... Once he (Henri Bergson) asked me what was my feeling while
playing great music like Bach or Beethoven—I said that what I
found was that if, after a good performance, I felt satisfied, I had a
special feeling which could be compared to carrying a weight of
gold inside me. He was very interested in this remark and whenever
we met he used to talk about it. One day he said, "This weight you
talk about, is it equal or similar to the one we should feel when we
have done a good action?" I also knew the feeling one has after a
good action, but it is of a different nature. In that I feel something
outside my own self, whereas the one which comes from artistic
creation seems to belong to the inner self, as if one's participation
had been deeper and more definite. There is another difference
between the two sensations; a good action with me is followed by a
desire to forget it, so as not to lapse into a state of self-admiration,
but a successful performance seems to become a part of me, even to
evoke a feeling of self-recognition.

—Casals

In this study of art and religion, we have come to see that as an
activity functions artistically or religiously, it displays the characteristics
of innocence, fascination, terror, distance, and now coalescence. By
this last term, I mean that at-one-ness of the activity itself with its
acknowledged fulfillment. But the previous chapter concluded with an
ambiguity rooted in awareness that if we wish to determine whether or
not a particular act is in fact functioning artistically or religiously, it is
necessary to achieve a fuller understanding of the particular appro-
priate circumstance in which it takes place. Further, we realized that we
must go beyond Austin's own explication of "appropriate circum-
stances." For example, on the same page in which he suggests that the
"force" of an utterance might well be a clue to its nature—a clue which

obviously is to be taken seriously but which is nevertheless vague—he observes that "when you do not have the requisite thoughts or feelings or intentions then there is an abuse of the procedure, there is insincerity."[192]

Of course he is correct. But does "abuse" mean a "misfire"? Must "insincerity" denote merely saying something as distinct from actually performing by saying something?[193] As far as the efficacy of the Christian sacraments is concerned it does not. If we remind ourselves of Austin's observation that the performative is not "some internal spiritual act, of which the words then are to be the report," this particular example will not be the exception. To insist that it is, is possibly to commit the fallacy of misplaced concreteness. That is, when sincerity is introduced as a *necessary* ingredient to the "appropriate circumstances," it immediately shifts the focus of attention away from the act to the author's frame of mind when he acted. The impact of my analysis thus far has been to lead us in the very opposite direction and to suggest that an author's frame of mind—his sincerity or his intention—is irrelevant to the task of ascertaining whether his work actually functions aesthetically or religiously.

Besides, two related problems are involved. First, it is no easy matter to recognize sincerity when it is present. What might encourage us to say that an act is performative upon a first inquiry into the appropriate circumstance, and therefore potentially artistic or religious, may upon a correct reading of the author's intention turn out to be an insincere act—thus a nonperformative act. Its kinship then could be only with craft or magic, which by earlier definition fails to carry men into new unifications or into new realities, which neither discloses that reality nor makes it be what is is, which affords no deviation, which signals no victory, which only rests on what already is.

Secondly, we ask, is an author's sincerity ever known, even to himself? Is there such a thing as a totally sincere act, or for that matter, a totally insincere one? If we follow this lead can there be any such thing as an act which does perform, or for that matter, which does not perform?

Of course, this line of inquiry is not designed to imply that Austin's appropriate circumstance is inappropriate with regard to artistic and religious activity. Rather, all indications suggest looking for clarification of the appropriate circumstances for art and religion elsewhere than in sincerity. Austin's concerns are different from ours. Whereas he was trying to come to a general theoretical understanding of the nature of certain utterances which in fact function performatively, I am trying to clarify certain generalizations in order to use them

as guidelines to determine whether this or that act, here and now, does in fact function performatively. The generalizations which on hindsight, he found to be necessary, create problems because applying them to future lines of consideration is a difficult and somewhat undependable operative procedure. It is one thing to recognize something where men know it exists; it is quite another to establish its presence in those activities when we are not so sure it is there.

This chapter's concern, then, will be to become as clear as possible about those characteristics which constitute that appropriate circumstance which in the previous chapter I had concluded is crucial in determining whether or not an activity functions artistically or religiously. Beginning with that chapter's conclusion—that what determines whether an activity or a work functions artistically or religiously is not merely lines on a canvas, notes in a score, or gestures of blessing, but these *plus* their actually functioning in a particular way in a particular culture or society—I shall evince three observations. The first will seem obvious, but explicating it leads to the more complicated and philosophically interesting second and third observations.

First, there is a many-layered context into which artistic and religious activities fit. It is more than these activities and in some ways independent of them, yet not so independent that it does not allow or permit them to function artistically or religiously. For example, first, the particular individual actions of Jane Austen's Elizabeth and Darcy must fit the established characters which she has created for them, but in a way which they themselves come to assume; next, the established characters must fit into the general milieu which she has created for them but which also spins out of the work itself; and finally, the characteristic actions and the general milieu must fit into a context which the reader and the writer recognize and accept, at least tentatively, as a coherent world view. In parallel fashion, Walter Gropius's Dessau *Bauhaus* must fit its own clean typography, the typography must fit its planned function to import "industrial simplification" into architecture, and finally, this specific functional building must actually fit into a history of architecture which architects and connoisseurs accept. Otherwise it simply does not rank as art. Finally, think of Athanasius' Christian cry, "For he was made man that we might be made God."[194] It has religious significance only because it contributes to a theology which serves men as they recognize themselves to be. Of course, along the way a certain freedom or leeway is permitted; but as a permitted freedom, it is always constrained by the limits of that leeway. Accordingly, Odysseus can be transported miraculously to the shores

of Ithaca and Manet's barmaid can be miraculously reflected to the side in that mirror on the wall of the Bar at the *Folies-Bergeres*, but within their context both Odysseus and the barmaid must behave or appear in a manner which fits into a world view which the reader or the viewer accepts as coherent.[195]

An example where this structured responsiblity partly breaks down in a painting—and therefore reflects negatively on the work's artistic standing—in Ghirlandajo's *Last Supper*. It fails to establish a general milieu to which each of its thirteen characters submit. Compare it to Leonardo's more familiar *Last Supper*. Even though each artist's characters fit the general character the artist or society has given them, and each painting fits into a context which the observer recognizes as a coherent world view, only in Leonardo's painting do we find an artistically created world where the characters and objects are no longer true to their old empirical associations but now, by fitting into a new compositional unity, possess a different validity. Whereas Leonardo has created a new milieu into which his characters fit, Ghirlandajo has reproduced thirteen familiar characters sitting side by side. Therefore it is Leonardo's *Last Supper* which more completely fulfills this first condition of a many-layered context which is so essential to the functioning of art and religion.

Among philosophers, Aristotle successfully encompasses the obligation of particular artistic and religious acts to fit into contexts both within and without the limits of their own activity. He does so by referring to the obligation to be true to "universals," meaning by "universals" that "as to what such or such a kind of men will probably or necessarily say or do" (*Poetics* 1451b, 5-10). I take this to mean that the artist and the religious person must be true to themselves in the universal applicability of their activities. Thus art and religion express the universal, through the individual, but no less so do they express the individual, through the universal. For example, not only does Martha Graham create from Emily Dickinson's poems but she also creates from *Clytemnestra*. In the first she 'represents' an individual experience in such a way that the dance points up or creates something that men did not previously see in that experience. It draws the universal applicability out of the original experience so to speak, so that future observers are not so much assaulted with its particularity as they are by the possible extension of meaning of that original experience. In the second she 'represents' the myth in such a way that the dance points up or creates something that men did not previously see in that familiar story. It draws a particular contemporary relevance from the universal

insight, so that future observers are made aware of this twentieth-century extension of the universal, mythical story.

The way Aristotle sees this relationship between the individual and the universal, incidentally allowing for the possibility of coalescence, is through his understanding of *ousia* or essence, simply defined as that which exists by itself. Significantly, he rejects the Platonic emphasis on an ideal real world, existing apart from the phenomenal one which men experience every day, and along with that ideal world, the Platonic tendency toward an abstract *ousia*—that is, one which separates that which is common to individuals from particular, phenomenologically experienced individuals. As noted in chapter 1, Aristotle affirms in its place what I called a concrete *ousia*, an essence in which what is common to individuals exists in the individual species themselves. This means that that which exists by itself, that with which and from which the artist and the religious person must act, variously called the real or *ousia*—from the point of view of internal analysis is the universal, a knowledge which transcends individual experiences; but from the point of view of external presentation is the individual experience. Whereas from the point of view of an internal analysis, the significance of the artistic or religious act transcends the original individual act and its creator, from the point of view of the external presentation, men achieve the significance of the original artistic or religious act through the experience of the act itself. Taking both considerations simultaneously, artists and religous people, through their various activities, awaken in themselves and in others, new experiences which fit into their past while also contributing to their future.[196]

Petrarch provides us with instructions on just how this is accomplished. A writer should

> take care that what he writes resembles the original without reproducing it. The resemblance should not be that of a portrait to the sitter—in that case the closer the likeness is the better—but it should be the resemblance of a son to his father. Therein is often a great divergence in particular features, but there is a certain suggestion, what our painters call an 'air,' most noticeable in the face and eyes, which makes the resemblance. As soon as we see the son, he recalls the father to us, although if we should measure every feature we should find them all different. But there is a mysterious something there that has this power.[197]

Fortified by "Seneca's counsel, and Horace's before him," he adds the note that writers should work as "the bees make sweetness, not storing up the flowers but turning them into honey, thus making one thing of many various ones, but different and better."

Both of these analogies are well put. Like writers who depict sons who resemble but are not their fathers, and like bees which make honey, which comes from the flowers but is not the flower, so artists and religious people awaken in men an awareness of that which they already know (that is, fathers and flowers), but in a different way, also awaken echoes within men which allow them to say yes to what art and religion show them (that is, sons and honey). Perhaps we could say that art and religion help men see what in a sense they already perceive (otherwise they would not have known they needed it), and help them find what in a sense they already conceive (otherwise they wouldn't have known it was lost or wouldn't be able to recognize it when it is found); but further, they help men see what they now cannot see without the aid of art and religion and perhaps even help them find what they do not yet conceive.

I will draw two deductions from this first observation and point up one complication, all of which will prepare for this chapter's second and third observations concerning the nature of appropriate circumstance. First, when an artist such as Whistler speaks of the necessity for art to be "independent of all claptrap . . . as devotion, pity, love patriotism, and the like,"[198] or an authority such as Suzuki asserts that religion must be "free from all conditioning rules or concepts,"[199] their use of "all" is deceiving. That independence or freedom about which they speak is relative. Whistler's "claptrap" is only that which is outside the current artistic style, tradition, or culture. Suzuki's "freedom" is only an independence from *foreign* "rules or concepts." Second, individual artistic and religious expressions do not founder from being refuted so much as they fade away. If fitting into a context is a necessary constituent for an activity functioning as art or religion, it dies by losing its relevance, by no longer having a society or culture in which to function, by slowly becoming the world's "claptrap," its "foreign" rules or concepts.

This fading away can take time. Jesus can be the Christ only as long a people sympathetically listen and are thereby "saved." Gautama can function as the Buddha only as long as people sympathetically listen to what he teaches upon awakening. Artists can develop their resonance or formal structure only as long as audiences are capable of picking up certain allusions in their work. Now if either audiences or shared allusions are not present, the works themselves well may try to do and re-explain everything, in effect to re-create an audience and its allusions. Of course, this is possible. New claimants create their audiences all of the time. For an old work built upon a long history of shared

allusions, however, it is difficult. Consider the short Elizabethan poem which simply does not have the space to elucidate its own world. As the allusions in these poems become less familiar to later generations, the poems will fade away as art either by becoming unintelligible or by being overwhelmed by academic commentary. In either case, these poems will become difficult to read; in time they will cease to be relevant, cease to function as art.

The complication I anticipate is that since new claimants to art or religion create their audiences, to say, as I have, that that which functions as art or religion functions as a socially *permissible* vehicle, is misleading. The word 'permit' or 'permissible' is too passive. A significant fact is obliterated: it is because of art and religion that men write their history, thereby changing the past, present, and future, and thereby adopting new time scales. In addition, even though society permits certain artistic and religious acts to function artistically and religiously, that society itself undergoes a change because of what these acts do.

For these reasons I will change my first observation to read: those activities which function as art or religion are those activities which are 'true-to' the open-ended context in which they operate.[200] This context is yesterday's, today's, and tomorrow's. To be true in this way means to coalesce continually with constantly new discoveries. It means that art and religion, like the reformed Ebenezer Scrooge, are less concerned with "ghosts of Christmas past" than with "ghosts of Christmases yet to come." They are less concerned with fitting into that context which literally here and now exists, than they are in fitting into and contributing to that context which in the long run of experience will appear.

This understanding of 'truth' is not unique to the likes of art and religion. Experimental facts in the realm of quantum phenomena have encouraged many scientists to conceive of their truth claims in the same manner. First, they have divorced a great deal of present-day physical theory from crude or simple-minded literalism. Their language is often concerned, not with the objective motion of material bodies in the classical sense, but with the bringing of order into observation reports. An example is the concept of an orbit of an electron in an atom. Any attempt to measure the distance of an electron from its atomic nucleus necessitates imparting to the electron energy sufficient to alter this distance. Consequently, scientists cannot correlate unambiguously the concept of electronic orbit with primary experimental data. Other similar concepts are the simultaneous position and momentum of a subatomic particle and the wave length and time of emission of a

quantum of energy by an excited atom. On the basis of certain consequences of the Heisenberg uncertainty principle, scientists categorize each of these as nonobservable concepts.[201]

Some physicists concerned with these data are thus quick to suggest that in relation to what 'is', the role of physical theory is functional rather than representational. Of course, physicists can provide descriptions that conform to the classical idea of description, but no longer do they automatically assume a one-to-one correspondence between such description and a physical 'reality'. As Schrodinger puts it, "A completely satisfactory model *of this* [that is, representational] *type* is not only practically inaccessible, but not even thinkable. Or to be precise, we can, of course, think it, but however we think it, it is wrong.[202] In short, experimentation with quantum phenomena has also pointed strongly to the crucial and influential role of the observer, that is, the worker or the scientist. Physical theory serves to bring order to the world of experience. As such, science is a tool-making discipline and its concepts are akin to artistic or religious acts in that they too create what men experience so that men can understand, in this instance so that they might "see coherent patterns of relationship." The differentiation of the world around us into things—individual, discrete, constant—is truly man's work. So, too, with such terms as matter and mind, identity and duration, proton and neutrino, complementarity and wave mechanics—they have come into use because men have tried to formulate what they have experienced in pictorial commonsense language so that they might understand.[203]

There is also a parallel with art and religion as far as the future is concerned. These scientific formulations must point up new "patterns of relationship"; these momentarily commonsense concepts and schemes must "be fruitful of further experiments and observations." Not only must the scientist present his experiments and observations in understandable language which will bring order into and fit his world, he must also use language that will lead him into new experiments, observations, and understandings. Like artistic and religious activities, scientific activities must fit into and contribute to that context which in the long term will appear. According to this interpretation, science, too, consists of more than its findings and its activity. It is these *plus* their actually functioning in a particular culture in that particular way which proceeds beyond simply clarifying what men now already see and goes on to the required distancing from these same understandings and to a continuing coalescing with newer visions and understandings.

Now I am ready to make my second observation. According to the first observation, a work or act can be judged to be art or religion if what it has to say or do fits in with, or is true-to, what crystallized moments of open-ended contexts lead us to expect. Now we see that, because these works or acts are art or religion, they contribute to fuller, more complete understanding of these moments and therefore of the open-ended contexts themselves. Whereas, according to the first observation, that into which art and religion must fit lies outside and apart from artistic and religious acts, now according to the second, that context becomes what it is because artistic and religious acts reverberate into it. In effect, artistic and religious works or acts are artistic and religious to the extent that they are true to what a culture or a universe has led us to expect, but which at the moment would not be conceivable except for these acts. Obviously, this incorporates the gist of my previous discussion on coalescence. Art and religion coalesce with that to which they are true. It is partly correct to say they can function as art and religion only to the extent there is some prior context of assumptions and value which the artist and the religious person share with their audience and from which they must distance themselves. But it is even more important and correct to observe that art and religion can function as art and religion only to the extent that they make this prior context of assumptions come to be what it is.

What we find is this: (a) my first observation, an inherited open-ended context with its structure, character, and problems, to which art and religion must speak; (b) a distancing, modifying, and coalescing artistic or religious act; (c) my second observation, an unfolding open-ended context which sums up this moment, which makes demands, and yet which takes on a new character with each artistic and religious act. Artistic and religious activities start the process by being the means by which the context comes to constitute the new, but the moment that new context or crystallized moment appears, it then becomes a part of the inherited structure which still newer artistic and religious activities must take into account. The process never ends. That which changes the old becomes in turn a part of that which a later artistic or religious act further changes. There is a continuous interaction of each with the other two, and all three contribute to the multifarious coming-to-be of that which we can say is somehow still always in harmony with what men already have known.

In the familiar language of the earlier chapters, my suggestion that art and religion must be true-to this unfolding open-ended context means that artists and religious people not only are fascinated by

an inherited context, perhaps a mythology, and are driven by a *terribile* obligation to distance themselves from these structures, but their activities also contain a fruitful key to the new contexts or mythologies as they move into the future.

Illustrations from art come readily to mind. In the preceding chapter I quoted Heidegger's observation that "the elegy 'Homecoming' is not a poem about homecoming; rather the elegy itself . . . is the actual homecoming." This means 'homecoming' as it is now understood comes after the poem, and after sensitive observers coalesce their understanding with it, and after the world makes this new fuller understanding the basis for future speculation. We can say the same thing about Leonardo's *Last Supper*. It is not about the last supper; rather the painting itself is the actual "Last Supper"; that is, it presents to the world a new understanding of that supper-event which is true to its inherited characters and they to it, a new understanding which the world now takes seriously and from which it continues its explorations into the supper's meaning. Hokusai's attempts to break previously established limitations of working with woodblocks, or Dürer's experiments with engraving, woodcut, and drypoint are different kinds of examples. These men's greatness as artists lies in their works' sympathy with, or sensitivity to, the limitations of the media or technique with which they work, yet which they modify through their work, and by this modification help to establish new limitations for future artists.

But it is religion, with its dogmas or doctrines, which provides us with the most interesting examples of how this molded-molding harmony works out its way in practice. Henry Adams's comments about "Mary, the Mother of God" in *Mont-Saint-Michel and Chartres* are particularly to the point.

> The convulsive hold which Mary to this day maintains over human imagination—as you can see at Lourdes—was due much less to her power of saving soul or body than to her sympathy with people who suffered under law—divine or human—justly or unjustly, by accident or design, by decree of God or by guile of Devil. She cared not a straw for conventional morality.[204]

Accordingly, in keeping with my first observation, Adams notes that devotion to Mary "makes sense" only in a world in which men want most of all "not merely law or equity, but also and particularly favor." It is a world in which "strict justice, either on earth or in heaven, was the last thing that society cared to face." This is the context or truth to which Mariolatry must appeal.

But Adams also takes note of my second observation. Such devotion to Mary's "sympathy" actually makes certain needs and understandings concrete, needs which come to be incorporated in a new context which now understands the divine order as not merely "Justice, Order, Unity, Perfection" but as "Love," perhaps as "human, imperfect," perhaps even as "Favor, Duality, Diversity." Of course, this means a new religious spirit in the land, new facts which interested people henceforth must take into account.

The reason why this transition can happen so readily in religion is the nature of religious dogma and doctrine. They are statements of fact which appear only within the religious context. Men form them in the spirit of worship, formulating that which their religious activity discloses. But these formulations do not have a one-to-one descriptive correlation to what that activity discloses. Their relationship is rather one of manifesting those insights gathered through the religious activity. For example, the Christian creeds were not formulated as descriptive accounts of a divine order once and for all given to the faithful, but as protective walls against inconsistent vagaries from an ongoing tradition. They were reactions to heresy. As such, these orthodox formulations are at best safe paths; attempts to block off unsafe ones. That is to say, their function and the function of all dogmatic statements and doctrinal confessions is more to direct religious thought within the confines of a particular system than to check or limit that thought to a completed understanding which men already have experienced. Their function is to call for a commitment, a call to let this holy object, or that holy place, direct him who is interested to what he must see. Thus dogma or doctrine derives its authority from the system into which it fits and into which it leads men. Its truth is a truth-to that particular system. He who believes in the Virgin birth, for instance, does so because he is a Muslim or a Christian, not vice versa. As a truth-to the system, dogma or doctrine derives its credibility from that system and from its fruitfulness to suggest new powers and possibilities which are consistent with the system.

It is thus that we understand the Christian claim that its faith is based upon history. It is a history which becomes a history when the Christian accepts it, participates in it and thereby makes it real. In art and religion, only remembered activity is history. It is similar to the historicity of say, Bach's cantatas. Its history, which includes Monteverdi, becomes its history when music lovers listen to and appreciate Monteverdi because he is part of the history of baroque music which

leads up to Bach. By this remembering and incorporating, it becomes history.

Unfortunately, there is an inbuilt conservatism here, which tends to undermine the sufficiency of my second observation—that dimension of the open-ended context which unfolds, which takes on a new character as it is continually buffeted by the activities of art and religion. The pattern is this: dogmas or doctrines dictate a path to follow. In turn, they dictate what path is not to be followed, namely, what is heretical according to this particular context. Thus the religion develops. Following these certain paths brings about what Ian Ramsey calls "a worshipful situation of disclosure," a situation which discloses fresh starting paths for new insights and new understandings, but at the same time affirms those insights which men previously have gained within the particular system. As for the condemned paths, they simply fade away.

Now it is certainly true that the dogma or doctrine must continually generate new insights, but note that it is the already established context or system which determines which dogmas or doctrines will have the opportunity to spawn these new insights. It is very much like that scientist I noted above who determines the content of his object-language by selecting an experimental arrangement in accordance with the information he desires. This is the conservative circle. On the basis of their relevancy or what I call here their true-to-ness, the community necessarily registers or "funds" some acts and not others, thereby acknowledging, while in part determining, their functioning role in the already existent, inherited culture and in the culture of the future. By accepting or listening to some, the already established system thereby becomes the medium by which these individual acts become artistic and religious, that is, those creative acts which in time will modify the funding community. By rejecting or not listening to others, the already established system becomes the medium that determines which acts are to function only as private visions or as leaps into meaningless voids. The individual act holds priority, but only at the mercy of the necessary but not sufficient funding community.

There is a related conservatism which may be a second step. It develops because the context of funding community to which art and religion must submit is truly an open-ended one, and therefore one which is capable of legitimately absorbing artistic and religious activities, but in a special way so as to insure its own continuity as a community. Let me clarify my meaning by referring to Basil Mitchell's contribution to the still influential *University* symposium of the early

1950s; to his parable which takes place in a wartime situation in which a member of the Resistance, a partisan, meets a stranger who deeply impresses him and who tells him that he himself is also on the side of the Resistance.[205] The stranger "urges the partisan to have faith in him no matter what happens," and the stranger's sincerity and constancy is so convincing, that the partisan does undertake to trust him. Now the partisan never privately meets the stranger again, but sometimes he sees the stranger helping members of the Resistance and sometimes he sees him in the uniform of the police handing over patriots to the occupying power. Thus far the parable is clear. If the partisan does intend to hold "his faith in him *no matter what happens*" [italics added] then obviously nothing the stranger will do can count decisively against that faith. In fact everything that the stranger does will be interpreted so as to reinforce the partisan's faith that the stranger is in fact a member of the Resistance.

But as Mitchell works out his parable the situation becomes more complicated and more relevant to the real problem of conservatism. The partisan recognizes that the stranger's ambiguous behavior could count against what he believes about him, but the partisan insists it never counts decisively. That is, the ambiguity never weighs heavily enough on him for him to declare his faith to be misplaced. Now if this means the stranger's ambiguous behavior may count against the partisan's trust in such a way that it might effect certain changes along the way in the partisan's expectations, but never a decisive rejection of his faith, then we have a parallel with a funding community absorbing artistic and religious creations in such a way that its own existence as a community is insured. Similarly, let us turn back to the Van Meergeren case. If there had been no confession, how far would the community of art scholars have been willing to go in its modification of what constituted a Vermeer before it would have been forced to reject the ever-expanding, all-inclusive, potentially characterless class 'Vermeer', and create a new precedent class 'Van Meergeren'—thereby allowing the original definition of 'Vermeer' to regain its original defined limits (or in keeping with our other example, rejecting it altogether)? Could a particular Van Meergeren ever count decisively against the sufficiency of the old categories? Perhaps in principle, yes—but in practice?

These two examples are related because they raise the same question. Once it is accepted in principle that facts and arguments can affect a decisive reorganization of prior categories of understanding, when is the appropriate time when the acceptance of just one more necessary modification or qualification to a hypothesis denudes it of all

meaning or makes its continued defense foolish or intellectually dishonest? When is it that the conservatism of the partisan or the community of art connoisseurs becomes foolish or dishonest? The question is akin to, When does the old boat, planked and replanked, become a new boat, and thereby merit a new name?

The sixteenth-century scientific community faced the question with their extended defense of Ptolemaic cosmology. Their introduction of the equant and eighty spheres or circles in order to account for the phenomena approximately is no different from those modifications or qualifications the art connoisseur felt forced to make in order not to hypothesize an as yet unknown painter, or those apologetical arguments advanced in defense of a believed-in 'truth' once and for all committed to the saints. Admittedly they constitute a far more creative defense than the partisan's simple assertion in the face of the stranger's ambiguous behavior that "he has reasons," but they all are conservative defenses of the already known, nevertheless.[206] What these sixteenth-century scientists were defending was a beautifully overarching Aristotelian cosmology which intricately dovetailed a whole host of elements into a hierarchic structure. Their question was whether the comparatively simple and more economical thirty-four spheres of the Copernican system provided a decisive enough advantage to merit the required complete overhaul of that community's current system. If the answer is to come from those who have a vested interest in that current system, the people who live in it and contribute to it, it will tend to be negative.

Nevertheless, revolutions which do neutralize this conservatism occur in art and religion, as well as in science. This fact necessitates my insisting upon making a third observation as to what constitutes art and religion's appropriate circumstance. The third observation will press the second observation a step further than it has gone thus far, and reestablish a transcendence of the actual doing of art and religion which the first observation upheld, but one which will be freer from that potentially conservative vested interest in the now of which I just have been speaking. It is that the context to which individual artistic and religious objects or acts must be true, my first observation, is itself not only open to the reverberation from those objects or acts, my second observation, but it is also open to what might be called the continuous reverberations of an ever-expanding present which moves into a future and absorbs or creates a past.

My points are these. In accordance with the first observation, art and religion, like eyeglasses, help men to see clearly what they already

perceive to exist. In accordance with the second observation, these eyeglasses are unique in that that which they help men see is not already perceived before they bothered to act artistically or religiously. Thus it seems the authority of the funding community, that with which men see before they don the artistic and religious eyeglasses, breaks down because art and religion create as well as discover what they make men see and understand. They discover because men recognize what they see as true, but they also create, because they put what men see there. But now there is also my point about that inbuild conservatism which undermines the sufficiency of this second observation. These glasses are provided by the already existing community, and they are so provided because they, up until now at least, have created that which is compatible with the already existing community.

I introduce the third observation at this juncture. Artistic and religious activities stimulate the mechanism of projection, coalesce with it, and bring into the open that with which men *henceforth* shall deal and with which they *henceforth* shall take seriously in their everyday experiences. In effect, the condition which flows from my third observation contributes to the breaking down of the conservative authority of the present already existing community because it notes that the true value of art and religion is their fertility, not their utility.

Again, let me cite as an example Leonardo's *Last Supper*. Whereas, in keeping with the first observation, I noted that it is superior to Ghirlandajo's *Last Supper*, and in keeping with the second observation, that it is not any longer about the last supper so much as it *is* the actual Last Supper, without which Jesus' last supper would not be understood the way it is understood, so now, with this third observation, I can note that it is its continuous reverberation into a present which itself moves into the future that so determines its continuing artistic value. This is to say, for it, and for all art and religion, the empirically significant unit is not the now already existing community which stands independent of the individual expressions of art and religion and allows them to so function, admittedly one which is molded by the contributions of that which it 'judges', but it is the ever-expanding whole or "total drift" of that now, to which it contributes.

I use the phrase "total drift" advisedly. Whereas "total" preserves the all-at-onceness of the appropriate circumstance which invites men's attention, "drift" preserves its open-ended chronological not-yet dimension. Both are important and somewhat at odds with each other. The former implies transformation, the latter, addition.

The eighteenth lesson of the *Bhagavadgita*, lines 19 through 28, provides us with an example of religious sensitivity to what I mean by "total." It especially neutralizes the chronological 'yet' and 'not yet' connotation of "drift." There we read that although some workers make particular things be everything and rest with them, and although others perceive these diverse and various things and are greedy for more, there are also a few workers who know instead one changeless existence in the divided and undivided, and who are thereby free of the attachments to currently perceived things and from speaking of an 'I' which stands in that now. In a traditional vocabulary, these are the few who have made the transition from *ajñana*, from the usual way of considering names and forms as ends in themselves and from *vijñana*, a "discriminatory knowledge," to *prajña*, "pure intellect," what Ramakrishna calls a "supremely rich knowledge." In such a mode of sensitivity, to say that one sees the truth of a religious act is to see it, not in its relevance to current things or needs, but in its relevance to the context of a total all-at-onceness. It is thus that the meaning of everything was revealed to certain men when the Buddha attained enlightenment or when Christ died on the cross and was resurrected. Through these acts which now are functioning religiously, old worlds passed over into new ones and these new ones are true to an unfolding future and to a reconstituted past. By them, and by acts like them, men come to determine the logical possibility of factual counterparts, to specify what can and cannot be. As long as they have this power they remain "supremely rich."[207]

A way of pointing up the significance of this dimension of totality is to say that art and religion are true to a new space and time. Once a masterpiece has emerged or men accept the religious significance of an act, everything else falls into a new place and into a new time around it. Because of it, men restructure everything and by doing so come up with new possibilities, new beginnings, and new ends. That which we now see exists independently of that which we previously saw as part of an old history. *Chronos*, the prepared moment, is given a new life by *kairos*, the correct moment. From the perspective of those who are preserving or gaining from the old time, dedication to the new perspective seems to be wasting time, but it is more accurate to say that art and religion have put an end to the old time. Apollodorus tells us that when Apollo first came to Delphi "where Themis at that time used to deliver oracles," he was forced to kill the guardian snake, Python, which attempted to prevent his approach.[208] By meriting resistance from the original powers of the Oracle, the myth implies that Apollo

brought something to the Oracle which was not there before, some-thing revolutionary. With the arrival of this new god, Delphi's space changes; it has become Apollo's space, a new space. Apollo arrives and changes Delphi.

As always, Catholic Christianity expresses its awareness through special liturgical acts—this time the insight that religious occupancy of old spaces transforms them into new spaces. For example, on an individual level there are rites for birth, puberty, marriage, illness and death, all of which are thought to be preludes to new times and new spaces. On the institutional level, the Christian bishop approaches his yet-to-be-consecrated space—the old space—first separating it "from all unhallowed, worldly and common uses," and then gives it new functions and new associations. In the words of *The Book of Common Prayer*,

> O Eternal God, mighty in power, and of majesty incomprehensible whom the heaven of heavens cannot contain . . . and who yet hast been graciously pleased to promise thy especial presence . . . Vouch-safe O lord, to be present with us, who are here gathered together . . . to consecrate this place to the honour of Thy Great Name . . . dedicating it to thy service, for reading thy holy Word, for celebrating thy holy Sacraments, for offering to thy glorious Majesty the sacrifices of prayer and thanksgiving, for blessing thy people in thy Name, and for all other holy offices.[209]

There are more dramatic examples. An observer steps back and the impressionist dabs of pigment suddenly come to life and he sees a landscape. The audience listens to Karlheinz Stockausen's meditative texts *Aus den Sieben Tagen*, and with the texts' help, the audience constructs new relationships, thus a new totality, a new time and a new space.[210] In each case the interested participant has hereby entered into a new playground, as it were, one with new rules and new limits which he henceforth must observe. It is as if art and religion do what a game does, what the telling of a joke, more specifically a pun, does. Would we dare say that artistic and religious activities are a joke? If a pun is what Hesse meant—certainly a kind of joke—there is a profun-dity in Harry Heller's comment that "eternity is a mere moment, just long enough for a joke."[211] Puns too bring about new totalities, in their case a sudden perception of an unsuspected relationship between what previously had been two unrelated or incongruous ideas or objects. Here, too, old eternities pass away and new ones are created.[212]

Obviously, each of these examples stresses transformation, not addition. They all deliver either a new totality, all at once, or else nothing. But my third observation as to what constituted art's and

religion's appropriate circumstance spoke of the continuous rever-
berations of an ever-expanding present which moves into a future and
absorbs or creates a past. That is, it spoke of a drift as well as a totality.
Though it might be said that once a masterpiece emerges, everything
else falls into a new place around it, because of its continuous rever-
beration into an ever-expanding present which is moving into a future,
the masterpiece, if it is to live, never yields up all of its meaning to any
one audience, to any one time or place. As Baudelaire put it, *"The
Beautiful is always strange."*[213] In the language of the previous chapters,
Constable's *Weymouth Bay* is a masterpiece because it has shown men
what they see and saw *and* because at the same time it distances itself
from these visions and understandings in order to continue to coalesce
with still newer visions and understandings. This is where, for exam-
ple, Thomas Cole's *Last of the Mohicans* fails. It rests content with a
particular understanding with which it once may perhaps have coa-
lesced. It no longer continues to distance from this understanding, and
now serves only as a useful means to remind a contemporary world of
it. In a like manner this is the danger of Athanasius' cry, "For He was
made man that we might be made God," to which I referred in the
beginning of this chapter. As an isolated affirmation it too serves only
as a reminder of victories or insights previously won. Its problem is that
in fitting into and contributing to a many-layered context, it is obvious,
contains no mystery, no longer reverberates into the future, is doomed
to be only of historical interest to note what brought Christians to
where they are.

The mechanism by which art and religion harbor their strange-
ness and thereby continue to coalesce with continuously newer visions
and understandings is through their effecting what is akin to the
feedback process in automatic control and information theory. The
arrival of the consequent causes the observer to modify his opinion of
the hypothetical meaning initially attributed to the stimulus. The point
is that the feedback mechanism throws light not only upon the ob-
server's estimates of future possibilities but also upon the initial
situation.[214] Let us consider an example which I have used previously.
If the works of Monteverdi are what might be called masterpieces, they
not only contribute to the appreciation of Bach, but also reserve a
'strangeness' which allows that appreciation to reflect itself back onto
an understanding of Monteverdi himself. Here, in the terms of that
familiar statement of Carnap's, not only does the acceptance of a thing
world mean the acceptance of a certain form of language, but, as he
noted, "To accept the thing world means nothing more than to accept a
certain form of language."[215]

This feedback process is at the root of much of the dissatisfaction with artistic and religious claims to truth. A truth which is true-to a drift is a truth which is not yet finished, which is forever receptive to the tomorrow. Stated negatively, that which is true is only tentatively so. Stated positively, that which is true is true because it preserves a strangeness which gives it leeway to move with the drift. Like the Gods which hover over us, masterpieces too maintain a dark side, the character of *terribilità*. But it is uncomfortable to deal in the dark with the strange, the *terribile*, with at best, the merely suggestive. Thus the Greeks threw stones at Thespis, and the Christians refused to bury actors in consecrated ground. Perhaps this is why Hindus found little room on their inner shrines for the suggestive sculpture which they let appear on the outer, less holy shrines. Like the Python at Delphi, each preferred to defend and deal with the familiar already established totality which stands in harmony with the now.

On a different front, a philosophical move to mitigate the tentativeness of artistic and religious truth is to recast the issue in terms of opinion and fact or to insist upon the existence of primitive 'facts' which stand independently of what men may think of them. Both moves however, ignore important data about the nature of artistic and religious activity as it functions in society.

The first move is to remind us of the distinction between revised opinion, or appreciations and revised facts. Whereas opinions or appreciations are dependent upon, facts are independent of, the person holding them. Thus whereas certainly something like terror is present, for example, when the Christian suddenly seriously becomes aware that his current understanding of Jesus Christ is subject to revision in the light of possibly new archeological discoveries, the impact is alleviated the moment he reminds himself that it is only his opinion of Jesus Christ which will change, not Jesus as he is in himself. He will say to himself, "Christ reigns no matter what the world or I think." It might be said the religious situation is no different from that in mathematics when Lobachevsky's system of geometry challenged Euclid's fifth postulate that only one line parallel to a given line can be drawn through a fixed point. It is not that Euclid's or Lobachevski's facts are tentative, it is man's appreciation of the facts which is tentative or partial, and in Euclid's case, in error.

To assert that there are primitive facts with which all activities must deal is to make a related distinction. How activities differ from each other resides in the way they use, interpret, or understand these facts. Thus the markings on the great stones at Stonehenge are a fact for all observers, but what distinguishes say, the social scientist, the

religious observer and the tourist, is what they understand or do with them. Scholars in both art and religion long have argued along this line. Literary critics will insist the prison symbolism of Charles Dickens' *Little Dorrit* is present in the 1855 novel although recognizing it was virtually unnoticed until Edmund Wilson's essay *The Wound and the Bow* (New York, 1941) and virtually undeveloped until Edgar Johnson's *Charles Dickens: His Tragedy and Triumph* (New York, 1952) and Lionel Trilling's Introduction to the New Oxford edition of *Little Dorrit* (London, 1953). Why is this so? asks Philip Collins; because the novel was previously ill-regarded and considered not worthy of the attention necessary to notice what for us is "so obvious."[216] Biblical commentators will speak of the Bible as history, but they add, not simply history. It is a history with a special interpretation. It is not a recording of the primitive facts as they are in their primitive plainness, but as a religious interpreter uses and understands them. Recognizing this prior assumption helps us to understand much of Bultmann's elucidation of the Gospel narratives, for instance, just as it helps us to understand Virgil Thomson's insistence that

> music in any generation is not what the public thinks of it but what the musicians make of it. The lay public has no responsibility at all toward music. It is under no obligation to like it, to protect it, encourage it, quarrel with it, or consume it. Musicians can cater to public taste, cooperate with it, raise it or lower it; and lay encouragement can stimulate them to great and disinterested achievement. But always the music of any time is the music that the musicians of that time make. Musicians, in other words, own music, because music owns them.[217]

Just as Collins implies *Little Dorrit* has a primitive status independent of its critical attention and just as Bultman gives history a primitive status independent of interpretations of history, so Thomson gives music a primitive status independent of that which functions as music. Their allies are those commentators who speak of landscapes interpreting moods of landscapes, not simply landscapes, and who speak of dance creating realms of "virtual" power, not simply power.

I suggest that my earlier findings concerning artistic and religious activity make it clear that these distinctions, which might mitigate artistic and religious tentativeness, are not applicable so far as art and religion are concerned. They speak, for example, of *Little Dorrit*, Christ, history, and music, as facts which only need men to discover them. They assume that that which is artistically or religiously true exists or is real independently of the men who utter it (that that which is artistic or

religious does not entail that it is knowable by men). On the other hand, what we have come to see is that the Christ who reigns "no matter what the world thinks," that novels and history which exist independently from all interpretation, that music which "owns" musicians and is independent of that which the public "consumes," are all hypostatizations, perhaps useful labels or ideals in order to *talk about* art and religion—but they *are* not art and religion. They are not a factual base which stands apart from and judges particular artistic and religious acts. By them no one is saved; through them no one comes into an understanding. They already are an understanding. It might be useful to think and say, for instance, that religious practices elevate men from a life confined to natural capacities, to a life to be lived in a transcendent reality, say in God. But it is a mistake to think of this transcendent reality as a primitive, prior existent fact which is independent of the elevating religious act and somehow capable of judging its effectiveness and thereby lending a stability to the world. It is a mistake because religious truth claims include the elevating act, the way it functions.[218]

This is not to imply that the religious act, or for that matter the artistic act, is *sufficient* to itself, that it can by itself simply in the doing justify its own objectification or its own truth claim. In the next chapter I shall discuss the means of checking out these claims of truth. Rather it is to say that the religious act or the artistic act is *necessary* for that objectification or that claim of being true-to. It is necessary because what artistic and religious people have to say depends upon it. And more, the artistic and religious acts which claim men's attention can make their claim only through the activities themselves. Not only is the fact dependent upon the act, but the fact can be approached only through the act. This means art and religion can distinguish opinion from fact only after the act, in terms of the act, and in the context of the act. We could say the act makes the artistic and religious fact. Those acts which reverberate into the total drift are the facts; to assert that they will continue to do so is to hold an opinion.

From this perspective Clive Bell's definition of "significant form" noted in chapter 5—that "combination of lines and colors (counting white and black as colours) that moves me aesthetically," is not quite so inadequate.[219] Artistic and religious facts are those which do so move men aesthetically or religiously, that is, to grasp the open-ended futures which they deliver. They are those vehicles which do make certain futures and pasts significant, factual, or known. To paraphrase Francis Bacon, whereas there are "experimenters" collecting and using like ants what they have already found, and "reasoners," weaving

cobwebs like spiders "out of their own substance," so there are "natural philosophers," as he calls them. We link them up with artists and religious people, who are like bees gathering "material from the flowers of the gardens and of the fields" and making it into something new by the power of their own act.[220] It is these people's works which deliver the total drift of the future. Their activity is equal to what it produces; we do not measure it by the substance from which it comes. Like a musical composition's last movement which alters its first movement and the drift of the whole composition, even for the composer who is writing it, and like a novel's conclusion which alters what precedes it and the meaning of the whole novel, all art and religion alter what was and coalesce with what will be.

This chapter's three observations must therefore stand. Insofar as art and religion claim truth, their truth is one that is true-to an appropriate circumstance which (1) is a context, into which artistic and religious works cohere, but which is inevitably changed (2) by the very activity it permits and (3) by the ever-expanding present (the total drift), to which it contributes. Where we might say those artistic and religious activities (1) allow us to see those things we already see, but more clearly, now, on second thought, (2) we realize that those things which they show us, they helped put there; and in fact, (3) they also create the time and place in which those things rest.

The usefulness of the ordinary language fact-opinion distinction to art and religion has been to heighten our awareness that the past, present, and future to which art and religion relate, is filled, not with literal brute facts, but with significant facts. Art and religion are concerned with those kinds of facts which constitute an occasion in which diverse experiences come together in a fashion that moves or grasps the individual who gives them his attention. In this kind of factual world, there is little danger of a misplaced concreteness—the tendency to accept a particular occasion as being literally the nature of reality, the tendency to convert particular hypostatizations into norms or models. In this kind of world men see everything through a temperament. There simply are no histories constructed without interpreters, no landscapes painted without moods. And the claim for existence of those histories and landscapes rests solely with that interpreter or sentiment, and with their separate name.

This means that artistic and religious facts are more existential than ontological. They are achievements or functional distinctions, not gifts. As facts, they exist only through and for the understanding. They are not artistic or religious facts before the related understanding, but

only afterwards. As such, they are like the "Mycenaean" daggers carved on one of the sarsen stones of Stonehenge or the prison symbolism of *Little Dorrit*. In one sense, the ontological sense, the daggers or the symbolism have been a fact ever since the carver carved them or Dickens wrote it; but in the artistic and religious sense—the existential sense—they have become facts only since men have come to see by them. For at least a portion of the preceding three centuries and for the hundreds of thousands of visitors who must have looked at the daggers without actually seeing them, and for the hundred years readers and critics have read *Little Dorrit* without actually seeing the symbolism, the daggers and the symbolism made no difference. They dissolved nothing; they illuminated nothing. Artistically and religiously, they were not facts.

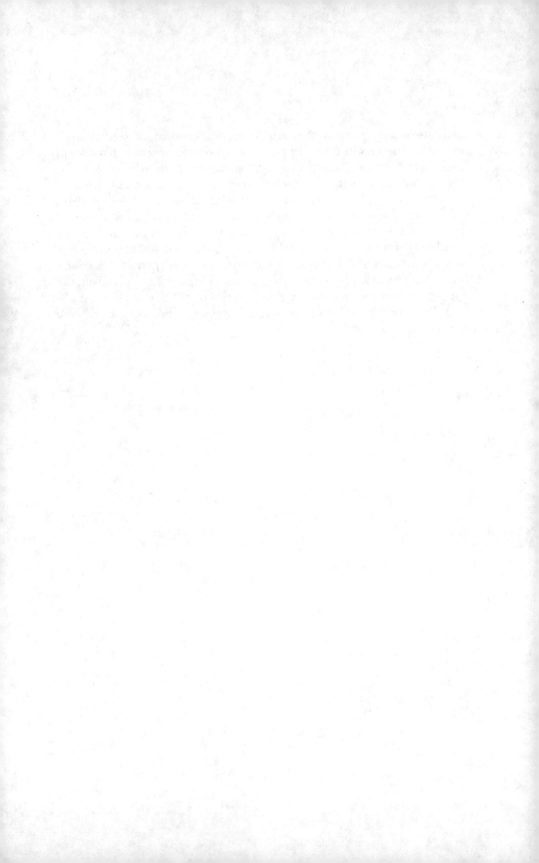

Verification

"I don't know what you mean by 'glory,' " Alice said.

Humpty Dumpty smiled contemptuously. "Of course you don't—till I tell you. I meant 'there's a nice knock-down argument for you!'"

"But 'glory' doesn't mean a nice knock-down argument,'" Alice objected.

"When I use a word," Humpty Dumpty said, in rather a scornful tone, "it means just what I choose it to mean—neither more nor less."

"The question is," said Alice, "whether you *can* make words mean so many different things."

"The question is," said Humpty Dumpty, "which is to be master—that's all."

Carroll

Rather than my uncovering a clear and distinct appropriate circumstance which stands apart from artistic and religious activity and which could serve as an appropriate standard of expectation against which we could determine whether certain other activities function artistically or religiously, the three principal observations of the previous chapter have brought to the fore the responsiveness or openness of the appropriate circumstance, to artistic and religious activities and to that total drift into the future to which those activities contribute.

Now insofar as my concern is to establish procedures whereby we can recognize when a particular activity is artistic or religious, it is time to ask: does this mean that art and religion have no standard, or that the appropriate standard is simply that all activities which influence their circumstances and their future are artistic or religious? Baudelaire

133

may well observe that the beautiful is always strange—but must we admit, conversely, that the strange is always beautiful? Are all strange activities or things by nature artistic or religious if they make us see in a different way? If not, we have to answer the question, how do we come to know which strange acts or things are artistic or religious, and which ones are not.

One possible answer, which I shall quickly consider and reject, is to say that it is the doer's *intention* which decides, so that those activities which intend to produce art or religion actually do produce art or religion. If p is what the doer intends to convey then p is what is conveyed in the work. But do intentions really make things so? John Hospers asks:

> Suppose he meant to convey one proposition, p, but didn't succeed, or succeeded in conveying to his readers another one, q, which he never intended or even thought of. And if all readers agree that q is the proposition implied, are we still to say that it is p that is implied because the author said so?[221]

If it were the doer's intention which decided the nature of his work, attention would need to shift from an attempted appreciation of the works themselves to reports about the conditions under which the works were created, that is, to an appreciation of the genetics of art and religion. Aside from the practical difficulty of ever comprehending the conditions under which a work is created, the previous six chapters have also made it clear that, in art and religion the distinction between the motivating cause and the end product cannot be smoothed over so readily. To understand the cause of these activities is not necessarily to understand the activities themselves. To understand with Hume that "Ignorance is the mother of Devotion;" that men do religion because they fear an unknown power acting in the world, because they desire to know the causes of certain events as they affect their welfare, and finally because they hope unceasingly for a quality of happiness that surpasses the one provided for by the technical control over nature and over human cultural relations—this is not to understand what religion is or does. Hume's "mother of Devotion" is not devotion any more than the motivating ends and purposes of the alchemist and the astrologer are chemistry or astronomy. They are neither necessary nor sufficient. What one intends to do in these instances is not what one does. Why men do something is not the same as what they do.

Plutarch vividly illustrates the distinction. He tells us that Pericles once brought in from his country farm a ram's head with only one horn. Lampon, the diviner, thinking in terms of its future significance, said

that the omen meant that Pericles would eventually gain the political victory over his opponent, Thucydides. In contrast, Anaxagoras, the "natural philosopher," thinking in terms of the strange configuration's natural cause, said that it meant "the brain had not filled up its natural place, but being oblong, like an egg, had collected from all parts of the vessel which contained it in a point to that place from whence the root of the horn took its rise." Plutarch noted that "Anaxagoras was very much admired for his explanation," but he wisely adds,

> and yet, in my opinion, it is no absurdity to say that they were both in the right . . . For it was the business of the one to find out and give an account of what it was made . . . and of the other to foretell to what end and purpose it was so made.[222]

It is this distinction between why a phenomenon is what it is and what a phenomenon means which provides the background for my distinction between art and craft, religion and magic. It also provides the background for my comments about science in the Overture. It was the diviner who thought in terms of what the phenomenon meant and it was the natural philosopher who thought in terms of why it was what it was. In chapter 4 I noted that whereas craft and magic reaffirm what men already understand and have seen, art and religion create anew and thereby open men's eyes to what they previously did not understand and have not seen. This means that craft and magic *are* effects which flow from their authors previous intention, and they *are* evaluated fairly when men measure them by their success in serving that intention. Since art and religion open men's eyes and understanding to what they previously have not understood or seen, these activities cannot serve prior intentions but instead must break new ground. The discussion in chapter 5 further demonstrated that though they well may be the result of their author's prior intentions, these intentions coalesce with the activities themselves; and the intentions change in the process of the activities' coming into being. In effect, there is no motivating intention which stands apart from the activities of art and religion themselves. Thus we never can ask beforehand of what the activities and objects of art and religion are a sign, if by this question we mean some clearly defined prearranged "something else," such as the craftsman's blueprint. The religious proclamation is God acts, and behold what he does is very good. The good comes after the act, not before it. The Lord Isvara is the lonely cosmic dancer who creates worlds out of sheer joy, simply in play (*līlā*) or in sport. There is no intention with acts such as these. There is only the spontaneous creative act, and nothing more.

An equally vulnerable answer to the question of how we are to know when an activity is artistic or religious would be to claim that art and religion are those activities or objects which I accept as art and religion, that is, to say those activities or objects which function as art and religion *for me.* The argument is simply that if there is only the act itself and nothing more, nothing against which men can measure this act, not even the author's intention, then the act is whatever it is—for me. This seems to be the view of art and religion which Oscar Wilde held, at least as he reveals himself in his published letters. "Poetry should be like a crystal," he writes, "it should make life more beautiful and less real."[223] Later he elaborates and includes in his view the whole of artistic activity: "Art is different. There one makes one's own world . . . A mirror will give back to one one's own sorrow. But art is not a mirror, but a crystal. It creates its own shapes and forms,"[224] and again, "The function of the artist is to invent, not to chronicle . . . Life by its realism is always spoiling the subject-matter of art. The supreme pleasure in literature is to realize the non-existent."[225] Especially interesting for us is his observation that the basis of Jesus Christ's nature is "the same as that of the nature of the artist."[226]

> Everything to be true must become a religion . . . But it must be nothing external to me. Its symbols must be of my own creating. Only that is spiritual which makes its own form. If I may not find its secret within myself, I shall never find it. If I have not got it already, it will never come to me.[227]

Wilde makes explicit the suggestion left here as to why we should or should not accept a particular artistic or religious act when he writes that "no artist recognizes any standard of beauty but that which is suggested by his own temperament."[228] Of course, there is some truth in what he says. It constitutes much of that element of 'fascination' which we found to exist in both art and religion. Martha Graham agrees when she insists that "dance . . . is not an escape. It is a realization."[229] William James generalizes on this truth; when he writes that "any view of the universe which shall completely satisfy the mind must obey conditions of the mind's own imposing, must at least let the mind be the umpire."[230]

In the last resort, our convictions of what is acceptable rest on an anterior assumption of a particular set of terms from which all our references to reality are constructed. The truth of the matter is, we do derive at least partially, our rules of observation, action, and verification from factual statements that we already have accepted as true.

Now, if Wilde had cared to defend his assertion that art and religion are those activities which satisfy his temperament, and therefore which function as art and religion for him, it might have gone something like this: just as, for example, the understanding and the recognition of a speech act depend upon a prior acceptance of the theory of the universe which that particular language postulates, or just as, for example, the understanding and recognition of the significance of a musical note depend upon a prior acceptance of the tensions and probabilities which the relationship of previous notes builds up, so the understanding and recognition of an act as artistic or religious depend upon a prior understanding of who I am and what constitutes my particular tastes, moods, and needs. Wilde undoubtedly would have made his defense in terms of coherence. Likely he would have argued that men can understand artistic and religious acts only by first understanding the context from which they extrapolate these particular acts, and since that context from which he extrapolates these particular acts centers about him, Oscar Wilde, only those acts which cohere with him, which fit into or satisfy his moods of what is beautiful or spiritual, would qualify as art or religion.

Though there is some truth here, there are also problems. One problem having to do with the sufficiency of coherence, we will face shortly when I begin to present my own verificatory procedure. At the moment there is a more immediate rub. It lies with Wilde's understanding of "me," of "who I am and what constitutes my particular tastes, moods and needs." Wilde has forgotten that, at least for art and religion, only the act exists, nothing more. It is true that the understanding and recognition of the significance of, say, a musical note, depend upon a prior situation but in contrast to what Wilde may want to say, this prior situation has no absoluteness or objectivity which stands apart from the musical process. It does not exist as something apart which can judge, evaluate, or verify that musical process.

> Think, for instance, of a simple folk tune such as "Au clair de la lune." The last four measures are exactly the same as the first four. But because their recurrence is the result (the effect) of what has gone before they are truly different. This difference is easily tested. No matter how many times the first four measures are repeated, they will not end the piece satisfactorily. In order for this sequence of tones to end the tune, they must be the result of the means-end relationship which brings about their repetition.[231]

The point is that art and religion alter our interpretative frameworks, including the "I who I am" no less than the first four measures

of "Au clair de la lune." Each is freed of its previous objectification. Thus the Zen master can take his staff and proclaim to whoever will listen that it is no longer a staff, that it is transformed into a dragon and the dragon has swallowed up the whole universe. This is what the Dharma meant when he answered the Emperor's question as to what was the first principle of the Holy Doctrine with "vast emptiness, and nothing holy therein."[232] He was saying that in religion, the essences of all things and situations, himself included, have no objectivity. They are devoid of determination, always waiting and coming into being, forever responsible and responsive to what is now going on. Though they may seem to be something and somewhere, artistically and religiously, they are emptiness, *Sunyata*, nowhere and in no time.[233] Renoir's son provides us with a nonreligious example. He reports that on the morning of his father's death, his father was painting the anemones which the maid had gathered for him. He continues,

> For several hours he identified himself with these flowers, and forgot his pain. Then he motioned for someone to take his brush and said, "I think I am beginning to understand something about it." That is the phrase Grand Louise repeated to me. The nurse thought he said, "Today I learned something.[234]

It is this learning process which is a necessary part of art and religion and for which Wilde has no taste. Because of it, the artist and the religious person are not confined to a single state or to a single moment, but to every state or to no state, and to every moment or to no moment. Though Wilde correctly insists that men must know what they are looking for before they begin to look, what the artist and the religious person find is that into which they move or that with which they finish. It is all a part of the process of coalescence. Wilde's attitude is that of the craftsman or the magician. He neither expects nor wants art and religion to distance him from his old self so that he can move into a new self. He uses what he calls art and religion not as vehicles to take him into the unknown but as vehicles to take him to the self to which he already has surrendered. "Only one thing remains infinitely fascinating to me, the mystery of moods. To be master of these moods is exquisite, to be mastered by them more exquisite still. Sometimes I think that the artistic life is a long and lovely suicide, and am not sorry that it is so."[235] Yet Wilde, in his willingness "to go to the stake for a sensation," never allows himself to let go of himself. For him, art and religion are those acts or activities which he accepts as such. It is his temperament or mood which decides to accept them and which justifies the decision. Perhaps in the process the artist and the religious person

do realize an ideal or a need, but these ideals or needs have always been there in the temperament, "within myself." That is enough.[236]

But it is not enough. In dismissing the artistic and religious obligation to move into a 'more' beyond the structures men already know, beyond the 'now' of who I am at this moment in this place and with this understanding, Wilde cannot conceive of artists and religious people as measuring themselves by anything outside of their own private satisfactions. To the question once asked of Paul Klee, "How do you escape the dangers of untrammeled fantasy?"—The religious parallel would be, "How do you escape the dangers of reciting nonsense?"—Wilde could only say, the question is wrongly put, false, irrelevant, a red herring. In his words previously quoted, "The function of the artist is to invent . . . No artist recognizes any standard of beauty but that which is suggested by his own temperament." It is the same with religion. "Everything to be true must become a religion . . . But it must be nothing external to me. Its symbols must be of my own creating. Only that is spiritual which makes its own form." The effect of this is to leave us with Hobbes's problem all over again. Wilde reminds us of the man who says God spoke to him in a dream, but from whose report all we can glean is that he dreamed that God spoke to him. He provides us with an account of what it is like to think and act *as if* there were a God speaking to him.

In contrast to Wilde's hypothetical response which would deny the legitimacy of the question put to Klee, Klee himself immediately assumed that the question was meaningful and by so doing recognized the need for a standard external to the artist and his moods. To the question, "How do you escape the dangers of untrammeled fantasy?" he replied, "A good thing you pin me down on that point. Yes, fantasy is my, and your greatest danger. That is the danger for all of us—the fatal byway for all so-called artists, the refuge for all who lack insight into spiritual reality and consciously or unconsciously try to fake such insight."[237] His *is* the artistic and religious response. His willingness to have something measure his work other than his own satisfactions and current understanding is analogous to the religious person's resorting to proofs for the existence of God. Each is hereby acknowledging a distinction between what he does and untrammeled artistic fantasy or mere religious noise. Each insists that what he does really pushes into new ground, really does open men's eyes, really does bring the world along with it—and here is the evidence.[238]

Unfortunately, that evidence must be found wanting. For all of his sensitivity to the need for men to measure the art object by some-

thing apart from the author's own justification, all that Klee can say is,

> Just how I continue to avoid the dangers of fantasy when I am
> seeking vision, insight, creative pictorial experience, I cannot say. It
> is a gift. But I do know that whenever I have succumbed to fantasy
> for the fun of it, or because it's so easy, I have felt rotten about it.[239]

His answer is no better than that of the Christian who insists his
dogmatic proclamations are subject to the *testimonium Spiritus Sancti*.
What contributes toward making these answers unsatisfactory is their
failure to provide a *measurable* standard external to the artist or to the
religious person. Artistic and religious acts must be consistent with *my*
gift, with the Holy Spirit as I recognize it. Each has failed to evade the
catch in Wilde's implied suggestion that the genesis of an artistic or
religious act determines its verification. The basis of their appeal is
comparable to that of appealing to the authority of Jesus Christ to
support the truth of what Christians say about God, or to appealing to
the Christian apostles as the authority for accepting Jesus as the Christ.
These appeals may well provide theoretical room for the receiving of a
gift or for the inspiration of the Holy Spirit, but how do we know that
such authorities actually do represent that outside standard and not
their own prior self-interest? Those judges judging Joan of Arc were
not entirely in error in insisting upon some evidence that Joan's "voices"
were truly from God. What are the grounds for accepting her voices, for
accepting the witness of Jesus or the apostles, for accepting Klee's gift?

This sort of challenge can go on endlessly unless we introduce the
factor of performance. What makes art and religion distinct from
fantasy and nonsense is that in Austin's sense, they perform, they make
a difference. But obviously I have not yet broken the circle. I must go a
step further and ask, How do people in the society in which art and
religion perform, come to know what acts really do perform? The rest
of this chapter will argue for a step-by-step answer.

The most obvious first step is that interested people in a society
must give those who claim to be involved in art or religion a chance to
do what they are doing. In other words, they must pay attention. If it is
correct to say that artistic and religious activities are activities which
'perform;' or, as described in chapter 4, which coalesce with their
fulfillment, meaning thereby that it is through artistic and religious
activity that the new comes about, and that it is only through a particu-
lar artistic or religious activity that a particular creation is brought into
being, then it seems to be clear that if men are to find a relevant
criterion for evaluating artistic and religious activity it must be a crite-

rion which is first in touch with, or sensitive to that activity itself. Art and religion can have no meaning for those who adopt a neutral stance. Tillich, for example, writes that

> man cannot speak of the gods in detachment. The moment he tries to do so, he has lost the god and has established just one more object within the world of objects. Man can speak of the gods only on the basis of his relation to them. This relation oscillates between the concreteness of give-and-take attitude, in which the divine beings easily become objects and tools for human purposes, and the absoluteness of a total surrender on the side of man.[240]

Art is less vocal in its insistence upon this prior commitment because it receives much of it unconsciously, as a matter of habit—a point Joyce Cary conveys through Gully Jimson's declaration:

> A picture isn't like an illustration in a magazine. You can't get to know it by looking at it. First you've got to get used to it—that takes about five years. Then you've got to know it, that takes ten years, then you learn how to enjoy it and that takes you the rest of your life. Unless you find out after ten years that it's really no good and you've been wasting your time over it.[241]

In his explication of what is involved in the perception of an artistic illusion, Gombrich provides us with a rather mundane list of what habits are developed in order to learn how to "get used to," "to know," and "to enjoy" a work of art. He notes, for example, that men could make little sense out of Constable's *Wivenhoe Park* without automatically assuming, along with the artist,

> that grass is as a rule sufficiently uniform in color for us to recognize the modifications due to light and shade, that Lilliputians rarely populate the English landscape and that therefore the small mannikins are far away, and that even fences are generally built fairly even in height so that the tapering off must indicate increasing distance. All these interpretations are found to dovetail and support one another so that a coherent picture emerges.[242]

First, then, if men wish to evaluate a work of art or a particular religious act, they must be willing to go along with it. As I previously noted with Kierkegaard, "only he who descends into the nether-world rescues the beloved, only he who draws the knife obtains Isaac."[243] It is something like the need to go into the water in order to learn to swim. In similar vein is Wallace Stevens's astute reaction to a critic's comment that "Mr. Stevens' work does not really lead anywhere." Stevens simply notes, "This is not quite the same thing as get anywhere."[244] He is

correct—both about the distinction between 'lead' and 'get,' and about what he implies for the nature of art. To think of art and religion as "leading" is to think of that something or somewhere to which they lead. To think of art and religion as "getting" is to think of art and religion as vehicles moving to that something or somewhere. Art and religion get somewhere but they do not lead to somewhere. Where they get is not in sight or even in the understanding until they get there. Therefore, if we wish to go where art and religion go so that we can evaluate them, we must "get with it," stay in touch with them or ride along with them. We cannot go to the place where they take us in any other way. James Johnson Sweeney provides us with an excellent and dramatic analogy:

> I have often thought of living art as a bus rolling down a long boulevard. We run to catch it. It does not stop . . . If we do not board it, it gradually draws out of our sight. We are left with only the after-images of what excited us while we were alongside it . . . But if we board it . . . we can enjoy the new landscapes as they open up on each side . . . Perhaps the figure would be better if one imagined the would-be passenger, hanging precariously outside the rail on the rear of the bus, forced always to make an effort to maintain the position of vantage he has won for himself. For true and courageous art collecting demands this constant effort to keep the view forward and the eyes clear.[245]

What I suggest, then, in the face of artistic and religious coalescence and in the face of the insistence that men measure these acts by something other than those prior intentions which motivated their authors, is that those who are to judge must first bring themselves to board the vehicle which promises to take them into new landscapes. In other terms, they must bring themselves to art and religion and not insist upon bringing art and religion to their preconceived structures of understanding and evaluation. Quite apropos is that story mentioned in chapter 3 about a Buddhist monk and his student who were crossing over a bridge. When the student questioned the monk as to the depth of river of Zen, the monk immediately tried to throw him into the rapids.[246] Only by floundering in the depths of art and religion will man be in a position to measure what they do.

It is interesting to contrast a failure to plumb the depths of religion with a success. Both are reported in the same chuan (12) of the same Ch'an Buddhist text, *The Transmission of the Lamp*, and both involve the same religious master, Chên Tsun-su. The failure has to do with a monk who has come to visit Chên Tsun-su. Upon his arrival, the master asks, "Where do you come from?" The monk answers, "Liu-

yang." Chên Tsun-su asks, "What did the Ch'an master in Liu-yang say about the meaning of Ch'an?" The monk answers, "You can go any-where, but you cannot find the road." Chên Tsun-su then asks, "Is that what the old master there really said?" The monk answers, "Yes, it is." Now it is here in this reply—"Yes, it is," that the traveling monk reveals how his structures and limitations of previous understandings still dominate. He has not let go of these in order to enter into the religious exchange with the old master, and thus the conversation is over. Appropriately, the master picks up his staff and gives the monk a blow, saying, "This fellow remembers only words."[247]

Now consider the successful example, one in which both dispu-tants do reveal a willingness to let go of their previous understandings, and simultaneously a moving into a new understanding. This time Chên Tsun-su meets an abbot and asks of him, "When one under-stands, a drop of water on the tip of a hair contains the great sea, and the great earth is contained in a speck of dust. What do you have to say about this? The abbot wisely answers, "Whom are you asking? Chên Tsun-su says, "I am asking you." The abbot's backsliding reply is "Why don't you listen to me?" Thereupon Chên Tsun-su quickly responds, "Is it you or I who does not listen to the other's words?"[248]

This first plank contributed toward the construction of a platform by which and from which we can verify artistic and religious activities is not new to either area of thought. It is the significance behind the formula *credo ut intelligam*, I believe in order to understand. It is especially evident in Vernon Lee's "empathy," a translation of *Einfühlung*, which is derived from the verb to feel oneself *into* something, and which, Lee insists, requires an abeyance of thought of the ego.[249] Ducasse adds that "in empathy we enter into another, whereas in sympathy another is received by us into ourselves.[250] The argument runs as follows: (1) art and religion open men's eyes to what they have not seen; (2) since it is logically impossible to arrive at these new visions through the old channels or through using old tools, men must be willing to employ the required new channels and the required new tools. This, by the way, is true for all new discoveries and creations. They all require a letting go of old frameworks and structures and the construction of new ones. But to see this is to see (3) the need for a listening *into* rather than a listening to on the part of these men who want to acquire or to evaluate these understandings which art and religion suggest.[251]

But we must now consider the obvious difficulty—obvious, that is if we agree that though men cannot evaluate art and religion as true

until they are receptive to artistic and religious claims, the converse does not automatically follow, namely, that being receptive to these claims is sufficient to assert that these claims are true. My assertion is that men cannot begin to verify artistic and religious claims until they can see and understand what art and religion claim to have done, and men cannot see and understand what art and religion claim to have done until they somehow let themselves enter into or intellectually move into these activities. The difficulty is, when does this cultivation of something akin to empathy, this willingness or sensitivity which results in what men variously call the required "mental set," or "provisional acceptance," or "necessary concession" become what we might call a total acceptance—in essence a surrender and therefore something rationally dishonest? Tillich alludes to this problem in the passage previously quoted. Once men do commit themselves, even provisionally, to accept an understanding or a viewpoint, their tendency is to begin to anticipate its findings and thereby relieve it of the obligation to prove these findings. This happens on the simplest of levels. For instance, experimenters have shown that if the shape of a leaf and that of a donkey are cut from identical material and observers are required to match their exact shade from a color wheel, we will find that these observers will tend to select a greener shade for the leaf and a grayer one for the donkey. Now the question is, How much legitimate anticipation can the artist expect from his observers? When does the required provisional anticipation begin to produce its own redundancy or feedback and the art or religion in question become the author's and/or the observer's untrammeled fantasy, an esoteric expression of private dreams or wishes? In short, how far can art and religion build upon this foundation of provisional acceptance of their activities before they begin to operate in a world of private experience, before they lose touch with that bit of 'objective reality' which allows men to hope for artistic and religious verification?

At this state I will designate a second plank of our verification procedure for the activities of art and religion. In the process of verifying artistic and religious activities, it is necessary that men check what they have come to see through this or that artistic or religious activity against the culture or tradition in which they function. As William James said, "The greatest enemy of anyone of our truths may well be the rest of our truths."[252] Verification must be in terms of an adequacy to the culture or tradition at hand. This is the shareable ground which goes beyond the merely subjective or private experience.

Christian spokesmen occasionally insist that the Bible and the creeds are addressed or directed exclusively to the church, not to the world. According to my first observation, this assertion is not entirely inaccurate. In a certain sense, we can agree that religion is for the religious. Understanding or evaluating religious categories is like understanding or evaluating happiness; the experience or the sense of happiness must first be present, or there is nothing to understand or evaluate. Hence, if a prospective critic finds God-talk and worship meaningless, the argument of those who insist that such activity is only for the church or for the religious, is that the critic should immerse himself as completely as possible in the activity and in its context. In this way, the critic will be giving God's grace a chance to work. The argument is simply that one must first experience religion in order to be in a position to evaluate it.

Going one step further, let us suppose that the critic *has* given God's grace a chance to work, that he *has* done everything the first step toward verifying art and religion requires, and that he still finds religion wanting. The second step now insists that our Christian spokesman cannot suggest endlessly that the critic's provisional acceptance has not been sincere or that he has not tried it long enough—in effect, suggest that the critic has not really given God's grace its chance to work.[253] Sooner or later the religious claim must stand and function. This is not to say that art and religion do not produce private or subjective experiences. Rather, if certain subjective or private experiences are to function as art and religion, they must not be *merely* private or subjective. If certain subjective or private experiences are to function as art and religion they must function in a culture or tradition.

On the other hand we should not assume too quickly that certain experiences usually associated with art and religion have forfeited their claim to a cultural setting and that they are therefore merely private or subjective. For instance, men may agree that art and religion answer certain needs, say, man's psychic need for intellectual and emotional confidence in life; but it is not necessarily the case that they would also agree to the implication that these needs exist first in an objective reality and that mankind then subjectively or privately makes its artistic and religious affirmations in order to satisfy those needs. The larger reality of the whole objective tradition or culture may well have within itself both the needs and that which satisfies the needs. Augustine seems to think so. He writes, "Thou hast made us for Thyself, and our hearts are restless until they find their rest in Thee."

As nature has at once things or objects, together with eyes which need objects to perceive and to constitute a visible world; or food together with a digestive system which needs it in order to function; so perhaps we have art and religion, together with men who need art and religion in order to be fully human, in order to move on into the new. According to this argument, man is artistic and religious because he is the kind of animal he is; and he is the kind of animal he is, because the world in which he finds himself is the way it is.

The difficulties that arise regarding this second step relate to artistic and religious coalescence. Although a methodology for artistic and religious verification is realizable only in terms of adequacy to a culture or a tradition, that culture or tradition remains open-ended. Austin tells us that the context explains the words. If this assertion is to be at all helpful even "to some extent," he must be referring to the former context, before the words were uttered. But his cannot be so regarding art and religion, because the words contribute something not previously there (otherwise, there would be no need for them). On the other hand, if he is referring to the new context including the words, this assertion is not viable, because in art and religion the words *are* the context. That is, there is not first a context into which the words fit, and then the words, but only this context made of words, waiting for the next word. To suggest otherwise would be to commit the fallacy of misplaced concreteness, something our hypothetical spokesman who endlessly challenged the critic who found God-talk meaningless was prone to do. It is equivalent to separating lightning from a flash, weather from varying temperatures, religion from expressions of religion. Aristophanes, in *The Clouds*, provides us with an example. Old Strepsiades asks Socrates, "Who causes the rain to fall? . . . who is it makes the thunder which I so much dread?" To which Socrates replies "These, when they roll one over the other." Strepsiades then questions, "But is it not Zeus who forces them to move?" Socrates answers, "Not at all; it's the aerial Whirlwind." "The Whirlwind!" responds Strepsiades. "Ah! I did not know that. So Zeus it seems, has no existence, and it's the Whirlwind that reigns in his stead."[254]

The difficulty is this. If it is true, as I constantly have asserted, that art and religion serve as creative impetuses to new ways of seeing and understanding the world, a culture, or a tradition which had previously been understood in a particular way will allow men to evaluate artistic and religious activities that lead them to see and understand in a new way only when that culture or tradition has incorporated this new way of seeing and understanding and has regrouped accordingly. But by

this regrouping it no longer is the same culture or tradition as it was before men came to see and understand in this new way. The root of the difficulty lies with this dual responsibility assigned to culture or tradition: it must provide a base from which the new distances itself, and into which the new coalesces, while at the same time it must offer the coherent pattern against which men evaluate the new. There cannot be a coherent pattern against which men evaluate the new until the new functions within the pattern. But when this happens as art and religion, the new becomes part of the culture or tradition which men then transcend by further new acts of art and religion which in turn must then be evaluated . . .

The tension and the process go on endlessly, and we cannot erase them by delineating two cultures or traditions—for instance, the one held by the masses, the base from which men must distance themselves, and the one to which those who lead or direct the masses adhere, the one to which men look to evaluate their artistic and religious activities. This will not work because it is only by first being part of or being a-part that men can recognize that which is out-standing or that which stands out from them. If men within a culture or a tradition are to evaluate artistic or religious activity, this culture or tradition must somehow be a part of, not totally apart from that which art and religion claim to leave behind. Otherwise, there are simply two isolated cultures or traditions, each standing apart from the other but neither standing out from the other.

Another thing we cannot say is that there is no culture or tradition against which men can measure the creative activities of art and religion. A culture or tradition does not cease to exist simply because it is in process any more than (Zeno notwithstanding) physical motion ceases to exist because an object has to be at some place at every moment in time.

What remains for us to do is to take seriously this idea that the culture or tradition to which we appeal is open-ended, and to see what that implies. It immediately suggests that at any particular moment the coherency of the ongoing culture or tradition is ambiguous. In fact Friedrich Waismann even affirms as much for the empirical concepts within that culture or tradition.

> Try as we may no concept is limited in such a way that there is no room for any doubt . . . there are always other directions in which the concept has not been defined . . . we could easily imagine conditions which would necessitate new limitations. In short, it is not possible to define a concept . . . with absolute precision, i.e., in such a way that every nook and cranny is blocked against entry of doubt.[255]

But it is equally fair to point out that often things do not stop with ambiguity. Though doubt sneaks into every nook and cranny, certain men are attuned to whatever happens. This means that though there is ambiguity they are aware that each concept closes off some possibilities and creates new ones, while allowing still others to remain. They try to make sense of the ambiguity. However, even in these instances, the unsettling fact remains; the possibilities which remain are always many, agreement with observed facts never singles out only one individual theory, men in society never conclusively verify their statements about material objects because of the open texture of the terms concerned. In effect artistic and religious activities are unverifiable in an absolute sense.

If verification is possible, then it will be only in terms of a particular moment, in terms of a coherence of or an adequacy to a particular limited vision or problem which stands at this moment in this process. If this situation at this moment is everything, there is no exterior or prior ready-made criterion or paradigm to which we can appeal, beyond adequacy to this particular cultural context.

This implication holds no briars for certain contemporary philosophers. In an influential article, Morris Weitz argues that the value of aesthetic theories and the criteria of evaluation which they advance, resides in the theories' "attempt to state and justify certain criteria which are either neglected or distorted by previous theories." He therefore concludes, "To understand the role of aesthetic theory is not to conceive it as definition, logically doomed to failure, but to read it as summaries of seriously made recommendations to attend in certain ways to certain features of art."[256] Paul Ziff answers his question, "What then is an aesthetician doing when he offers . . . one and only one definition of a work of art?" in somewhat the same fashion. He writes,

> It should be clear that he is not describing the actual use of the phrase . . . Instead, an aesthetician is describing one, perhaps new, use of the phrase 'work of art,' which he either implicitly or explicitly claims to be the most reasonable use of the phrase in the light of the characteristic social consequences and implications of something's being considered a work of art, and on the basis of what the functions, purposes, and aims of art are or ought to be in our society. What these purposes and aims are or ought to be is a matter of here and now. As the character of society changes, as new methods of working are developed, these purposes and aims will also change.[257]

He then concludes: "An attempt to provide a definition and a justification of a definition of a work of art is . . . as R. G. Collingwood has

stated . . . an attempt to provide 'the solution of certain problems aris-
ing out of the situation in which artists find themselves here and
now.'"258

Another suggestion, which follows from taking seriously the diffi-
culty that what we measure art and religion against is an open-ended
process which art and religion in part bring about, is one which philos-
ophers scrutinizing art and religion are less quick to recognize. If we
wish to verify or falsify artistic and religious claims, we cannot begin to
do so by reproducing them the way we do experiments in a scientific
laboratory. This is because they are like acts of thinking in that they
themselves do and mean. If successful they bring about something new
and the activity and its fruit are one. Recognizing this, Stravinsky once
commented,

> I care less about my 'work' than about composing; This is partly
> because one never composes exactly the piece one sets out to
> compose, just as I am not now saying exactly what I had in mind to
> say but what the extenuating words that come to mind as I go along
> lead me to say.259

Though it is true that for us who come after the activity, the 'works' are
the only thing that matters, composing is the important thing because
composing is the composition, just as dancing is the dance. The mo-
ment the composer is asked to return to the composition a second time,
with the intention of repeating the first time, the second time no longer
does what the original did, it no longer coalesces, it no longer performs
or brings about the new, but now only points to a meaning which the
original composition already has achieved. As such, the repeated act
becomes other than art or religion, it becomes craft or magic.

Clearly, those critical procedures which depend upon an act's
being reproducible at will in order to verify or falsify its claims, are here
irrelevant. Whereas the scientist can make correlations which future
experiences bear out and can therefore speculate that there must be a
correlation between what men are doing and the nature or reality
which is shaping their experiences, the artist and the religious person
make singular existential claims, and as Hempel for one has pointed
out, we cannot falsify this type of affirmation by a finite set of observa-
tion reports.260 Because their efforts coalesce with their fulfillment,
there is no claim about the nature of reality apart from being in the
process of going to it. That reality remains forever on an other shore—
a mystery, unknown, simply not yet in existence, in itself, irrelevant to
art and religion. The proper artistic and religious question is not what
reality is like or whether there really is another shore, but whether to

accept or use a particular scheme or object in this reality and thereby create from it. In this sense, the artist and the religious person are akin to those mathematicians who refuse to ask whether such things as number really exist, or those physicists who refuse to ask whether the space-time points are real. To answer the question which they do ask means to do something—to give this or that shape or direction to a life or to a field of inquiry.

I am now prepared to contribute the third plank to the procedure for verifying artistic and religious activities. If it is true, (1) that in art and religion the unfocused eye sees nothing, that we see only what we are prepared to see, and that this requisite preparation involves a mood of provisional receptivity or anticipatory openness, and (2) that this prior provisional acceptance means that art and religion only function in particular contexts, cultures, or traditions where particular individuals are open to what comes to them, then (3) we must be willing to take the hint offered by the two preceding paragraphs and settle for a kind of experiential confirmation of artistic and religious activity as against the more familiar experimental method of confirmation. Only an experiential method of verification is sensitive to this ongoing process of cumulating and funding through which a culture or a tradition goes. An example is the task of appreciating those elaborate, three-dimensional woodblocks of Albrecht Dürer. They represent the cumulative funding of fifteenth-century woodcutting skills and a commensurate change in artistic sensitivities as those skills developed. Together, those skills and sensitivities, mutually influencing each other as they go along, constitute the standard by which men today aesthetically evaluate the woodblocks and which all future appreciations must be receptive. This, of course, is no easy task, but if it is applied, people can put themselves into that position whereby they can be receptive to and actually aesthetically anticipate the complicated and varied woodcut compositions of, say, modern expressionism.

My third point, then, is that artistic and religious verification must come as the result of an experiential sensitivity to, and participation in, this cumulating, spiraling process which gathers within itself selective relevant material from experience. Because of the particular and selective nature of the cumulating process, and because of the potentially infinite number of alternatives to this particular process, only this kind of verificatory and participatory procedure will recognize the artistic and religious claim, much less verify or falsify it. It will grasp the drift of the actual process or development, the sense of the massed or accumulated impact.

Marshall McLuhan expects this kind of attention from his readers. The argument for his case succeds or fails not through linear progression so much as the overall impact of selectively massed evidence. His strategy might be called a mosaic, a circumstantial procedure oriented more towards filling in potholes in a dirt road already laid down, than actually laying the road itself. When this argument is finished, either it is passable or it is not, makes sense or does not. The decision is made instantaneously by the reader on the basis of his willingness to submit to the weight of the selectively massed evidence. Early Buddhism expected its Eightfold Path to be evaluated in similar fashion. The eight categories are not links or steps to be taken one at a time, but an all-at-once listing of the eight areas of behavior which men must control before they may reach spiritual attainment. In this sense the path is like that dirt road, an all-at-onceness which is either functioning or not. The path is not so much a means for becoming free as, once entered, freedom itself. Men are on the path, have caught its drift, only when life is under control. Not before.

John Wisdom's broader social example acknowledged in the Overture is relevant here. He shows us how the "massed impact" accumulates new data and therefore changes by referring to those cases in the courts of law which settle not questions of fact but whether somebody "did or did not exercise reasonable care, whether a ledger is or is not a document, whether a certain body was or was not a public authority."[261] These cases proceed by "a presenting and representing of those features of the case which *severally cooperate* in favor of the conclusion, in favor of saying what the reasoner wishes said, in favor of calling the situation by the name by which he wishes to call it."[262] It is a matter of selectively cumulating independent and inconclusive premises and weighing with provisional receptivity one mass effect against another. As pointed out in the Overture, this does not rule out an appeal to observables. It is simply that the observables become observables only by dint of the cumulating spiraling process which establishes the basis for selective observation. What is assumed is a willingness to look at the spiraling process from a particular vantage point, in a particular direction, and with a contextual consistency of expectation that has spiraled out of the cumulated premises.

At this point, it is especially interesting to notice how new data are accumulated and massed. Remember that conversation which Boswell had with Samuel Johnson, to which I referred in chapter 5 in discussing coalescence. In it Boswell learns that sometimes the judge's decision is that kind of decision which not only takes seriously the massed

impact of the heretofore collected premises, but of necessity goes beyond the massed impact, contributes to it, and makes it so.[263]

First, men must understand their "facts fairly," that is, they must understand them in their own allowable context, which their culture or tradition provides. This is where the facts touch ground, so to speak, where men derive art's and religion's verifiable meaning and their logical—but at the same time contextual—necessity. It is to say that artistic and religious assertions, facts, or activities, are necessary and have meaning only to the extent that they have a clearly defined place in a theory, or in what this book calls a culture or a tradition, that is, only to the extent that they help to explain or make clear or create some limited range of experience within that culture or tradition.

Second, certain authoritative decisions which certain men make about the facts are decisions which *contribute* to their factual status and to their "now determined for the moment impact" on the culture or tradition. Such decisions actually change the drift of the common ground by going beyond its heretofore established impact or meaning. The drift or massed impact is still felt all at once (either the road *is* passable or it is not), but now it seems that the process of "presenting and representing . . . those features of the case which severally cooperate in favor of the conclusion" actually determines the content of the conclusion. It is as if filling in the potholes in an old dirt road actually determined the direction of the road itself. A man once approached the High Priest Hōnen, the Japanese founder of the Jodo (Pure Land) sect of Buddhism,

> Sometimes as I am saying the *nembutsu* I am seized by drowsiness and I neglect my devotions. How can I overcome this obstacle?" Hōnen replied, "Say the *nembutsu* as long as you are awake." This was a most inspiring answer. Again, he said, "If you are certain you will go to heaven, you certainly will; if you are uncertain, it is uncertain." This too was a sage remark. Again, he said, "Even if you have doubts, you will go to heaven provided you say the *nembutsu*." This too was a holy utterance.[264]

As the judge's decision goes beyond the facts and determines their massed impact, and as Dürer's woodblocks and Bach's cantatas go beyond their already existing structures and thereby determine the new structures against which relevant future artistic activities must move, likewise, appropriate religious activities go beyond the facts and determine their massed impact.

All of this complicates things immeasurably. The difficulties are similar to those found in the psychiatrist's laboratory procedure as

contrasted to the physician's. Both begin with an analysis. Like those who wish to verify artistic and religious insight and distinguish it from a faking of such an insight, both the psychiatrist and the physician wish to fit their analysis into some previously recognizable pattern of understanding. At each moment it is especially important for them to be able to supply a hypothesis which is coherent with the rest of our truths, one which also contains a suggestion of what action they should take and a meaningful prediction of what will happen. From this point on, however, their methodologies differ. Whereas each must wait for the future to determine whether his hypothesis is valid, only the physician's answer comes, at least in theory, from a fixed understanding or meaning related to a fixed situation. The psychiatrist, like those who wish to verify artistic and religious claims, finds that his answer comes from an ever-expanding situation. Whereas the physician can verify his analysis if his hypothesis works, that is, if the patient takes the prescription and it solves the patient's particular problem, the psychiatrist finds that even though he tries to verify his analysis in the same general manner, his analysis, if acted upon, creates a new situation which demands a new analysis which he now must subject to that new situation. This in turn contributes still newer data or a new understanding which again creates still newer analyses and situations. In other words, he too is doomed to function in that incomplete, ever-cumulating, spiraling process very much akin to the process whereby Edward Munch's woodblocks now contribute to the cumulative funding of woodcutting skills or Hindemith's piano sonatas contribute to the cumulating development of the form of the sonata.

I am prepared to contribute the fourth and final plank to that methodology whereby we can verify art and religion. Artistic and religious verification must come by making a decision which fruitfully, yet economically, contributes to that culture or tradition in which the challenged activities function. Thinking in terms of economy, we can say that we verify an act as artistic or religious if its denial raises more problems than does its acceptance. If affirming a certain activity to be artistic or religious helps men to function within a culture or a tradition, so much so that it is impossible to give as simple or as economical an account of that data without it, it is verified as artistic or religious.

But economical or simple projections are only measurably economical in terms of contexts and procedures which men already have established. Such projections cannot measure activities which, because they contribute uniquely to today's culture, may claim economic justification in terms of tomorrow's culture or tradition. In fact we might well evaluate such activities as anything but economical.

It is for this reason that I add the criterion of fruitfulness to the procedure for verifying art and religion. Artistic and religious verification will occur through fruitful economy; certain acts will be understood to function in a culture or tradition artistically or religiously because such a hypothesis solves more problems than denying them artistic or religious status would solve and because these acts provide the categories of thought by which later generations come to understand their problems and experiences. The two requirements are related. An assertion that particular activities are artistic or religious is true if and only if their implications actually extend beyond the problems they originally were meant to solve economically, if the shapes or directions which they take and the objects they so affirm, illuminate or sustain the new facts which now are to come into view. Artistic or religious claims are true-to man's experiences if and only if the total drift of these claims brings what we now consider to be today's economy into the context of tomorrow's coherence. Artistic and religious claims are true insofar as they suggest ends, purposes, or insights which men cannot otherwise grasp, or at least have not grasped, and which are themselves fruitful in suggesting systematic correlations in agreement with new observations. Not only must art and religion be true-to these newer observations, but their categories must be heuristically valuable in bringing them about. Art and religion must help provide the new parameters with which mankind expands into unknown territory.[265]

As a first example of arguing on the basis of fruitfulness, consider the statement 'Lorenzo Ghiberti's *Gates of Paradise* is art.' It is true because it fruitfully explains the prevailing presence of agile, slender, and elegant bodies throughout the second half of the fifteenth century as manifested in the paintings of Botticelli, Filippino, the Polloaiuolos, in the reliefs of Agostino di Duccio and Desiderio and in the sculptures of Verrochio. It also explains with the help of Alberti's *Della Pittura*, the shaping of the "pathos style" of the latter part of Quattrocento.[266]

Northrop Frye, in his essay "Lord Byron," provides a second example of fruitfulness. He suggests that what makes Byron's work art is that it has released, produced or created, a new sensitivity, a new cultural force, which lives today in such writers as Melville, Conrad, Hemingway, Housman, Thomas Wolfe, Lawrence, and Auden, writers whom he notes, "have little in common except that they all Byronize." Frye's point is that they all have responded to the Byronic hero, to the outcast from society who in his loneliness can make no judgment or commitment, and who thereby assumes no responsibility for his life or for his actions. Obviously, Byron's works do have a fruitful impact, so

fruitful that their insight has contributed to the most modern of ailments, ontological boredom, that sense of inner emptiness which we recognize in the *ennui* of Baudelaire, Sartre's *nausée* or simply existential angst.[267]

The key to this, my fourth contribution toward a procedure for determining whether activities or works are in fact art or religion, is that art and religion live. As Byron lives, so Renoir lives:

> Our world which before him [Renoir] was filled with people with elongated pale faces has since his time seen an influx of little round, plump beings with beautiful red cheeks. And the similarity is carried further by the choice of colors for their clothing. He is responsible for that too.[268]

As I anticipated in the Overture, each presents a *tabula rasa* upon which the new world is to write. Again, since Claude Lorrain, our conscious world is populated by Roman ruins and Italian landscapes; since Jacob van Ruisdael, by northern landscapes; since Jan van Goyen, by Dutch windmills. Claude is a particularly good example, for his paintings taught the English and in turn influenced Americans to see the formal gardens in the style of Versailles as "artificial," and thus encouraged us all to construct in their place the "more natural" English park.

An object or an activity is art or religion insofar as it is in part responsible for the massed impact of that common ground which leads into the future. To recognize that something is art or religion is to recognize a particular future which, in turn, illuminates a particular present and a particular past. The claim here is that art and religion turn men around and put them into an order, so to speak. They mass the impact of man's experiences into time and into history. Adopting this or that object or activity as art or religion means living into a particular future and in a particular present and past. Italo Svevo understands the process well:

> The past is always new; as life proceeds it changes, because parts of it that may have once seemed to have sunk into oblivion rise to the surface and others vanish without a trace because they have come to have such slight importance. The present conducts the past in the way a conductor conducts an orchestra. It wants these particular sounds, or those—and no others. That explains why the past may at times seem very long and at times very short. It thunders forth or murmurs *pianissimo*. The only part of it that is highlighted is the part that has been summoned up to illumine, and to distract us from, the present; and it is then that one recalls pleasant memories and regrets more vividly than recent happenings.[269]

As long as this particular construct of past, present, and future illuminates, so long as it actually "thunders forth" into lives men now live, so long is this construct which started the whole thing art or religion. It has shown men their tomorrow, building that tomorrow the way composers build the sonata form, or judges build the binding custom of their legal community. This is to say, art and religion bestow on the past, the present, and the future its reality of life.

The contrast between the book illustrations of Ernest H. Shephard and John Vassos effectively demonstrates this process. Whereas Shephard's work seems to have always illuminated Pooh and in turn, our understanding of what it is to be a child, Vassos until recently only commemorated a decorative style which preoccupied the art world in the 1920s and early 1930s. His illustrations and Art Deco were historically interesting, but they lacked the status of art because they no longer touched the massed impact of society's common ground, because they no longer found a completion in anything which society experienced. They were no longer true-to anything alive and becoming. They had no potentiality. Because they did not reverberate into a present, they were thus devoid of a future. Their shapes and directions had a place only as memorabilia, in the period decor of railroad stations or restaurants. Society seemed to realize their implications and know their consequences—they had no more "thunder" and consequently they no longer illuminated. But with society's new awareness of Art Deco's shapes and directions its status may shift. Art Deco, like Art Nouveau, can be art. If it does its fruitfulness will be the criterion.

My insistence upon fruitfulness is not unique to verifying art and religion. For example, some hundred years after Saccheri's geometrical exploration into alternatives to Euclid's postulate of parallels, mathematicians, with the help of Lobachevski and Bolyai, declared, quite in harmony with my fourth plank or contribution, that Saccheri's findings were now acceptable to them in the same way Euclid's postulates were to be acceptable to them, namely, because they were fruitful in suggesting a wide range of new and interesting ideas. We also have the example of contemporary scientists' accepting the undulatory theory of light and the four-dimensional continuum not only because each allows them to describe their physical experiences in a simple and practical way, but also because each helps them to find new theories which continue to be in agreement with still newer observations. In other words, both are acceptable because they do what the caloric theory of heat fails to do and Art Deco until recently failed to do. Each theoretical construct suggests further system correlations within ex-

perience beyond those from which scientists originally drew their assertion or model.

My methodology for verifying art and religion is now complete. I have suggested that our acceptance of certain objects and activities as art or religion must be fruitful the way the acceptance of, say, Saccheri's findings or the undulatory theory of light have proven to be fruitful; each must contribute to the order of things, to *physis*, to nature, to that which will be, to that which will endure. But the recurrent difficulty raised by coalescence is still with us. It is not simply that men advance a particular thesis and it does or does not prove to be fruitful. Rather, the thesis itself, i.e., that something is art or religion, effects the situation, coalesces with it. The situation is akin, remember, to the psychiatrist's suggestion, which, if acted upon, constantly created a new situation which in turn demanded new suggestions which, if acted upon, created a new situation which in turn demanded new suggestions, *ad infinitum*.

For this reason two inherent limitations must be recognized. The first is an insidious relativism.[270] What is artistically and religiously true is only true for this particular moment in this particular context with its past, present, and future. This was particularly noticeable in the discussion on Art Deco. The second limitation is a tentativeness which extends beyond the chronological one, shared with the physician, of simply waiting for decisive evidence. The open nature of the ever-expanding situation insures that no matter which way the decision goes, that decision will always be compatible with some facts, at least potentially. Since there always will be more evidence or data coming in, and thus always another possible future to herald and always another possible yesterday to analyze or tomorrow to determine, there never will be decisive evidence to allow a permanent, final decision—"Yes, this is art or religion; no, this is not fantasy or nonsense"—not even for a particular and limited period. The physician can escape this inherent tentativeness because he functions in a closed situation and therefore can anticipate and declare what in fact will give meaning to the data under consideration. Of course, he must face the possibility that his evidence, which is internal to the closed or fixed situation, will not be persuasive to a qualified or reasonable man, but the physician can eliminate this tentativeness, at least theoretically, by settling upon what he means by "qualified" and "reasonable." Not so for the psychiatrist, or for the patient who accepts the analysis to the extent that he is willing to act upon it, or for those people who are interested in recognizing art or religion. For them, "qualified" and "reasonable" are as much caught up in the ever-changing context as is everything else. If the context changes,

certainly that which constitutes "qualified" and "reasonable" changes.

I must conclude that since no decisive evidence is available, even the contextual decision as to whether this or that object or activity is art or craft, religion or magic, is at best akin to a probability statement, or perhaps akin to those learned statements which defended an earth-centered or a sun-centered theory of planetary motion during those first one hundred and fifty years or so after the publication of *De Revolutionibus Orbium.* No matter which theory they defended, no specific emergent fact could decisively contradict it.

But to close with the largely negative or limiting effect of these two observations should not by any means suggest that we have folded up our critical tents and have gone home in defeat. Even though we can speak of only tentatively and contextually knowing when an object or an activity is art or religion, we do speak nevertheless; first, by reminding ourselves that the ongoing context or culture in which art and religion function provides the shareable ground or standard against which we can say that this or that object or activity is art or fantasy, religion or nonsense; second, by knowing that we come into contact with this culture by being sensitive to its impact as it is being cumulatively massed at this moment; third, by knowing that when an object or an activity is an art or religion, it is economically fruitful in providing new parameters by which men expand into unknown territory.

Even though our specific evaluations are tentative and contextual, we expect art and religion, by their thunder and promise, to turn men around and open their eyes and to provide them with a new future. One day, while the Emperor was admiring Wu Tao-tzu's glorious painting of a landscape with mountains, forests, clouds, Wu Tao-tzu pointed to a doorway on the side of one of his mountains, and invited the Emperor to enter and behold the marvels within. Wu Tao-tzu himself then climbed up the painting and entered, beckoning to the Emperor to follow. But the Emperor paused, afraid. The door then closed and Wu Tao-tzu was never seen again. It seems only Wu Tao-tzu was willing to discover whether his work was art.

Reprise [271]

IN THE PRECEDING chapters I have suggested that what art does, religion does: both provide directions on how to see and on what to do. More specifically the thesis of *Religion As Art* has been that art and religion present collectively created frames of perception and meaning by which men interpret their experiences and order their lives. With an innocence somewhat akin to that which men traditionally claim to find in children, but also admittedly with a sense of contingency or anguish, the artist and the religious person create and welcome the new and the strange. Chapter 1 observed that art and religion call men to make clear, to understand, to see what they do not see; most certainly not to relive. While chapter 2 found that what art and religion teach men is related to their previous structures of understanding which they already know, chapter 3 noted that it is equally evident that an object or an activity which functions in society as art or religion is an object or an activity which is also distanced from those previous structures of understanding. In fact chapter 4 concluded that distancing is the characteristic which best distinguishes artistic and religious objects and activities. The craftsman's and the magician's objects and activities do the very opposite. They are instruments by which men reinforce their preestablished habits, values, needs or structures.

Chapter 5 added that artistic and religious objects and activities are necessary to the process by which, with which, and through which men come to understand what art and religion teach them; and chapter 6 discovered that what art and religion make men see or understand is a new time and a new space.

However, chapter 7 was altogether another matter. It pointed to how men come to know and accept a particular activity as art and

159

religion, and in this sense it introduced new material, but essentially it was a coda which embellished the previous chapters; as such it was less an epilogue and more a climax. To know what functions as art or religion is to stand in critical innocence and fascination before the object or activity under scrutiny, to distance it and oneself from previous associations and to allow it to coalesce with new associations, in effect to allow it to create its new time and its new space.

1. But there is something more in these chapters. The Overture strongly suggested the study itself expected a similar innocence on the part of the reader. He too was expected to stand in critical innocence and fascination, this time before certain material garnered from what ordinary language brackets together as 'religion' and before certain material garnered from what ordinary language brackets as 'art;' he too was expected to distance himself from dominant tendencies which consider this material as data, as a description or a manifestation of something else, and to allow it instead to express its own space.

The reasons for this expectation have to do with the nature of art and religion. Remember, neither exists in a place or at a time. For example, what the Indians of Guayana do at certain times and in certain places may be religious but it is not equal to what men mean by 'religion' nor is it equal to what men mean by acting religiously. This is to say it is not like this:

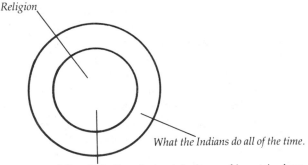

Religion

What the Indians do all of the time.

What the Indians do at certain times and in certain places.

Equally significant, what the Indians of Guayana do at certain times and in certain places is not even a part of the sum of all appropriate activities appropriately described as religion or as acting religiously because art and religion are not single finished or continuing events or functioning wholes that transcend individual activities or objects. This is to say it is not like this either:

Religion

What the Indians do at
certain times and in certain places.

What the Indians do all of the time.

This illustration is as fallacious as was the first because there is no closed container 'art' and 'religion' into which certain activities fit. In Platonic terms there are no universal models for art and religion of which the specific arts and religions which we encounter are the copy and against which we can evaluate our analysis.

2. What this means for the preceding study, which attempted to explore a relationship between art and religion, is that by dint of the nature of that material with which it had to deal, it could not expect to begin with empirical descriptions or expect to evaluate its conclusions by sense perception. There simply is no art and religion to describe or to perceive; there are only individual activities and objects which society labels as art and religion.

3. This in turn introduced its own implication, which the study also accepted. What ordinary language brackets together as 'religion' and as 'art' is tentatively, corrigibly, and prescriptively art and religion. But this did not mean the study was willing to assume these prescriptive labels were *merely* prescriptive, that is, imperative sentences—not statements—which assign names to activities or objects for such purposes, for example, as establishing syntactic or semantic rules to simplify linguistic operations. On the contrary, from the beginning this study assumed that society's prescriptive labels of 'art' and 'religion' conveyed information—were statements or cognitively significant sentences—about the nature of these now related activities and objects, and that this information might be uncovered by an analysis of the objects and activities so labeled.

In effect this study did not identify the *meaning* of the terms 'art' and 'religion' with the experienced objects or activities capable of being

described and named, nor did it identify their meaning with the customary usage of the words; rather it identified the meaning of 'art' and 'religion' with an idea which it assumed it was capable of uncovering. Thus what came to the foreground in the preceding chapters were problems of authenticity rather than problems of stipulation or problems of linguistic usage. Certain experienced objects and activities were recognized as being art and as being religious, but the problem always was what they are when they are authentically artistic or religion, not what they are when they are identified as artistic or religious. It was a matter of finding meaning through description.

4. This then is why this study expected a critical innocence from its readers. Assessors weigh, describers set forth. It is recognizing the truth in the formula *credo ut intelligam*, I believe in order to understand. It is recognizing the truth in Scott-James's observation that

> I will content myself with saying that, while I do not suggest that the business of criticizing is just a matter of sympathetic vision, or intuition and no more, I do suggest that for all criticism worth the name this is the first essential.[272]

5. Finally, when authentic versions of art and religion have been assessed alongside failed or worn-out versions, what this study has uncovered is that those objects and activities which society labels as 'art' and 'religion' are objects and activities which fulfill man's need to create frames of perception and meaning by which men interpret their experiences and order their lives. So understood, descriptions of such things as Renaissance patronage, or of the New York collusion of gallery owners and critics, point to the "art scene" only so far as what they describe does what art does. So too, descriptions of such things as ecclesiastical institutions and of holy men are related to the "religious scene" only so far as what they describe does what religion does.

6. This suggests one last parallel. Not only does art and religion do what they do, and the world follows, but this study presents what it does, and descriptions of art and religion follow. As art and religion provide patterns of meaning or frames or perception by which society interprets its experiences and from which it makes conclusions about the nature of its world, so this study has attempted to uncover the "meaning" of art and religion in accordance with which society acknowledges what is its authentic art and its authentic religion. Thus, as art and religion provide men with what is their world, so this study attempted to provide its readers with what is the meaning of art and religion. So far as they are successful both point out what is the case.

7. But we must never forget their difference. Art and religion point out what is the case by declaring it to be so. If this study makes its way, it points out what is the case because it has uncovered what already is the case, so far as art and religion are concerned. With Ludwig Feuerbach, I say,

> Speculation makes religion say only what it has *itself* thought, and expressed far better than religion; it assigns a meaning to religion without any reference to the *actual* meaning of religion; it does not look beyond itself. I, on the contrary, let religion itself speak; I constitute myself only its listener and interpreter, not its prompter. Not to invent, but to discover, "to unveil existence," has been my sole object; to *see* correctly, my sole endeavour.[273]

Notes

Overture

1. In the sense of the operatic overture, which since Wagner not only incorporates material from what is to come but also sets its mood.

2. Nelson Goodman, *Languages of Art* (Indianapolis, 1968) pp. 53-67. Also see Charles Altieri, "Presence and Reference in a Literary Text," *Critical Inquiry*, 5.3 (spring 1979): 489-510, esp. 507-510. I am not talking about what artists and religious people *intend* to do with their art and religion; intention is an entirely different matter.

3. Peter L. Berger, *The Sacred Canopy* (New York, 1969), p. 23.

4. This does not mean meta-, second-order questions are unimportant. For the most part there is no first-order equivalent to them. For example, although my first-order concern to argue that art and religion do such and such has a second-order equivalent, specifically, 'Is the statement which the sentence "Art and religion do such and such" is used to make defensible,' there is no first-order equivalent to the logically prior second-order question, 'Is the sentence "Art and religion do such and such" used to make a statement?'

5. An example of art's openness is its incorporation of Marcel Duchamp's *The Bride stripped bare by her Bachelors, even* (also called *The Large Glass*), "A machine for producing meanings" which goes completely against the dominant conception of art as a sensuous experience. The work is to be "read" with the assistance of an accompanying text-manual called "The Green Box," which assumes equal importance with the work it explains. The relationship of the two elements raises the question of exactly what 'art' designates.

An example which points up religion's openness is Wilfred Cantwell Smith's declaration, "Neither religion in general nor any one of the religions, I will contend, is in itself an intelligible entity, a valid object of inquiry or of concern either for the scholar or for the man of faith" (*The Meaning and End of Religion* [New York, 1962], p. 12). Smith then proceeds to present the 332-page scholarly work which he subtitles "A New Approach to the Religious Traditions of Mankind."

C. J. Bleeker's arguing for the existence of the *entelecheia* of religious phenomena is an attempt to incorporate openness into a theoretical understanding. He writes, "It is certainly true that the significance of religious phenomena can be clarified to a great extent if they are examined, so to say, as arrested pictures. But it should not be forgotten that they are also moving pictures, i.e. that they are subject to a certain dynamic. In order to do justice to this element I introduced the notion of 'the entelecheia of the phenomena,'"

pointing out in the process that what religion is is realized by its manifestations (*The Sacred Bridge* [Leiden, 1963], p. 14; see also pp. 16-24).

6. In effect, art and religion are more than what appears before us; they are that which appears before us encountered as art and religion. At this juncture George Dickie's "institutional analysis of the notion of aesthetic object" is relevant. He argues that 'art' is a status conferred by the conventions governing the presentation of the work. See his suggestive *Art and the Aesthetic* (Ithaca, N.Y., 1974), especially chaps. 1, 7, and 8.

7. Pieter Geyl, *Napoleon For and Against* (New Haven, 1963), p. 15.

8. Mircea Eliade, "Methodological Remarks on the Study of Religious Symbolism," in *The History of Religions*, eds. Mircea Eliade and Joseph M. Kitigawa (Chicago, 1959), p. 15. Historians of religion, like historians of art, and I dare add historians of philosophy, are especially sensitive to this need for general structural schemes. Their subject matter demands interpretation because of those difficulties discussed in section 1 and dealt with further in section 3. Perhaps this is why they tend to function not in departments of history but in divinity schools or in departments of art or philosophy. Like choreographers of ballet, they do not even attempt to begin with the raw data but start with already defined classroom steps out of which they make their dance. The best biographies of artists and religious leaders have traditionally expressed truths first inscribed in artistic and religious manuals of instruction. Although it is true that Winckelmann turns things about and directly examines works of art, is he not also primarily looking for support for his previous judgments?

9. I hope it is clear that I am speaking of a methodology appropriate for my thesis that art and religion do present forms of perception and meaning by which men interpret their experiences. Ramakrishna may be right about religious people; and he certainly can find support for his claim that they do not touch ground, suggesting in effect their religious views are sufficient simply in the proclaiming, that they need not verify their knowledge claims by any standard other than their own. Perhaps that is the meaning of the slogan "Let the church be the church." Philosophers, too, from G. E. Moore's day on, are quite willing to agree with Ramakrishna; early it was their habit to think that artistic and religious knowledge, and moral knowledge too, were derived from undiscussable flights of intuition. Later, by the 1930s, with the ascendancy of logical positivism, philosophers began to question whether in fact these activities did produce knowledge. Thus not only did they agree that what art and religion did was undiscussable, but unintelligible as well. It was only in the 1950s, partly because of Austin's concept of performatives and Hare's prescriptivism, that once again a basis for philosophical discussion about art, religion, and ethics could be established, this time on the basis that these disciplines are candidates for logically autonomous action-guiding pursuits. For my views on this, see chapter 7.

10. Eliade, "Methodological Remarks," [above; note 8] p. 95.

11. (New York, 1967). It is interesting that in spite of a continuing tradition of historical interpretations such as this, and of historical explanations such as Peter Gay's *Art and Act* (New York, 1976) and Pieter Geyl's previously mentioned study on Napoleon, we find sensitive writers such as W. B. Gallie insisting "that narrative is the form which expresses what is basic to and characteristic of historical understanding . . . that history is a species of the genus Story" (*Philosophy and The Historical Understanding* [New York, 1968], p. 66). W. W. Walsh, in his introductory text, *Philosophy of History* (New York, 1960), p. 14, asserts no less; that 'history' "ambiguously covers (a) the totality of past human actions, and (b) the narrative or account we construct of them now." Even Bleeker asserts that "history is a narrative of continuous changes" (*The Sacred Bridge* [above; note 5] p. 18). See also Arthur C. Danto, *Analytical Philosophy of History* (New York, 1965). Maurice Mandelbaum, *The Anatomy of Historical Knowledge* (Baltimore, 1977), esp. pp. 24-45, is the rare exception.

12. Gay, *The Enlightenment* [above; note 11] p. 8.

13. Ibid., p. 419.

14. *Philosophy and The Historical Understanding*, [above; note 11] pp. 157-191.

15. Clifford Geertz, *Islam Observed* (New Haven, 1968), p. 98.

16. Marcel Proust, *Remembrance of Things Past* (New York, 1934), 1:950.

17. William H. Gass, *Fiction and the Figures of Life* (New York, 1970), p. 49.

18. The seemingly obvious contemporary Western example of a dominant religious conservatism is Roman Catholicism, but the situation is not at all clear cut. Certainly Catholicism before the Council of Trent is not Catholicism after Trent, and Roman Catholicism from 1870 to 1963, rather than focusing upon an already understood past, seems to have understood itself, and Christianity, to be a developing, evolving entity responsible only to a magisterium whose office is to approve what is taking place. In seeing itself as such, its relationship to Jesus Christ is not unlike Mahayana Buddhism's relationship to the Buddha. It is not at all certain whether the efforts of Vatican II to call the Roman Catholic church back to its conservative biblical origins will succeed.

19. See, for example, James B. Pritchard, ed., "Ugaritic Myths, Epics and Legends," in *Ancient Near Eastern Texts*, trans. H. L. Ginsberg (Princeton, 1950), pp. 72-99.

20. Friedrich von Schiller, *Naive and Sentimental Poetry* (New York, 1966), *Säkular-Ausgabe* 249, p. 175. Note the "nonetheless." The word reveals his grudging acceptance of both characters. It is obvious that his allegiance is with the sentimental artist, from his declaration that naive "satisfaction in nature is not aesthetic but moral" (*Säkular-Ausgabe* 84, p. 162).

21. Otto von Simson, *The Gothic Cathedral* (Princeton, 1974), p. XV.

22. John Wisdom, *Philosophy and Psychoanalysis* (New York, 1964), p. 157. This is not to say that the conclusion is merely the application of a name. Wisdom adds that "we must remember that with this name a game is lost and won and a game with very heavy stakes" (p. 158).

23. P.F. Strawson, *Introduction to Logical Theory* (London, 1952), pp. 3-4, 174-176, 211-214.

24. This is not to say the sciences cannot equally well speak of "inspiration"or even of "revelation." Of course they can, and do. What it is to say is their "inspirations" are rooted in empirical observation. But see the discussion in chapter 6.

Innocence

25. Arthur Schopenhauer, *The World As Will and Representation*, trans. E. F. J. Payne (Indian Hills, Colo., 1958), 1:428.

26. Ludwig Wittgenstein, *Tractatus Logico-Philosophicus*, trans. D. F. Pears and B. F. McGuinnes (London, 1961), Preface, p. 3 (6.53), p. 151.

27. T. S. Eliot "Burnt Norton," *Collected Poems 1909-1935* (New York, 1958), p. 219.

28. Michel de Montaigne, "On Some Verses of Virgil," *The Complete Works of Montaigne*, trans. Donald M. Frame (Stanford, Calif., 1958), Bk III; Ch. 5, p. 556.

29. Saint Cyril of Jerusalem, "Lenten Lectures (Catecheses)," in *The Works of Saint Cyril of Jerusalem*, trans. Leo P. McCauley, S. J., and Anthony O. Stevenson (Washington, 1969), Catechesis VI, paragraph 2, p. 148. Chapter 3 deals with this concept more extensively.

30. I refer to that aspect of the doctrine which imputes the universal condition of mankind as being no longer in harmony with God.

31. I do not wish to imply that Hinduism and Buddhism think of the world of "all this" (*sarvam idam*) in the same way. They do not. For example, Śankara considers it to be illusion, the Buddhism of the ancient Pali texts considers it to be impermanent. Nevertheless, they do interpret the world, that interpretation reflects among other things a definite value judgment, a judgment that if one wishes to do what religion does, one must turn away from the world.

32. *The Autobiography of Alice B. Toklas* (New York, 1933), p. 14.

33. Roger Fry writes: "We go to art for what it brings to us from outside, what it will add to our life by its definite communication, by giving us feelings which we have never had and never could have but for the artist. We want something added to us, not something that will release what is already there" (*French, Flemish and British Art* [London, 1951], p. 198).

34. Robert Frost, *The Letters of Robert Frost to Louis Untermeyer* (New York, 1963), p. 22.

35. Mao Tse-Tung, *Talks at the Yenan Forum On Literature and Art* (Peking, 1967), p. 49.

36. This challenge and discussion in its defense is antithetical to the "modernist" temper. As shall be evident, whereas the medieval painter and sculptor were willing to "represent" familiar stories or beliefs in order to begin their creativity, and whereas traditional Elizabethan and Kabuki theater willingly "represented" culturally understood mannerisms and costuming, and

appealed to commonly experienced feelings and emotions in order to begin their creativity, so-called "modernist" painting, sculpting, and theater begrudge even these concessions. What the "modernist" artist frowns upon is the implied assertion that he is obligated to "represent" any experience which stands apart from his activity or work itself. He is more aware than ever that if the art object really is to detach and create, the audience must be encouraged to hear the sounds, see the gestures and the colors as they are in themselves, apart from all contextual associations they now might have or they might have had in the past. For example, in the theater, the ideal would not be a Stanislavsky, who insists upon drawing on previous associations, but the *Übermarionette*, that dramatic creation which refuses to represent any ground, and which insists upon being a completely self-contained vehicle to a totally new place. Productions like Schechner's *Mother Courage* and Servan's *Cherry Orchard* which superimpose a new life not previously found in old texts are included in this extension and renovation of meaning.

I am not so confident that the "modernist" temper will carry through the 1980s. But it still very excitingly attracts attention in literary criticism and philosophy. Read Gayatri Spivak's "Translator's Preface" to her translation of Jacques Derrida's *Of Grammatology*, (Baltimore, 1976), pp. IX-LXXXVII, and Richard Rorty's *Philosophy and the Mirror of Nature* (Princeton, 1979).

Incidentally "naive" as it is used here is a bit more negative than is Schiller's "naive" as discussed in the Overture. *Naïve*, the feminine of *Naïf*, means 'unaffected' or 'natural'; our English 'naive' implies the simple or unsophisticated assumption that what one now knows is Natural, spelt with a capital 'N'.

37. Rudolf Arnheim, *Art and Visual Perception* (Berkeley and Los Angeles, 1966), p. 156.

38. Ananda K. Coomaraswamy, *The Transformation of Nature in Art* (New York, 1934), pp. 117, 128.

39. Ibid., p. 204.

40. Ibid., pp. 203, 204.

41. Of course, Duccio was not alone. Ecclesiastical authorities from the twelfth century to the Renaissance encouraged artists to represent, with religious fervor, stories of the Christian Savior and of his mother in styles governed by the canons of theology rather than the precepts of art. Even though the church as patron and protector obviously did not ask the artist to represent the Madonna or Jesus Christ literally, it did ask him to evoke feelings of religious sentimentality and what it considered to be proper values. Artists were expected to paint in such a way that men would direct their attention not to the artist's work and to the new in which, he hoped, they participated, but to those feelings and values which society previously had accepted. An easily documented example of the effect of this pressure to conform can be seen in the way Italian art in the latter half of the sixteenth century bowed to the heavy-handed authoritarianism of the ecclesiastical authorities of the Counter-Reformation.

42. Incidentally, in this regard religion is more closely akin to ballet and traditional music than to theater and painting. Its communicable base is also an internal imposition modified from time to time with embellishments and spirited cadenzas. The importance of the internal locus of religious authority will be developed especially in the final chapter, on verification.

43. Fritz Meier, "The Transformation of Man in Mystical Islam," in *Man and Transformation*, Bollingen Series XXX.5 (New York, 1964), p. 44.

44. Miguel de Cervantes Saavdra, *The Ingenious Gentleman Don Quixote de La Mancha*, trans. Samuel Putnam (New York, 1949), p. 270.

45. Felix Klee, *Paul Klee*, trans. Richard and Clara Winston (New York, 1962), p. 16.

46. *The Gospel of Sri Ramakrishna*, trans. Swami Nikhilananda (New York, 1942), p. 396.

47. Jean-Paul Sartre, *The Words*, trans. Bernard Frechtman (New York, 1964), p. 232.

48. Ibid.

Fascination

49. David Hume, "The Natural History of Religion," in *Four Dissertations* (New York, 1970), pp. 94, 116.

50. Vincent Van Gogh, *The Complete Letters of Vincent Van Gogh* (Greenwich, Conn. 1958), 1:189.

51. I cannot help but interpret Moses Mainmonides' comment, which Gershom G. Scholem tells us is found in all Cabalistic manuals, that "no one is worthy to enter Paradise who has not first taken his fill of bread and meat," to be a delightful example of religion's having it just this way, which incidentally is the whole point of this chapter (*On the Kabbalah and Its Symbolism*, trans. Ralph Manheim [New York, 1960], p. 26).

52. Wallace Stevens, *Letters of Wallace Stevens*, ed. Holly Stevens (London, 1966), p. 364.

53. "Of the Standard of Taste," *The Essential David Hume* ed. Robert Paul Wolff (New York, 1969) p. 380.

54. Ramakrishna, *The Gospel of Ramakrishna* (New York, 1907), p. 243.

55. Gregory of Nyssa in Migne, *Patrologia Graeca* 54, 720C. Cited in Jean Danielou, "The Dove and the Darkness," *Man and Transformation*, (New York, 1964) p. 287.

56. Isaac Bashevis Singer, "A Piece of Advice," *The Spinoza of Market Street* (New York, 1961), p. 144.

57. John Dewey, *Art as Experience* (New York, 1958), p. 118. Karl Jaspers writes, "The faith through which I am convinced, and the content of faith, which I comprehend—the act of faith, and the faith that I acquire by this act—*fides qua creditur* and *fides quae creditur*,—are inseparable. The subjective and the objective side of faith are a whole." (*The Perennial Scope of Philosophy* [New York, 1949], p. 7.

58. *The Gospel of Ramakrishna*, [above: note 54] p. 159.

59. Jerzy Grotowski, *Towards a Poor Theatre* (New York, 1968), p. 234.

60. Ibid., p. 56.

61. Rudolf Otto, *The Idea of the Holy*, trans. John W. Harvey (London, 1950). I think it is only fair to remind ourselves that Otto's book is subtitled "An Inquiry into the Non-Rational Factor in the Idea of the Divine," and as such the attributes studied are "only to be used as 'idograms' for what is itself properly beyond utterance" (p. 24). If *fascinosum* and *tremendum* be "ideograms," we are obviously permitted that same freedom a contemporary philosopher granted himself, who said, when analyzing a distinction Aristotle made, "I am, in

general, less concerned with what Aristotle actually says than with the relevance of what I interpret him as saying." On the other hand, my use of Otto's "ideograms" must at least be consistent with what Otto himself suggests by them. It is this obligation to be consistent with the original source which allows me no empathy for another contemporary philosopher, who, when analyzing religion, wrote that if his analysis does not square with the world's religions, "so much the worse for them." If such lack of faithfulness were to prevail—whether in relationship to Otto or the world's religions—so much the worse would it be for my thesis.

62. Archibald MacLeish, *Poetry and Experience* (Boston, 1960), p. 9.

63. Jacob Epstein to Arnold Haskell, *The Sculptor Speaks* (Garden City, N.Y., 1932), p. 26.

64. Joyce Cary, *The Horses' Mouth*, in *First Trilogy* (New York, 1958), p. 46.

65. Erle Loran, *Cézanne's Composition* (Berkeley, 1943), p. 95.

66. Arnold Schönberg is a personification of this tension in music as far as it has to do with composition. Even though he radically denied the tonal principles of nineteenth-century music with his twelve-tone technique, he nevertheless wrote that "every combination of notes, every advance is possible, but I am beginning to feel that there are also definite rules and conditions which incline me to the use of this or that dissonance" (Arnold Schönberg, "Harmonielehre," as quoted in Wassily Kandinsky's *The Art of Spiritual Harmony*, trans. M. T. H. Sadler [London, 1914], p. 35.) In effect, there are two kinds of improvisation: the instrumental, which was discussed in the previous paragraph, and the structural, which was discussed in the first chapter and is here recognized by Schönberg. Whereas jazz players and folk singers improvise cadenzas built on a predetermined phrase structure, composers improvise, within limits, on the phrase structures themselves. Now it makes no difference whether Schönberg was thinking of those nineteenth-century rules and conditions which his cultural inheritance had established or of those possible rules and conditions, such as pitch relationships, which his nervous and motor system may have predisposed him to perceive. Either case constitutes a given structure or limit which stands apart from the composer and to which he must pay attention.

67. *Pausanias' Description of Greece*, trans. Arthur Richard Shilleto (London, 1886), vol. 1, bk. 3, ch. 19, p. 209.

68. Euripides, *The Bacchae*, in *The Complete Greek Drama*, ed. Whitney J. Oates and Eugene O'Neill, Jr. (New York, 1938), 2: 234.

69. Plutarch, "Of El at Apollo's Temple in Delphi," *Morals*, trans. Rev. William W. Goodwin (Boston, 1870), 4:487-488.

70. W. Norman Pittenger, *The Word Incarnate* (New York, 1959) p. 82. I could have referred to the theologian Hans Küng, but he is a special kind of theologian. In his Preface, to "Those for whom this book is written," in *On Being a Christian* (New York, 1976), he writes that he wishes to "make the traditional articles of faith intelligible to modern man . . . not another gospel, but the same gospel rediscovered for today." (p. 20) As such, Küng's most influential book is a modern Christian apologetic. See note 142, chapter 4 below.

71. The fourth-century Christian Father Basil of Caesarea cautiously suggests two separate names, *dogma* and *kerygma,* for these two separate functions, *ta dogmata* and *ta kērygmata.* The two relevant texts are in his *De Spiritu Sancto,* chap. 27, par. 66. See Emmanuel Amand De Mendieta, "The Pair *KERYGMA* and *DOGMA* in The Theological Thought of St. Basil of Caesarea," *Journal of Theological Studies* 16 (April 1965): 129-142; "The Unwritten and Secret Apostolic Traditions in the Theological Thought of St. Basil of Caesarea," *Scottish Journal of Theology, Occasional Papers* 13 (1965): 19-59, and R. P. C. Hanson, "Basil's Doctrine of Tradition in Relation to the Holy Spirit," *Vigiliae Christianae* 22.4 (1968): 241-255.

72. These comments help clarify the significance of Aquinas's traditional arguments for the existence of God. As philosophical arguments they are one thing; to have them function religiously is something else—that is, we are told that while he worked through them, Thomas Aquinas's faith and understanding concerning God were changed. For them to continue functioning religiously, it is necessary that those people who anxiously follow their development undergo change in *their* faith and understanding. The arguments prove themselves to be religious works by their force of creativity not by any loyalty to an already established Aristotelian logic or Catholic theology. In chapter 7 the complications of this issue will be sorted out.

73. John Dewey, "Classicism As an Evangel," *Journal of Philosophy* 18 (24 November 1921): 664-666.

74. Some fifteen years earlier William James had made a similar distinction in terms of "tender-mindedness" and "tough-mindedness." He associated rationalism (going by "principles") intellectualism, idealism, optimism, religion, free will, monism, and dogmatism with tender-mindedness and empiricism (going by "facts"), sensationalism, materialism, pessimism, irreligion, fatalism, pluralism, and skepticism with tough-mindedness. Although these associations blur Dewey's sharp dichotomy, it is evident from this listing and elsewhere that James was equally intent upon distinguishing that activity directed by prior rules, from that activity marked by a courageous facing of the open universe with its plural and unfinished directions. Still it is also evident that neither James nor Dewey thought of these two tendencies as operating together in religion (William James, *Pragmatism* [New York, 1907], p. 12). See also his *Collected Essays and Reviews* (New York, 1920), p. 415.

Distance

75. I really should not be so quick to say this. Certainly we think of ourselves as being in the process of birth, growth, and dissolution and yet at the same time as being detached from it, capable of commenting on it. Perhaps this kind of I-talk can be applied analogically to God-talk.

76. Basil, "Letter XXXVIII," *St. Basil Letters and Select Works, in A Select Library of Nicene and Post-Nicene Fathers of the Christian Church*, ed. Philip Schaff and Henry Wace, Second Series (Grand Rapids, 1955), 8:139. The Cappadocians seemed to have argued this with some authority. At the Council of Constantinople the Christian church at large accepted their formulation of the doctrine of the Trinity.

77. Friederich Schleiermacher, *The Christian Faith* (Edinburgh, 1928), 10, Postscript, p. 52.

78. John Calvin, *Institutes of the Christian Religion*, trans. Henry Beveridge (London, 1953), I. 13. 1 in vol. 1, p. 110.

79. Frederick Seebohm, *The Oxford Reformers* (London, 1887), p. 92. John Hick makes a philosophical move from understanding revelation in this way. If God's revelation is not about what God is, but about what is knowable about God, then in order to verify such knowledge it is not necessary to go to the nature of God as he is in himself, a requirement which is obviously beyond the scope of finite human capability, but simply to go to the individual who has received the revelation and see whether his experience has resulted in the removal of rational doubt ("Theology and Verification," *Theology Today* 17.1 [April, 1960]:29). I will expand on this insight in chapter 7.

D. H. Lawrence gives this "milk instead of meat" theme of Colet's an uncomfortable elitist twist. He writes, "Try as you may you can never make the mass of men throb with full awakenedness. They *cannot* be more than a little aware. So you must give them symbols, ritual and gesture, which will fill their bodies with life up to their own full measure. Any more is fatal" (*Etruscan Places* [London, 1972], p. 79). Also see that interesting exchange in *The Questions of King Milinda* later in this chapter.

80. Ludwig Feuerbach, *The Essence of Christianity*, trans. George Eliot (New York, 1957), p. 16.

81. George Santayana, *The Life of Reason*, rev. by author in collaboration with Daniel Cory (New York, 1954), p. 285.

82. Perhaps our ordinary language distinction between the beautiful and the pretty provides evidence for another theoretical example. Does not the

beautiful suggest, while the pretty presents? To be beautiful is to be desirable, to excite. It promises something more, an "endless end," a depth, a beyond, which is now veiled and unpredictable but which, if men could see—which they never will—flows smoothly and necessarily from that which they already do see, i.e., the beautiful thing. On the other hand, the pretty presents the perfection which beauty only suggests. It presents the end of archaic striving in the form of an inert all-at-onceness. There is no longer any suggestion of something more, of a further depth; therefore there is no longer any freedom to move beyond where men are. There are no veils—only a fullness that borders upon Sartre's *de trop*, upon 'too much', which in turn almost seems to suggest decay, what he calls an "obscene nakedness," that which "appears when the body adopts postures which entirely strip it of its acts and which reveal the inertia of its flesh" (Jean-Paul Sartre, *Being and Nothingness*, trans. Hazel E. Barnes [New York, 1956], p. 401). For Sartre, *de trop* suggests the obscene because it is all there, "wholly within the last act." We would say there is no room for distancing, no veil suggesting more not yet seen.

83. Wilhelm Worringer, *Form in Gothic*, ed. Herbert Read (New York, 1957), p. 107.

84. If we wish to salvage Worringer's insistence that architecture must not submit to preordained impositions, while at the same time not losing the idea that art must collaborate with or take those impositions into account, we might cite the glass-and-steel buildings which currently line New York's Fifth, Sixth, and Park Avenues as architectural examples guilty of one kind of delinquency, and those endlessly repeated twentieth century, pseudo-Gothic churches and cathedrals as architectural examples guilty of a different kind of delinquency. Whereas the glass-and-steel skyscrapers are too closely tied to representing their material, or maybe functional, purpose, the pseudo-Gothic churches are not sufficiently aware of the material and functional suggestions and restrictions out of and for which they are made. Whereas the buildings of the first sort fail because they do not distance and stretch, the buildings of the second fail because they do not acknowledge that from which they must distance.

85. Gustave Flaubert, *Bouvard and Petuchet, Intimate Remembrances, Selected Correspondence* in *The Complete Works of Gustave Flaubert*, vol. 10 (New York, 1904), p. 59.

86. John Keats, *The Letters of John Keats*, ed. Hyder Edward Rollins (Cambridge, Mass., 1958), 1:387.

87. Robert Frost, *Selected Letters of Robert Frost*, ed. Lawrence Thompson (New York, 1964), p. 344.

88. Edward J. Thomas, *The Life of Buddha*, 3d. ed. (London, 1949), p. 154.

89. Miguel de Unamuno insists instead that faith is a matter of will and that its "function is to create. Faith, in a certain sense creates its object. And faith in God consists in creating God." (*Tragic Sense of Life*, [New York, 1954], p. 192). This assertion comes close to getting us enmeshed in that difficulty suggested by Feuerbach (above, note 80). Of course, the answer depends upon what Un-

amuno means by "in a certain sense." In a certain sense, he is correct, in another sense, not necessarily so.

90. In chapter 5 this particular artistic and religious characteristic will be related to J. L. Austin's "performative utterance."

91. Vincent Van Gogh, *The Complete Letter of Vincent Van Gogh* (Greenwich, Conn, 1958), 1:451, 469, 470.

92. Sören Kierkegaard, *Fear and Trembling*, trans. Robert Payne (London, 1946) p. 23.

93. Eugene Delacroix balances the implied passivity of 'innocence' with the implied aggression of 'raiding' when he notes that "Execution in painting, should always have about it something of improvisation, and therein lies the capital difference between it and the execution of the actor. That of the painter will be fine only if he has saved himself up for a certain abandon later on, for discoveries made as the work advances." (*The Journal of Eugene Delacroix*, trans. Walter Pach [New York, 1937], p. 138).

94. at-Taborī, *Ta'rīkh ar-rusul ua'l-mulūk* (Leiden, 1881), I 1147-1152 cited in *Islam Muhammad and His Religion*, ed. Arthur Jeffrey (New York, 1958), p. 16.

95. F. Scott Fitzgerald, *The Letters of F. Scott Fitzgerald*, ed. Andrew Turnbull (New York, 1963), p. 11.

96. A. Foucher, *The Life of the Buddha* (Middletown, Connecticut, 1963), pp. 234-237. E. H. Johnston translates a different version, this one from a Pali text; note that it, too, emphasizes religious initiative. He "made up his mind for enlightenment and proceeded to the root of a *pipal* tree, where the ground was carpeted with green grass . . . and betaking himself to the foot of the great pure tree, he made a vow for enlightenment and seated himself . . . Then he took up the supreme immovable crosslegged posture with his limbs massed together like the coils of a sleeping serpent saying 'I will not rise from this position on the ground till I achieve the completion of my task'" (*The Buddhacarita or Acts of the Buddha*, trans. E. H. Johnston, pt. 2, Panjab University Oriental Publications, no. 32 [Calcutta, 1936], Canto XII, 115-120, p. 186).

97. These examples in the face of inevitable death will keep us from assuming more than the facts allow. We are saying that artistic and religious distancing, first, reveals a sense of the contingency, of artistic and religious worlds, and second, the obligation to assume the initiative and work toward determining a new world. This is not to say the initiative all by itself is enough to create that new universe. In the next chapter, the evidence is decisive in maintaining that the initiative is necessary but not sufficient. Artists and religious people cannot by themselves determine when their activities actually function as art and religion and thereby actually do create new worlds. In religious terms, God's grace is also necessary; in art, society's attention. For this reason, those same religious authorities who condone tribal killings can at the same time condemn murder or individual suicide.

98. Clement of Alexandria, "The Instructor," in *The Ante-Nicene Fathers*,

ed. Rev. Alexander Roberts and James Donaldson (New York, 1903) vol. 2, bk. 3, ch. 1, p. 271.

99. Schopenhauer, *The World as Will and Representation*, trans. E. F. J. Payne (Indian Hills, Colo. 1958), 1:367.

100. The *Brhadaranyaka Upanishad* reports that "whoever worships another divinity (than his self) thinking that he is one, and [Brahman] another, he knows not" (I. 4. 10). It is this kind of progression which the Japanese wish to effect with their rock gardens. The garden is what provides the basis for the "innocent" mind to move on by its vacant spaces, peacefully into new understandings. This implies the possibility of no new understandings, perhaps even of false ones. Not everyone leaves behind "the dark night of the soul." Nevertheless, Aristotle notes, "In art [the translation of *technē*, which really includes more than is generally meant today by art] he who errs willingly is preferable," and adds, "but in practical wisdom, as in the virtues, he is the reverse" (*Nichomachean Ethics* IX, 1140b5).

101. Of course the *Koran* is not alone. Its appeal to fear is akin to Jesus's suggestion of reward or a Zen master's blow, each designed to stimulate right action, correct work. In similar fashion, the monk, who while walking across a bridge with his disciple, upon being asked by the disciple what was the depth of the river of Zen, immediately seized the questioner and attempted to throw him into the river. Through the fear of violence and of drowning, the monk was attempting to force his questioner to effect this religious work of distancing from every refuge in the past so that the disciple might himself experience the depths of Zen.

102. For an interesting example of how this lesson can have a practical consequence, read Eugen Herrigel's *Zen in the Art of Archery* (New York, 1953).

103. *Sons of the Conqueror* is T. W. Rhys David's translation of *Ginaputtanam*. Obviously a certain elitism is being preached here. The title means "Members of the Order."

104. John Evelyn, *The Diary of John Evelyn*, ed. William Bray (Washington, 1901), 1: 171.

105. William Wordsworth, Preface to the *Lyrical Ballads* in *Wordsworth's Literary Criticism*, ed. Nowell C. Smith (London, 1905) p. 34.

106. R. G. Collingwood, *The Principles of Art* (Oxford, 1950), p. 275.

107. Reprinted in *Aesthetics* (Stanford, 1957) pp. 95-97. These points about converting art and religion into an inward "psychic" act have been suggested by Dickie in 1974, in his *Art and the Aesthetic*, (Ithaca, NY. 1974) chap. 4. One year later Berel Lang, in his *Art and Inquiry* (Detroit, 1975) points to a similar uncomfortableness with "psychical distance," but whereas Dickie recommends dropping all reference to distance Lang, as I, continues to use it. He speaks of "aesthetic distance" and then introduces "aesthetic proximity" as that which restricts distance, as that which fascinates. Especially see his chapter 4.

108. It is because of this gradual coming-to-be aspect of some artistic and religious knowledge that commentators are tempted to describe it by the word

'experience' rather than by the word 'knowledge'. Their argument is that 'experience' connotes the little-by-little act of going or passing through something—a tunnel, say, or life. As such religion is the experience of distancing oneself little by little from those structures of the past and the experience of stretching oneself little by little into the structures of the future. Perhaps this helps us to understand Collingwood's distinction, referred to previously, between the simple act of expressing one's emotion and the more complicated one of having the experience of expressing one's emotions.

'Experience' may also connote an all-at-onceness, however; if so, the term's usefulness is diminished here.

Craft and Magic

109. DeWitt H. Parker, *The Principles of Aesthetics* (Boston, 1920), p. 41.

110. Jean Cocteau provides us with an example of what we mean by 'a freeing from.' He subtitled "Parade," the famous 1917 cubist and modernist ballet, a "realist ballet" because it conveyed a reality which was "more real than real." Cocteau's interpretation is in keeping with the spirit of the Englightenment where thinkers viewed reason as a critical weapon to gain release from what was. For example, in his little essay "What Is Enlightenment?" Kant passionately expounds: "Enlightenment is man's release from his self-incurred tutelage. Tutelage is man's inability to make use of his understanding without direction from another. Self-incurred is this tutelage when its cause lies not in lack of reason but in lack of resolution and courage to use it without direction from another *Sapere aude!*—'Have the courage to use your own reason!'—that is the motto of enlightenment" (*Critique of Practical Reason and Other Writings in Moral Philosophy* [Chicago, 1949], p. 286).

111. Thus we can understand the following exchange. When the Emperor Wu of the Liang dynasty enumerates his meritorious deeds, "I have built so many temples and monasteries, I have copied so many sacred books of Buddha, I have converted so many Bhikshus and Bikshunis" and asks the Bodhidharma,, "Now what merit does your reverence think I have thus accumulated?" the simple answer is, "Your majesty, no merit whatever." (D. T. Suzuki, *Studies in Zen*, ed. Christmas Humphreys [New York, 1955], p. 13).

112. Miguel de Unamuno, *Tragic Sense*, (New York, 1954) p. 205.

113. Rainer Maria Rilke, *Letters of Rainer Maria Rilke, 1892-1910*, trans. Jane Bannard Greene and M. D. Herter Norton (New York, 1945), p. 57. The still popular Kahlil Gibran warns, "But let there be spaces in your togetherness" ("Or Marriage," *The Prophet* [New York, 1970], p. 15).

114. *Psalms of Maratha Saints*, trans. Nicol MacNicol, *The Heritage of India* (London, N.D.), pp. 34, 83.

115. A readily available source is *Buddhist Texts*, ed. Edward Conze (New York, 1954) p. 239.

116. From his Platonic yet Christian perspective, Origen makes this same affirmation. He tells us that when the redeemed first reach heaven, they will come to know the nature of stars, the reason for their positions, the causes of phenomena, and eventually those things which we now cannot see and which are ineffable. But later he relates that when the redeemed have made proper

progress, they will put away their bodies and their souls, and as pure intelli-gences they will come to contemplate rational and intelligible substances face to face. Here, too, there is neither samsara nor nirvana. He wants to acknowledge the ever-present old divisions, but at the same time to insist they be put away (*Origen on First Principles*, trans. G. W. Butterworth [London, 1936] bk. 2, chap. 11, p. 153).

117. Felix Klee, *Paul Klee*, trans. Richard & Clara Winston (New York, 1962), p. 177.

118. Marquerite Wilkinson, *The Way of the Makers*, (New York, 1925) p. 207.

119. John Herman Randall, Jr., *The Role of Knowledge in Western Religion* (Boston, 1958) pp. 110ff. Randall himself hesitates to use the label "representa-tive" in conjunction with religion and art, for all the good reasons discussed in chapter 1. His own preference is for "sign" and "symbol." But these words need to be sharply defined. C. S. Peirce, Charles Morris, and Susanne Langer in her later works, prefer to think of 'sign' as the generic term for which 'symbol' and some other term like 'signal' are the species. But if we wish to continue with Randall's own usage, we could say that a 'sign' makes men notice something other than itself, whereas a 'symbol' presents and participates in something which has its meaning within the symbol itself. Therefore, it points to that which can be known only by paying attention to the symbol. In this regard we could say the 'sign' is transparent, the 'symbol' opaque. The reality signified by the 'sign' is assigned by convention, the reality symbolized by 'symbol' is known by resemblance.

Obviously, calling the visual presentation of numbers, letters, and dia-grams 'symbols' is incompatible with this usage. They should be called 'signs'.

120. Note also that these acts are intended to function, like art master-pieces, beyond their natural limit of time and space. This is most obvious in the celebration of the Eucharist, the sacramental consecrating and eating of bread and wine which traditional Christians, at the moment of eating, consider as a partaking of God, or more specifically, a participating in Christ's sacrifice on the cross. The Eucharist represents the last Supper, but it derives its religious symbolic power or 'grace' from that in which the Last Supper participates, the Crucifixion. Thus the act of correctly receiving the consecrated bread and wine also brings about the new situation, and thus is itself a religious act.

121. In *Documents of the Christian Church*, ed. Henry Bettenson, 2d ed., (London, 1967), p. 94.

122. These extreme reactions are akin to Muhammad's appeal to men's fear of burning in hell-fire for not doing God's work, as was discussed in chapter 3. Both examples sacrifice the tension of 'representative symbol'. Whereas Muhammad's appeal compromises the symbolic element by appealing to the representative element, the mystics compromise the representative element by appealing exclusively to the symbolic.

123. The role of the witch complicates matters. She serves not the witch herself, but the devil—traditionally as much an other self as is God. But she

does serve herself, at least indirectly, because—again as traditionally understood the devil, like the narrow self, tolerates no new relationship or understanding, only reaffirmation. Thus the witch is serving a relationship already established and understood.

124. Roger Fry, *French, Flemish, and British Art*, (London, 1951) p. 121.

125. Thomas Aquinas, *Basic Writings of Saint Thomas Aquinas*, ed. Anton C. Pegis (New York, 1945) 1, Q 105, Art. 5, p. 977.

126. Stephen C. Pepper, for one, is so sure that Brueghel is a great artist that he develops his entire discussion on what is a work of art around Brueghel's winter scene, *Hunters in the Snow*. Why this picture? Pepper declares it is of "unquestionable aesthetic worth" (*The Work of Art* [Bloomington, 1955], p. 14). If there is truth in what Fry says about Brueghel, it can be applicable only to his *genre* paintings of peasant scenes. Although it might not be quite fair to imply along with Fry that if an observer has to follow the subject matter in order to understand a picture, then the picture must be bad, it is fair to ask in such paintings as *Children's Games* and *The Netherlandish Proverbs* whether the observer's understanding, which Brueghel *does* enlarge, is merely an enlarged understanding of the subject matter of Brueghel's own time. If so, these pictures constitute an end, not a beginning. They herald no decisive reorganization; they carry no symbolical force into the future. Their value extends only to clearing up the past, to representing the sixteenth century, but not to stretching into and transforming the age in which we live.

127. James Whistler, *The Gentle Art of Making Enemies* (London, 1943), p. 138.

128. Again from the Second Council of Nicea, A.D. 787. In Bettenson, *Documents*, [above; note 121] p. 94.

129. Archibald MacLeish, "Invocation to the Social Muse," *New and Collected Poems, 1917-1976* (Boston, 1976), p. 296.

130. G. W. F. Hegel, *The Philosophy of Fine Art*, trans. F. P. B. Osmaston (London, 1920), 1: 34.

131. This is an early distinction. In Homer and Hesiod *technē* seems to involve cunning of hand, even a kind of trickiness. See J. J. Pollitt, *The Ancient View of Greek Art: Criticism, History, and Terminology* (New Haven, 1974), pps. 32-37. For these same authors *dikē* means due share, the principle or structure which guarantees one's rights when one is injured by such as *hybris* (originally meaning illegal action) or by tricky or cunning actions. See Werner Jaeger, *Paideia: the Ideals of Greek Culture*, trans. Gilbert Highet (New York, 1945) I, pps 68-69, 102-106. With this background we can understand Aristotle saying "In art (*technē*) he who errs willingly is preferable, but in practical wisdom, as in the virtues, he is the reverse." (*Nicomachean Ethics*, 1140b 23-24).

132. Of course, religion also prohibits unauthorized individuals from sounding its holy sounds, but for a different reason. Whereas magic does so for fear the uninitiated will be unable to control its force, religion does so for fear the uninitiated will not show the sounds proper respect, that to the uninitiated

the sounds will remain strange. The *cancelli*, the *iconostasis*, and the *parochet* all separate, simply so that "the people might sit down."

133. This latter interpretation seems to be Bhartrhari's own understanding. In the original, the 'sound' to which he refers reads *sphota*, not *śabda*, which is the ordinary word for sound. *Sphota* suggests the meaning bearer, the first principle of the universe, the essential *śabda*.

134. Two theoretical categories—the sublime and the ecstatic—express this dimension of not being in control, of needing to participate in the sounds themselves and not in one's reasons for effecting the sounds. Each suggests a going beyond the limits, beyond what men already know. Each somehow affirms what will be by encountering it now as that which transcends the expected. Through the feeling of the sublime and of ecstasy, a particular place or an action, a person or an object, here and now participates in the 'more'. But of course, this participation must remain sublime or ecstatic. The moment men claim they can conceptualize it, that future becomes fixed in the present and men lose their participation in what will be.

135. The most that we can say is that Constable is now aesthetically important because here and now, he does show men how to see. The world in which men operate is the world it is partly because of him. To label his work "masterpiece" simply conveys his contemporary effect and only suggests to future generations that they consider him seriously, consider whether his universe is relevant to what they see—or, as I shall put it in the sixth chapter, consider whether what he has to say is 'true-to' their understanding.

136. Hwui-Li, *The Life of Hiuen-Tsiang*, trans. Samuel Beal (London, 1911), 1: 21.

137. Augustine, "On Baptism, Against the Donatists," in *The Works of Aurelius Augustine*, ed. Rev. Marcus Dods, trans. Rev. J. R. King (Edinburgh, 1872), vol. 3, bk. 4, chap. 12-18, p. 98.

138. Meyer Shapiro, *Romanesque Art* (New York, 1977), pp. 116-120.

139. To assert otherwise—that God does what he does because it is good, and by implication, that God saves the saved because they deserve it—subjects God's actions to that philosophical scrutiny so effectively insisted upon and amplified in, for instance, Ronald W. Hepburn's *Christianity and Paradox* (New York, 1968), pp. 129-133. Although I cite these particular pages his entire book is relevant to this point. He insists that religious assertions must be weighed and evaluated by something other than their internal coherency. I fully agree as far as religious *systems* are concerned. The last chapter will explore the ramifications of this reasoning.

140. Kenneth Clark, *The Nude*, (Princeton, 1956), p. 366.

141. Odilon Redon, "From His Journal and Letters," quoted in *Artists on Art*, ed. Robert Goldwater and Marco Treves (New York, 1945), p. 359.

142. We might think of apologetics as a religious attempt to break this circle of self-congratulation because it directs its activity to the outside world, thereby allowing the world to judge its claims. Traditionally, however, the

apologist considers the external judgment to be relevant only to what others might think, not to what he himself thinks. In other words, he wants the world, not religion, to change its expectations. This bias makes his activity propaganda, an activity dedicated to defending or expositing the integrity and the validity of those structures of faith he already holds in terms of the cultural assumptions of those who do not hold them. Thus the apologist, too, is a craftsman, working on a more appropriate or a more marketable package to present an old product to a new consumer.

As I noted in chapter 2, Hans Kung's *On Being a Christian* (New York, 1976), is an example of "modern Christian apologetics." See above, note 70.

Coalescence

143. Wallace Stevens, *The Necessary Angle* (New York, 1951), p. 165.

144. We must not think that arguments which recognize that religion can provide security or a sense of identity necessarily compromise this quality of having no purpose or goal beyond the doing of the act itself. To do so would imply that function is purpose. It need not be. For example, *karma* may well function in such a way as to determine our next incarnation, but that *karma* which the Hindu does with the intention or purpose of bringing about a particularly desirable reincarnation fails to function in the way intended. Thus to say that religion functions in such a way that it provides security is not to say its purpose is to provide security. So it is with art. To say, for example, that art functions in such a way that it gives pleasure is not the same thing as to say its purpose is to give pleasure.

145. G. W. F. Hegel, *The Philosophy of Fine Art*, trans. F. P. B. Osmaston (London, 1920), 4:46. Could this also be what Hegel is saying when he reports elsewhere that "religion is (1) conceived of as result, but (2) as a result which at the same time annuls itself as a result, and that (3) it is the content itself which passes over in itself and through itself to posit itself as a result"? (*Lectures on the Philosophy of Religion*, trans. Rev. E.B. Speers and J. Burdon Sanderson [London, 1895], 1:105.

146. Bronislaw Malinowski, *Magic, Science and Religion and Other Essays*, (Garden City, N. Y., 1948), p. 38.

147. Daisetz T. Suzuki, *Zen and Japanese Culture*, 2d ed., (New York, 1965), p. 376. The force of this insistence is not compromised by those authoritative Western religious texts which report the equivalent of "he who loves and hates only for Allah's sake, who gives and withholds only for Allah's sake, has attained a perfect faith." This is because those actions which men do for God's sake are really only a commitment to doing what they must—in effect, to being open-ended. In pursuing pleasure or happiness, for instance, though we may consider them men's goals, if they are pursued on any terms other than open-endedness, they are lost—or never attained. That is, men cannot act with the specific intention of being happy or having pleasure. Like love, these states come to men only as an aside, a by-product, as a functional adjunct to their doing what they do. Doing specific acts in order to serve God is a functional adjunct to the awaiting of His favor, His lead, or His revelation. This is what it means to be waiting for the 'sounds' themselves. Men do what they do and find that they are happy. They await his favor and find that they are doing him service. But also see the reference to this passage from Suzuki in chapter 6.

148. This point will be significant for my discussion on verification in chapter 7.

149. Martin Luther, "A Treatise on Christian Liberty," *Three Treatises* trans. W.A. Lambert (Philadelphia, 1947) p. 282.

150. Cited in Laurence Binyon, *Painting in the Far East* (New York, 1908), p. 243.

151. "Oration On The Dignity of Man," trans. Elizabeth Livermore Forbes in *The Renaissance Philosophy of Man*, ed. Ernst Cassirer, et al., (Chicago, 1948), p. 224. "By faith Abraham obeyed when he was called to go out to a place which he was to receive as an inheritance; and he went out, not knowing where he was to go" (Heb. 11:8).

152. W. B. Yeats, "Among School Children," in *The Collected Poems of W. B. Yeats* (New York, 1952), p. 214.

153. *The Platform Sutra of the Sixth Patriarch*, trans. Philip B. Yampolsky [New York, 1967], paragraph 17. p. 137).

154. *Foxe's Book of Martyrs*, ed. G. A. Williamson (London, 1965), p. 285.

155. The 1960s were especially aware of this obligation to be free from the structures of the past. Of course this is also reflected in the religious pronouncements of the era. Whereas Paul Van Buren insists, "The Christian gospel is the news of a free man who did not merely challenge men to become free; he set men free" (*The Secular Meaning of the Gospel* [New York, 1963], p. 169), Thomas Altizer explicitly declares this freedom to be not only for Christians but for "the universal body of humanity" (See *The Gospel of Christian Atheism* [Philadelphia, 1966], p. 83).

156. Jean Renoir, *My Father*, trans. Randolph and Dorothy Weaver, (Boston, 1962), p. 220.

157. Kenneth Clark, *The Nude*, (Princeton, 1956), p. 366.

158. Bell vaguely defines it as "arrangements and combinations that move us in a particular way" (*Art* [New York, 1958], p. 22). On page 13 he says it is that "combination of lines and colours (counting white and black as colours) that moves me aesthetically."

159. Consider, for example, Giovannida Bologna's *Mercury*, or even better, Constantin Brancusi's now familiar *Bird in Flight*, the one in Philadelphia. An appreciation of this sculpture should involve the intensive attention to the concavity or convexity of the curves, the relation of masses, the proportion of part to part, of base to superstructure, of line to line, of combination of space, mass, and line which light and shade reveal, as well as the extensive appreciation of the delivered content of a bird in flight. But Stendhal's "disappointment" with his imaginary traveling companions is well placed because they are no longer looking at that *significant* form in front of them: "We began our tour by seeing again for the fifth time Domenchino's frescoes at the convent of San Basilio in Grotaferrata. San Nilo, a Greek monk, represented in these frescoes, was in his time a man of the greatest courage and wholly superior. He found a painter worthy of him. What I told our female travelling companions of his

history doubly enhanced the effect of the frescoes. I was deeply disappointed in these ladies when I perceived this. They are still a long way from enjoying and understanding painting. The subject has nothing to do with a painter's merit: it is a little like the words of a libretto for the music" (*A Roman Journal*, trans. Haakon Chevalier [London, 1959], p. 30).

160. Jacob Epstein, *The Sculptor Speaks*, (Garden City, 1932) p. 61. How similar this is to the ancient Eastern doctrine of *rasa*: The word literally means 'tincture' or 'essence.' In an aesthetic context it most often suggests 'flavor.' The aesthetic experience is thus described as *ravâsvadana*, the tasting of a flavor, or simply as *svāda*, or *āsvāda*, tasting. (See Ananda K. Coomaraswamy, *The Transformation of Nature in Art* (New York, 1956), p. 47.) Epstein, too, is demanding that his works be tasted. It is only by their being tasted that men will come to understand them.

This requirement will be important in the last chapter's discussion on artistic and religious verification.

161. "The Twin Verses," in *The Dhammapada, Sacred Books of the East* (New York, 1900), p. 116.

162. Ramakrishna, *The Gospel of Ramakrishna*, p. 306.

163. Virginia Woolf, *A Room of One's Own* (New York, 1929), p. 191.

164. See, for example, Rogers' treatment of Shelley's poem "Mont Blanc," in which he alters some of the poem's original 1817 punctuation, changes some of its words, and actually adds two lines. "It is not without great hesitation that I add to a text based on Shelley's own printing the lines I have numbered 27a and 28a, but they improve the symmetry of the whole passage, and there is at least one other instance . . . in support of my belief that he was capable of missing a line in copying from his draft." (*The Complete Poetical Works of Percy Bysshe Shelley*, vol. 2, ed. Neville Rogers [Oxford, 1975], p. 350). The "improved" poem is presented on pp. 75-80.

165. For Dewey, experienced objects are somebody's world, a product of somebody's juncture of organism and discriminated environment. They are material "taken out of the context of direct experience and placed in the context of material within discourse for the purpose of meeting the requirements of discourse." ("Experience, Knowledge and Value: A Rejoinder," in *The Philosophy of John Dewey*, ed. Paul Arthur Schillip [New York, 1939], p. 548.)

166. Martin Heidegger, *An Introduction to Metaphysics*, trans. Ralph Manheim (New Haven, 1959), pp. 102-103.

167. Naum Gabo, "A Retrospective View of Constructive Art," in *Three Lectures on Modern Art* (New York, 1949), p. 65.

168. Michel de Montaigne, "Of Giving the Lie," *Works*, Bk. 2, Ch. 18, p. 504.

169. Berel Lang's anthology, *Philosophical Style* (Chicago, 1980), suggests as much for all of philosophy.

170. Edward Conze, *Buddhism*, (New York, N.D.) p. 81.

171. Hiley Ward, *Documents of Dialogue* (Englewood Cliffs, N.J., 1966), p. 257. In chapter 2, I referred to a tendency in religion to blur the criteria-evidence distinction, and it is now evident once again. I shall say nothing more

about that conflation but will say that Paul VI's and Athenagoras II's declaration supplies another example of religion's clearly not functioning as a feeling or experience which comes before or after doing, with the words then being the report. Religion *is* the doing itself. Like love and fear, forgetfulness can be religiously enjoined because it isn't the sincerity of the forgetfulness that is at issue, only a certain liturgical act. Obviously, sincerity cannot be enjoined, but only invoked.

172. Alfred Guillaume, *Islam* (London, 1963), p. 175.

173. Theodore Gaster, "The Religion of the Canaanites," in *Forgotten Religions,* ed. Vergilius Ferm (New York, 1950), pp. 118-121.

174. Malinowski, *Magic, Science, and Religion,* (Garden City, N.Y., 1948) p. 40.

175. Ibid., p. 52.

176. Sergius Bulgakov, *The Orthodox Church,* trans. Elizabeth S. Cram (New York, 1936), p. 92.

177. Ibid., p. 79.

178. Gunter Grass, *The Tin Drum,* trans. Ralph Manheim (New York, 1962), p. 525.

179. Martin Heidegger, *Existence and Being* (London, 1949), p. 281.

180. Benedetto Croce, *Aesthetic as Science of Expression and General Linguistic,* trans. Douglas Ainslee, 2d ed. (London, 1922), p. 8.

181. Friedrich Nietzsche, *On the Genealogy of Morals,* trans. Walter Kaufmann and R. J. Hollingdale (New York, 1967), p. 45.

182. Though he said that he formed these ideas as early as 1939, Austin first made use of them in print in an article "Other Minds," published in the *Proceedings of the Aristotelian Society,* suppl. 20 (1946), 173ff. This was followed by his lectures "Words and Deeds," at Oxford in 1952, 1953, and 1954; by the William James Lecture at Harvard University in 1955, later published as *How to Do Things with Words;* and finally by a 1956 BBC lecture, "Performative Utterances" (later published along with "Other Minds," in the 1961 volume, *Philosophical Papers*).

183. J. L. Austin, *How to Do Things with Words* (Cambridge, Mass., 1962), p. 6.

184. Vincent Van Gogh, *Letters,* (Greenwich, Conn., 1958) 2:429.

185. Dietrich Bonhoeffer, *The Cost of Discipleship,* trans. R. H. Fuller (New York, 1963), p. 206. There is also the Buddhist initiation ceremony *Abbishika,* literally meaning 'Besprinkling.' The initiate is sprinkled with holy water and thereby "from that moment" transformed into a spiritual world-ruler, a Buddha.

Obviously, in so identifying Van Gogh's creating from his palette, Bonhoeffer's speaking the name of Christ, and the Buddhist priest's sprinkling holy water, with Austin's performative which indulges or does, I have conflated utterance and doing. I do so for the same reason Austin does it, "precisely because the decision is not in point" (Austin, *How To Do Things With Words,* [above; note 183] p. 11). What *is* "in point" is what this kind of uttering and

doing does, or what Austin calls its "force." It is clear that in uttering q—in the appropriate circumstances, of course—I do q. I only wish to add that in doing p, which has (again, in the appropriate circumstances) the force of uttering q, I also do q.

186. James Boswell, *The Life of Samuel Johnson LLD* (New York, N.D.), p. 333.

187. J. L. Austin "Performative Utterances," in *Philosophical Papers* (Oxford, 1961), p. 223.

188. John Wisdom, *Philosophy and Psychoanalysis*, (New York, 1964) p. 158.

189. Austin says of 'force,' "Besides the question . . . as to what a certain utterance *means*, there is a further question distinct from this as to what was the *force*, as we may call it of the utterance. We may be quite clear what 'Shut the door' means, but not yet at all clear on the further point as to whether as uttered at a certain time it was an order, an entreaty or what not" ("Performative Utterances," p. 226).

190. Roderick Chisholm, *Theory of Knowledge* (Englewood Cliffs, N.Y., 1966), p. 16.

191. Ibid., p. 17.

Truth-To

192. J. L. Austin, "Performative Utterances," *Philosophical Papers* (Oxford, 1961), p. 226.

193. The distinction itself is important. Frege acknowledged it when he introduced into his logic the 'signpost' symbol to be prefixed to a statement. Thus .p signifies the actual assertion of p, whereas the bare symbol p signifies only the content of the assertion of p.

194. Athanasius, "Incarnation of the Word," *St. Athanasius: Select Works and Letters* in *A Select Library of Nicene and Post-Nicene Fathers of the Christian Church*, ed. Philip Schaff and Henry Wace, Second Series (Grand Rapids, 1953), Vol IV, Paragraph 54, p. 65. Man can become god but only after God first has accepted him, man can become like the gods creating new worlds through his artistic and religious acts, but only because society first empowers him, leads him, and finally accepts what he has done. Desire and activity by themselves are never enough. The final social act of acceptance is determinative, or in Austin's terms, part of the "appropriate circumstances."

195. None of this should come as a surprise. More than a hundred years ago Delacroix reflected, "It is necessary to use the means familiar in the time when you are living, otherwise you will not be understood and you will not live. That instrument of another age that you want to employ in order to speak to the men of your time will always be an affected instrument, and the public of a later time comparing that borrowed manner with the works of the period when it was the only manner known and understood—and therefore used with full effect—will condemn you to inferiority, and you will have already pronounced the condemnation yourself" *The Journal of Eugene Delacroix*, trans. Walter Pach (New York, 1937) p. 579.

196. This Aristotelian *ousia* is crucial to the Christian understanding of the Trinity. Remember, for the Church Fathers, it is the *ousia* which preserves the single existence of God while the *hypostaseis* assert the three particular expressions of existence. But if it is the Platonic *ousia* to which they refer, there is a Godhead independent from the three *hypostaseis*. The declaration of the *hypostasis* Son to be *homoousios*, of one stuff, with the Father clearly suggests this is not what they intended.

197. Petrarch, *Letters from Petrarch*, trans. Morris Bishop (Bloomington, 1966), p. 198.

198. James Whistler, *The Gentle Art of Making Enemies*, (London, 1890), p. 127.

199. D. T. Suzuki, *Zen and Japanese Culture*, (Princeton, 1970) p. 376. In chapter 5 I discussed the extended passage from another perspective.

200. This idea of truth-to is not original. I owe a great deal to John Hospers, *Meaning and Truth in the Arts* (Chapel Hill, N.C., 1946). See also his article "Aesthetics, Problems of" in *The Encyclopedia of Philosophy*, ed. Paul Edwards (New York, 1967), 1:35-56.

201. Max Born, *Atomic Physics*, trans. John Dougall, 7th ed., (New York, 1966), pp. 39-99.

202. Erwin Schrodinger, *Science and Humanism*, (Cambridge, 1951), p. 25.

203. Perhaps the best example is the quark, which some theoretical physicists think is unobservable in principle because they cannot produce it, i.e., cannot detach it from the hadron of which it is a part.

In order to emphasize the role of the human observer in constructing the language of contemporary physics, it is easy to speak of the meta-language of physics, that language which attempts to introduce some regularity among concepts of observables, and then of interpretations of meta-language. But the role of the observer also affects the object-language level, the level of statements about observables, or concepts subject to quantitative gradation which can be correlated, indirectly or directly, with primary experimental data. Here the experimenter selects an experimental arrangement in accordance with the information desired. This selective experimental design puts him in a position to obtain information about a particular observable, e.g., the position of a subatomic particle, but by virtue of its selectivity also excludes the possibility of obtaining information about certain other conjugate observables—in this case, momentum. Thus the observer determines the content of the object-language.

204. (New York, 1957), p. 253. Of course her "convulsive hold" is far more broadly based than this. For an interesting review of her two thousand-year history as virgin, queen, bride, mother, and intercessor, see Marina Warner's *Alone of All her Sex*, (New York, 1976).

205. *New Essays in Philosophical Theology*, ed. Anthony Flew and Alastair MacIntyre (London, 1955), pp. 103-105.

206. They are, of course, doing the "reasonable" thing. *Logos* is Greek for 'reason,' and Heraclitus and the Stoics suggest that *logos* also means 'word.' Thus "reasonable" might well mean placing reason in harmony with the word (language), assuming that the word (language) somehow is already in harmony with reality. The problem arises when we must decide whether the word (language) *is* in harmony with reality, or whether we must construct a new word (language).

207. This phenomenon explains the great value of parables or myths, as contemporary novelists like John Gardner are well aware. They provide a common experience, but by their nature they clearly are meant to lead to or suggest something more than their literal meaning. Following a lead suggested by P. W. Bridgman, we might think of them as operational fictions, that is, fictions which are useful, which take men who take them seriously into a totality

or a meaningful unit. As the *Bhagavadgita* points out, it is the ignorant, made so by their lethargy or greed, who do not let these fictions become "supremely rich."

208. Apollodorus, *The Library*, trans. Sir James George Frazer (London, 1921) 1:27.

209. A prayer for the consecration of a church, 1945 edition, p. 564.

210. Improvisations or incongruities always have played a constructive role in music, but within the limits of accepted convention and syntax. In this 1968 work, Stockhausen wishes to eliminate these conventions, and contribute to the construction of completely new and fresh understandings. Of course whether his work actually does this cannot be ensured and remains to be seen.

211. Herman Hesse, *Steppenwolf* (New York, 1929), p. 105.

212. Art and religion often have been associated with play, albeit in an underground fashion. See Johan Huizinga, *Homo Ludens A Study of the Play Element in Culture* (Boston: 1950), Robert E. Neale, *In Praise of Play* (New York, 1969), and Harvey Cox, *The Feast of Fools* (Cambridge, MA, 1969). This association with punning is less familiar. The artist, the religious person, and the punster each assume a bond between what at first glance seems to be contradictory and each cultivate it. A monk anxious to learn Zen, asked, "I have been newly initiated into the Brotherhood. Will you be gracious enough to show me the way to Zen?" The master said, "Do you hear the murmuring sound of the mountain stream?" The monk answered, "Yes, I do." The master said, "Here is the entrance" (D. T. Suzuki, *Studies in Zen*, p. 199). Secondly, they do not cultivate their openness to the world's seeming incongruity for itself but for its potentiality to bring about a new unified whole. If they are good at what they are doing, they do not opt out at any one partial or incomplete capturing of a totality but by the nature of their activity continually participate in the always-at-present incongruity, hopefully creatively contributing bridges which will be true to that which people will eventually see.

213. Charles Baudelaire, *The Mirror of Art*, trans. Jonathan Mayne (New York, 1955), p. 195.

214. Much of this is applicable to Thomas S. Kuhn's study of *The Structure of Scientific Revolutions*, 2d ed., (Chicago, 1970). He first considers "normal science" with its priority of paradigms which influence the writing of textbooks and the direction in which scientists do their research. Then he considers the "anomaly" and how it prepares the way for a new paradigm, the changing of textbooks, and even of the history of science. This "resulting transition to a new paradigm is scientific revolution." (p. 90).

215. Rudolf Carnap, *Meaning and Necessity* (Chicago, 1956), p. 208.

216. Philip Collins, "Little Dorrit: The Prison and the Critics," *Times Literary Supplement*, 18 April 1980, p. 446.

217. This is from his address to the 1978 graduates of the Mannes College of Music [*The New York Times*, 2 July 1978, p. D13]. It sounds very much like that rearguard slogan of the 1960s, "Let the church be the church."

218. Edmund Wilson comments, "It was in vain that Marx tried to bar out Providence: '*History does nothing*,' he had insisted in *The Holy Family*; it 'possesses *no* collossal riches;' it 'fights no fight.' It is rather *man*—real, living man—who acts, possesses and fights in everything. It is by no means 'History' which uses man as a means to carry out *its* ends, as if it were a person apart; rather 'History is *nothing* but the activity of man in pursuit of his ends.' But as long as he keeps talking as if the proletariat were the chosen instrument of a Dialectic, as if its victory were predetermined, he does assume an extra-human power" (*To the Finland Station* [New York, 1972], p. 229). Also see discussion on Dewey's epistemological fallacy, above chapter 5.

219. Clive Bell, *Art*, (New York, 1958) p. 13.

220. Francis Bacon, *The New Organon*, ed. Fulton Anderson (Indianapolis, 1960) Bk. I, paragraph XCV, p. 93. Also remember Petrarch's counsel quoted above, wherein he too noted that artists (writers) should work as the bees.

Verification

221. John Hospers, "Implied Truths in Literature," *The Journal of Aesthetics and Art Criticism* 19.1 (Fall 1960), p. 40.

222. Plutarch, *The Lives of the Noble Grecians and Romans*, trans. John Dryden and rev. Arthur Hugh Clough (New York, N.D.), p. 186.

223. Oscar Wilde, *The Letters of Oscar Wilde*, ed. Rupert Hart Davis (New York, 1962), p. 217.

224. Ibid., p. 415.

225. Ibid., p. 259.

226. Ibid., p. 476.

227. Ibid., p. 468.

228. Ibid., p. 302.

229. Ana Kisselgoff, "Graham's Creativity Remains Unabated," *New York Times*, 26 April 1973, p. 52.

230. William James, "Reflex Action and Theism," *The Will to Believe*, (New York, 1897) p. 125.

231. Leonard Meyer, *Music, the Arts, and Ideas* (Chicago, 1967), p. 63.

232. Suzuki, *Studies in Zen*, (New York, 1955) p. 14.

233. This does not mean things or objectifications have no existence or that they are nothing. If it did, the fifteenth-century *Ten Oxherding Pictures* preserved in Shokokuji, would be only eight; the group would end with that picture of an empty circle signifying that the whip, the rope, the man, and the ox are all gone out of sight. Instead the series of ten ends with the man's entering the city and proclaiming, "I visit the wineshops and the market, and everyone I look upon becomes enlightened." The pictures seem to tell us that Zen has emptied the world *of its old content* so that now it no longer is distinguished from Nirvana: "he touched, and lo! the dead trees are in full bloom." Negation has passed into affirmation.

Remember, though, this affirmation is only partial. The new objectivity is synonymous with nonduality, or the affirmation that all dualities are abolished. "Vast emptiness" now means that these objectifications which religion establishes stand before a no and a yes, before nonexistence and existence. Though they are empty, nowhere and in no time, they are everywhere and completely present in every time. Thus the religious spokesman can just as well say that God is creating the world now in the present, in this time; as that God created the world in another time, before time, or even once upon a time. All moments are significant and no particular moments are significant. "If you say that I am

young and tender, and that the time for seeking wisdom is not come, You ought to know that to seek true religion, there never is a time not fit; impermanence and fickleness, the hate of death, these ever follow us, And therefore I [embrace] the present day, convinced that now is time to seek religion" (Asvaghosha Bodhisattva, *The Fo-Sho-Hing-Tsan-King A Life of Buddha*, trans. Samuel Beal, in *The Sacred Books of the East*, vol. 19 [Oxford, 1883], Kioven II. 6. 440-441, p. 62). Thomas J. Altizer makes an interesting attempt to relate this affirmative concept of nothingness to Christianity's *creatio ex nihilo* in "Buddhism and Christianity: A Radical Viewpoint," *Japanese Religions* 9 (March 1976), pp. 1-11. There are still problems, e.g., Christianity insists there are particular moments which cannot be emptied.

234. Jean Renoir, *Renoir My Father* (Boston, 1962) p. 458.

235. Wilde, *Letters*, [above, note 223] p. 185.

236. Of course, Wilde is not alone here. Consider the following passage from Willem Zuurdeeg, a fideistic theologian very much concerned with challenges to the meaningfulness of religious discourse: "The languages of the Hebrew and the Christian faiths certainly contain sentences which refer to historical events, but they belong to 'narrative' language . . . If a Christian says: 'I believe that nearly twenty centuries ago Jesus Christ lived, and died, and rose again,' he does not intend to make a cognitive statement, but to repeat the old recital, be it in an abbreviated and flat form . . . What is required in the Hebrew and Christian faiths is therefore not a belief in the truth of cognitive sentences, but a willingness to repeat the old recital. Such sentences are not primarily cognitive but convictional" (*An Analytical Philosophy of Religion* [New York, 1951], p. 193).

First, he has successfully defused any potential judgment of religion in terms of historical and cognitive accuracy by declaring that the traditional roots of the Hebrew and Christian faiths are not meant to be cognitive but rather are meant to be convictional. Second, what he offers in its place is a willingness so to use the language. When all is said and done, that which judges the use of religious language is the user's willingness so to use religious language.

237. Felix Klee, *Paul Klee*, trans. Richard and Clara Winston (New York, 1962), p. 183.

238. Another way that religion makes clear its insistence that its pronouncements have truth value is its willingness to talk of God's "accommodation" to the moment. That is, no matter how valid is the claim that present beliefs about God are a person's or a society's own creation, stemming from individual temperament or cultural needs, there is still a 'more,' a reality, which is independent of those needs. *Quid Deus sit nescimus*, What God is, men do not know.

239. Felix Klee, *Paul Klee*, [above; note 237] p. 184.

240. Paul Tillich, *Systematic Theology* (Chicago, 1951), 1:214.

241. Joyce Cary, *Horse's Mouth*, (New York, 1944) p. 236.

242. E. H. Gombrich, *Art and Illusion*, (New York, 1961), p. 271.

243. Sören Kierkegaard, *Fear and Trembling*, trans. Robert Payne (Oxford, 1939) p. 23.

244. Wallace Stevens, *Letters of Wallace Stevens*, ed. Holly Stevens (London, 1966), p. 863.

245. James Johnson Sweeney, *Vision and Image* (New York, 1967), pp. 113-115.

246. D. T. Suzuki, *Studies in Zen*, [above; note 232] p. 56. Similarly, Georges Braque and those who appreciate his later surfaces want the observer to feel the physical reality of Braque's tools and materials.

247. Trans. Chang Chung-Youan, *Original Teachings of Ch'an Buddhism* (New York, 1969), p. 108.

248. Ibid., p. 109. I would have liked to cite as my example of a willingness to bring oneself to religion the following more famous dialogue between the Emperor Wu of Liang and Bodhidharma. It is also found in the *Records*.

WU: "Since my enthronement I have built many monasteries. I have had many holy writings copied. I have invested numerous monks and nuns. How much merit have I gained?"

BODHIDHARMA: "None."

WU: "Why so?"

BODHIDHARMA: "Those are inferior deeds. They may conduce to favorable births in the heavens or on earth, but are of the world and follow their objects like shadows. They may seem to exist, but are nonentities. Whereas the true deed of merit is of pure wisdom, perfect and mysterious in its nature beyond the grasp of men's intelligence, and not to be sought by way of material acts."

WU: "What then is the Noble Truth in its highest sense?"

BODHIDHARMA: "It is empty. There is nothing noble about it."

WU: "And who is this monk now facing me?"

BODHIDHARMA: "I do not know."

But D. T. Suzuki differs with my interpretation of the significance of Emperor Wu's last question and hence I hesitate to press my interpretation. See his essay, "History of Zen Buddhism from Bodhidharma to Eno (Hui-Neng)," *Essentials of Zen Buddhism*, ed. Benard Phillips (London, 1963), pp. 95-149, esp. p. 117.

249. Vernon Lee, *The Beautiful* (Cambridge, 1913), p. 67.

250. Curt John Ducasse, *The Philosophy of Art* (New York, 1929), p. 153.

251. "Understanding" is appropriate. Ducasse notes "that sympathy is truly and directly a phenomenon of the realm of feelings; whereas the phenomenon . . . called Empathy is not this but is, directly, a phenomenon of *knowing*." *Philosophy of Art*, [above; note 250] p. 153.

252. William James, *Pragmatism*, (New York, 1907) p. 78.

253. In a similar vein, once it becomes evident that the critic is still critical, our spokesman cannot suggest endlessly that the religious works which he has accepted provisionally as evidence, are not sufficient, that he now must be responsive to others, or suggest that the parable which he now is trying to understand must be balanced by still another parable, and so on. These suggestions are not acceptable because they prevent men from evaluating religion. They never let it stand on, or touch, a common ground shared by anybody other than those who are thoroughly committed. In effect, the evidence which

this kind of Christian spokesman finally comes to accept as appropriate is defined not in terms of what we are calling the overarching culture or tradition at hand, but in terms of that which results in making a critic accept what the religious spokesman wishes him to accept. As long as the critic can say no to the spokesman's question, "Do you see?" so long does the spokesman continue to assert, "You do not have the appropriate attitude" or "You now must look in this place, no longer in that one."

254. Aristophanes, *The Clouds*, lines 368-380 in *The Complete Greek Drama* 2:556. Nietzsche insists that this tendency toward hypostatization is at the root of Descartes's argument, "There is thinking; consequently there is that which thinks!" The truth is, he tells us, arguments such as these are merely a formulation of our grammatical habit, which posits a doer for what is done." (Letter to Overback, no. 484, in *The Portable Nietzsche*, trans. Walter Kaufman [New York, 1954], p. 455).

255. Friedrich Waismann, "Verifiability," in *Logic and Language*, ed. Antony Flew (New York, 1951), p. 120.

256. Morris Weitz, "The Role of Theory in Aesthetics," *The Journal of Aesthetics and Art Criticism* 15.1 (Fall 1956): 35.

257. Paul Ziff, *Philosophic Turnings* (Ithaca, N. Y., 1966), p. 45.

258. Ibid., p. 46.

259. Interview with Igor Stravinsky, *New York Review*, 14 March 1968, p. 3.

260. Carl Hempel, "The Empiricist Criterion of Meaning," in *Logical Positivism*, ed. A. J. Ayer (Glencoe, Ill., 1959), p. 114.

261. John Wisdom, *Philosophy, and Psychoanalysis*, (New York, 1953) p. 157.

262. Ibid.

263. James Boswell, *The Life of Samuel Johnson, LLD* (New York, N.D.) p. 333.

264. *The Tsurezuregusa of Kenko*, trans. Donald Keene (New York, 1967), p. 36.

265. Interestingly, W. B. Gallie writes, "But history is not just past human actions, nor just those past human actions that happen to be known by men of a later generation. It is our name for the study of any past human action insofar as it is understood through its interconnectedness with other actions which a particular community or generation regards as of special interest to *them*. In other words 'our' history is whatever past actions our historians have succeeded in making intelligible to us, whoever 'we' happen to be." (*Philosophy and Historical Understanding*, [New York, 1968] p. 62).

266. This example clearly implies that whereas it is legitimate to judge art and religion by what they explain, it is not legitimate to judge them by what they do not explain. But this is obvious. The classical tenants of moderation and form, simplicity and harmony, proportion, stillness and clarity, are certainly inappropriate for evaluating works constructed in the baroque style.

The Buddha was quick to make this clear so far as religion was concerned. When challenged to generalize beyond those contextual truths which grew out of the questions he himself asked, he rather caustically responded,

"Consider as unexplained what I have not explained, and consider as explained what I have explained." The text then tells us that "with joy" his disciple "Mālunkyaputta applauded the words of the Lord" *Majjhima Nikāya*, Sutra 63, trans. E. J. Thomas in *Buddhism* ed. Clarence H. Hamilton (New York, 1952), p. 56.

267. Max J. Friedländer suggests fruitfulness is an appropriate category even for attributing paintings to painters. He writes, "A false verdict shows itself to be sterile. With the true something could be done, it was possible to build on it." (*On Art and Connoisseurship*, trans. Tancred Borenius [London, N.D.] p. 177). I wish that he had said more.

268. Renoir, *Renoir My Father*, [above; note 234] p. 220.

269. Italo Svevo, "Death" in *Short Sentimental Journey and Other Stories*, trans. Beryl de Zoete, L. Collinson Morely, and Ben Johnson (Berkeley, 1967), p. 302.

270. Friedrich Schleiermacher writes, "In all human things nothing remains unshaken. Every man must continually face the possibility of having to abandon the very belief that determines his place in the world and binds him to the earthly order of things and he may find no other, but sink in the general whirlpool." (*On Religion: Speeches to Its Cultural Despisers*, trans. John Oman (New York, 1958) p. 120.

Reprise

271. In the sense of recapitulation or possibly reiteration, certainly not in the sense of repetition which in music, it is true, may complete or may give rise to further expectation, but equally true, may do what I am afraid would happen here: simply saturate.

272. R. A. Scott-James, *The Making of Literature* (New York, 1929), p. 21.

273. *The Essence of Christianity* (New York, 1957), p. XXXV.

INDEX

A

abbishika 194
Abraham 25, 58, 192
Academia del Disegno 19
accommodation, doctrine of 46-49, 202
Adams, Henry 118
African face masks 11
 sculpture 60
Agostino di Duccio 154
ajñana 124
Alberti, Leon Baptista 154
Allah 191
Altieri, Charles 167
Altizer, Thomas J 192, 202
Amiens, Cathedral 8
Among School Children 91
Analects 88
Ananda 51, 55, 60
Anastasius 61
Anaxagoras of Clazomenae 135
Anaximander 45
Anaximenes 45
Andersen, Hans Christian 93
Andrea Del Sarto 71, 86
Anthropology 11, 12
Apollo 8, 38-39, 124-125
Apollodorus 124
Apologetics 176, 188-189
Apostles, Christian 20
Aquinas, Thomas 30, 45, 73, 85, 177

Architecture 50, 111
 Albany, NY 50
 Greek and Gothic
 compared 49-50
 Nervi's exhibition hall in
 Turin 50
 Nervi's Pallazzetto dello Sport in
 Rome 50
Aristophanes 66-67, 146
Aristotle 17, 18, 19, 31, 112, 113, 122, 175-176, 177, 182, 187, 197
Arjuna 49, 67
Arnheim, Rudolf 19
Art
 defined 2-9, 15ff
 as decadent 8, 20
 as naive 8, 19, 20, 172
 as minor or secondary 8, 59
 as realistic 20
 etymological associations 15
Art Deco 156-157
Art Nouveau 156
As I Lay Dying 63
Asvaghosha 202
Athanasian Creed 46
Athanasius of Alexandria 111, 126
Athenagoras II of
 Constantinople 100, 194
at-Tabarī 54
Au Clair de la lune 137, 138
Auden, W.H. 154

Augustine of Hippo 45, 48, 72, 81-82,
 104, 145
aum 17
Aurignacian painting 19, 98
Aus den Sieben Tagen 125
Austen, Jane 96, 111
Austin, J.L. 7, 104, 106, 107, 108,
 109-111, 140, 146, 168,
 181, 194-195, 197
 analysis of "performative
 utterance" 104-105
 analysis of "appropriate
 circumstances" 104-105,
 107-108, 109, 110
Australian aborigines 12

B

Baal 7
Bacchus 39
 Bacchae 38
Bach, Johann Sebastian 29, 37, 99,
 109, 119-120, 126, 152
Bacon, Francis 129
Ballet 22-23, 168, 173, 185
Balthus 84
Bar at the Folies-Bergeres 112
Baroque 59, 204
 music 99, 119
Basil of Caesarea 177, 179
Baudelaire, Charles 126, 133-134,
 155
Bauhaus 111
Beardsley, Aubrey 73
beautiful, contrasted with pretty 180
Beethoven, Ludwig, van 23, 57, 109
Being and Nothingness 180
belief, contrasted with faith 51-52
Bell, Clive 93, 129, 192
Benedict VII, Pope 61
Berg, Alban 22
Berger, Peter 1
Bergson, Henri 109
Bhagavadgita 47, 49, 58, 67, 82, 94,
 124, 199
Bhartrhari 55, 188
bhasya 95
Bible 128, 145

Bible 68
 New Testament 55, 57, 93
 Old Testament 94, 192
Bird in Flight 192
Bleeker, C.J. 167-168, 169
Bodhidharma 138, 185, 203
Bodhisattva 68, 79
Boethius 19
Bologna, Giovannida 192
Bonhoffer, Dietrich 105, 194
Book of Common Prayer 16, 125
Born, Max 198
Boswell, James 105-106, 151-152
Botticelli, Sandro 154
Boulez, Pierre 22
Bounty, His Majesty's Ship 10-12
Bourges, Cathedral 8
Brahman 17, 41, 45, 55, 77, 82,
 102-103, 182
Brahmanas 28, 29
Brancusi, Constantin 192
Braque, Georges 203
Brhadaranyaka Upanishad 182
*Bride stripped bare by her Bachelors,
 even* 167
Bridgman, P.W. 198
Browning, Robert 71, 86
Brueghel, Pieter the Elder 29, 73-74,
 187
Buddha 15, 51, 54-55, 60, 79, 80,
 99-100, 114, 124, 169, 181, 202,
 204-205
Buddhacarita 181
Buddhism 45, 60, 71, 78-79, 90,
 99-100, 142, 151, 152, 169, 171,
 182, 194
Bulgakov, Serge 101-102
Bullough, Edward 62
Bultman, Rudolf 128
Burnt Norton 53
Byron, George 154-155

C

Calvin, John 46
Canaanite Religion 7, 101-102
cancelli 188
Cappadocian Fathers 45, 179

Caravaggio 52
Carnap, Rudolf 126
Carroll, Lewis 133
Cary, Joyce 36, 141
Casals, Pablo 109
Cervantes, Miguel de 173
Cezanne, Paul 36, 89
Chandogya Upanishad 16, 51
Charles VII of France 64
Chartres, Cathedral 8, 20
Chaucer, Geoffrey 71
Chavannes, Pierre Puvis de 84
Cherry Orchard 172
chiaroscuro 52
Children's Games 187
Chisolm, Roderick 107-108
Choral dithyramb 38
Christianity 30, 60, 71, 74, 94, 102,
104, 105, 119, 125, 127, 140,
145, 172, 179, 186, 192, 202
Donatist controversy 80-82
Iconoclastic controversy 72
Roman Catholicism 169
Validity of its
sacraments 80-82, 110
chronos 124
Clark, Kenneth 83, 92, 93
Clement of Alexandria 55-57, 66, 73
Clouds, The 146
Clytemnestra 112
Coalescence 109, 115, 116, 117, 118,
126, 140, 142, 149, 151, 157, 160
Cocteau, Jean 185
Cole, Thomas 126
Colet, John 46-47, 179
Collingwood, R.G. 62, 148-149, 183
Collins, Phillip 128
Cologne, Cathedral 8
Conrad, Joseph 154
Constable, John 77-78, 126, 141, 188
Constantine 61
Coomaraswamy, Ananda 20, 193
Copernican cosmology 122, 158
Corregio, Antonio 84
Courbet, Gustave 18
Cox, Harvey 199
Craft 63, 87, 109, 138, 149, 159

criteria-evidence distinction 33,
193-194
Croce, Benedetto 104
Crusades, Christian 74
Cyprus, King of (legendary) 74
Cyril of Jerusalem 16

D

Dance 136, 168
Dante, Alighieri 71
Danto, Arthur 169
Debussy, Claude-Achille 22, 27
Delacroix, Eugene 181, 197
Della Pittura 154
Delphi, temple at 38, 39, 124-125,
127
Depression, the great 3
De Revolutionibus Orbium 158
Derrida, Jacques 172
Descartes, Rene 204
Desiderio, Da Settignano 154
De Spiritu Sancto, Basil's 177
De Trinitate, Augustine's 45
devil, the 83, 186-187
Dewey, John 33, 177, 193
analysis of "Classicism as an
Evangel" 40-42
philosophical fallacy, the 2, 97,
101, 110, 130, 200
Dhaniyasutta 16, 43
Dharma 15, 91, 138
etymological associations 15
Dickens, Charles 115
analysis of *Little Dorrit* 128-129,
131
Dickenson, Emily 70, 112
Dickie, George 168, 182
Die Walküre 37
diké 76, 187
Dionysus 7, 38
Bacchus 38
dithyrambic verse and the
temple at Delphi 38-39
Diptich of Melun 64
Distance 65, 67, 72, 75, 77, 79, 80, 83,
84, 85, 86, 87, 109, 116, 117,
159, 181, 182

Dithyrambic verse 39
Donatists 80-82
Don Quixote 24
Doré, Gustav 73
dragon, Chinese symbol 42
Dryden, John 3
Ducasse, Curt 143, 203
Duccio Di Bouninsegna 57, 58, 77,
 80, 172
 analysis of the *Maestà* 20-21
Duchamp, Marcel 78, 167
Dürer, Albrecht 118, 150, 152
Dutch Still Lifes 74

E

East Coker 54
Economics 12
ecstatic 188
Eddington, Arthur 4
Egypt, Ancient religion of 7, 28, 77
El 8
Elgin Marbles 60
El Greco 59
Eliade, Mircea 4, 5
Eliot, T.S. 14, 53-54
empathy (*einfühlung*) 143, 144, 176,
 203
Empedocles 67
emptiness (*sunyata*) 138, 201-202
energeia 17
Enlightenment, The 5, 185
entelecheia 167
Epstein, Jacob 35-36, 94, 98, 193
Etruscan Places 179
Euripides 38
Evelyn, John 61
experience, contrasted with
 knowledge 183

F

Fact-opinion distinction 127-192, 130,
 131
Faith 72, 99, 103, 121, 175, 177, 180,
 191, 192
 contrasted with belief 51-52
fascinosum 34-37, 39-40, 52, 175-176
Faulkner, William 63

Feuerbach, Ludwig 47, 163, 180
filioque clause 45-46
Fitzgerald, F. Scott 54
Flaubert, Gustave 50
folk music 37-38, 176
Fo-Sho-Hing-Tsan-King 201-202
Foucher, A. 181
Fouquet, Jean 64
Foxe, John 92
freedom 16, 192
Frege, Gottlob 197
frescoes 71
Freud, Sigmund 65-66
Friedländer, Max J 205
Frost, Robert 18, 50-51, 70
fruitfulness 123-127, 153-155, 157,
 205
Fry, Roger 73, 93, 171, 187
Frye, Northrop 154
Fulbert of Chartres 83
fu shen 20

G

Gabo, Naum 98
Galatea 74
Galen 74
Gallie, W.B. 6, 169, 204
gardens, French
 and English compared 2, 155
 Japanese rock 182
Gardner, John 198
Gass, William 7, 8
Gaster, Theodore, analysis of punctual
 and durative levels of religious
 expression 101-102
Gates of Paradise 154
Gay, Peter 5, 169
Geertz, Clifford 6, 8
Geometry 127, 156, 157
Gepetto 74
Geyl, Pieter 4, 169
Ghiberti, Lorenzo 154
Ghirlandajo, Domenico, analysis of his
 Last Supper 112, 123
 analysis of *Giovanna Tornabuoni
 degli Albizzi* 34-35
Giacommetti, Alberto 25
Gibran, Kahil 185

Giorgione 84
Giotto 20, 57, 93
Giovanna Tornabuoni degli Albizzi 34-35
glorify, to 97
Glover, John 92
God 11, 16, 17, 19, 25, 29, 30, 32, 33,
 40, 53, 55-57, 66, 81, 88, 90,
 94, 95, 104, 139, 145, 171,
 177, 180, 181, 186, 188,
 191, 197, 201, 202,
 as an incomplete
 concept 44-49, 82-83
 fear of, as the beginning of
 knowledge 51
 as love 67-69
Gogh, Vincent van 29, 30, 32, 52,
 105, 194
Gombrich, E.H. 141
Goodman, Nelson 1
Gothic 8, 49, 50, 59
Goyen, Jan van 2, 155
Graham, Martha 112, 136
Grass, Günter 103, 104
Gregory of Nyssa 33
Gropius, Walter 111
Grotowski, Jerzy 34
Guayana Indians 160-161
Guillaume, Alfred 194

H

Hallaj 23
Hanafi system of law 100
Handel, George Frideric 37
Hanson, R.P.C. 177
Hare, R.M. 168
Hayden, (Franz) Joseph 23, 57
Heaven 68, 80, 88
Hegel, G.W.F. 75, 88, 191
Heidegger, Martin 97, 103, 118
Heisenberg's Uncertainty
 principle 116
Helena 61
Hemingway, Ernest 63, 154
Hempel, Carl 149
Hepburn, Ronald W 188
Heraclitus 97, 198
Hermes 38

Herrigel, Eugen 182
Hesiod 52, 187
Hesse, Herman 125
Hick, John 179
Hindemith, Paul 153
Hinduism 47, 68, 102, 127, 171, 191,
 caste system 28ff, 41
 Vaishnavite school 30, 68-69
 Tantra 68, 69
History 3, 4, 119, 128, 200, 204
 and Historians 11, 168
 of religion 168
 of philosophy 168
 of art 168
 of science 199
Hiuen-Tsiang 78-79, 81
Hobbes, Thomas 139
Hokusai, Katsushika 89, 118
Holy Family, The, Karl Marx's 200
Homecoming, Friedrich Hölderlin's
 elegy 103-104, 118
Homer 8, 111, 187
homoousios 197
Hōnen 152
Horace 31, 113
Hospers, John 134, 198
Housman, A.E. 154
Huizinga, Johen 199
Hume, David 5, 28, 31, 134
Hundred-Guilder Print 93
Hunger Artist, The 89
Hunters in the Snow 187
Husserl, Edmund 3
hybris 187
Hyperboreans 39
hypostaseis 45, 197

I

icon 72
Imàm 47
Industrial Revolution 6
Information theory 4
 feedback mechanism 126, 127,
 144
Initiation ceremony 1, 53, 194
Innocence 79, 109, 160, 162, 181
Ino 38
Invocation to the Social Muse 75

Islam 30, 47, 57-58, 88, 100, 119, 182,
 186, 191
 Shiite 47
 Sufis 72
Isvara 135
Italian Concerto 37

J

Jaeger, Werner 187
James, William 136, 144, 177
Jaspers, Karl 175
jazz 37-38, 95, 176
Jesus Christ 4, 20, 25, 39, 55, 57, 71,
 74, 80-82, 105, 114, 123, 124,
 129, 136, 140, 169, 172, 182,
 186, 194, 202
Jñanesvar 68
Joan of Arc 140
Job 58, 83
Jodo 152
Johnson, Samuel 105-106, 151-152
Johnston, E.H. 181
Judaism 7, 33, 44, 46, 58, 94, 141,
 202
Judas Iscariot 61

K

Kabuki 22, 27, 171
Kafka, Franz 89
kairos 124
Kandinsky, Wassily 73, 176
Kant, Immanuel 185
Karma 88, 191
 etymological associations 53
Katia Reading 84
Keats, John 50
Kena Upanishad 44, 47
Kenko 152
Kierkegaard, Soren 53, 141
Kisselgoff, Ana 201
Klee, Paul 24, 52, 69-70, 94, 139-140
knowledge, contrasted with
 experience 183
koan 16, 60
Koran 54, 57-58, 59, 88, 182
kouros 28

Krishna 67
Kritik 99
Kuhn, Thomas S 199
Küng, Hans 176, 189
Kwan-Yin 79, 81

L

Lampon 134
Lang, Berel 182, 193
Langer, Susanne K 186
Laokoon 49
Laon, Cathedral 8
Last of the Mohicans, Thomas
 Cole's 126
Last Supper, Ghirlandajo's 112, 113,
 123
Last Supper, Leonardo Da Vinci's 112,
 118, 123
Law 9, 105-107, 151, 152
Lawrence, D.H. 154, 179
Lee, Vernon 143
Leonardo Da Vinci 31, 32
 analysis of *Last Supper* 112, 118,
 123
Lessing, Gotthold Ephraim 49, 99
Little Dorrit 128-129, 131
Lives of the Virgin and Christ 93
logos 198
London, Herrold's 73
Loran, Erle 176
Lord Byron, Northrop Fry's 154-155
Lorrain, Claude Le 2, 155
Love (*bhakti*) 24, 66-69, 86, 94, 119,
 191, 194
Luther, Martin 89
 and the Peasants' Revolt 6
Lyrical Ballads 62

M

MacLeish, Archibald 35-36, 75
Madhva 68-69
Madonna della Misericordia 21
Maestà 20-21, 57, 77, 80
Magdalenian painting 19, 98
Magic 63, 87, 109, 138, 149, 159
Maha-Vairocana Sutra 79

Mahler, Gustav 60
Maillol, Aristide 64
Mainmonides, Moses 175
Maitri Upanishad 17, 32, 75, 88
Majjhima Nikāya 43, 204-205
Malinowski, Bronislaw 88, 89,
 101-103
mana 77
Mandelbaum, Maurice 169
Manet, Édouard 112
Mannerism 59
Mantra 78-80
Manumission, act of 105-107
Mao Tse-tung 19
Marat/Sade 32
Marx, Karl 99, 200
Marxism 11, 19, 74
Mary, Mother of Christ See Virgin
 Mary
Maxentius 61
māyā 16, 20, 171
McLuhan, Marshall 151
Meergeren, Van 84, 85, 121
Melanesians, religion of 101
Melville, Herman 154
Mendieta De, Emmanuel Amand 177
Mercury 192
Messiah 74
Messiah, Handel's 37
Messianic age 68
Metaphysics 17
Meyer, Leonard 201
Michelangelo Buonarroti 36
Middle Ages 5, 20
 German mystics of the 72
Milne, A.A. 87
mimesis 17-18
Miserere 103
Mitchell, Basil 120-121
moksa 68
Monet, Claude 27, 112
Montaigne, Michel de 14, 16, 98, 99
Mont Blanc 193
Monteverdi, Claudio 99, 119, 126
Moore, G.E. 168
Morris, Charles 186
Mother Courage 172
Muhammad 54, 186

Munch, Edward 153
Mundaka Upanishad 17, 55, 56, 58
music 22, 128, 130, 137, 149, 155,
 173, 176, 199
 fascinosum and *tremendum* in
 tension 37-38, 176
myth, use of 198

N

Nârada 4
Neale, Robert 199
nembutsu 152
Nervi, Pier Luigi 50
Netherlandish Proverbs 187
Nichomachean Ethics 182, 187
Nietzsche, Friedrich 25, 104, 204
Nirvana 28, 68, 69, 186, 202
nothing 16, 201-202
Notre Dame of Paris 8
nude, the 83-84, 92-92
Nude Descending a Staircase 78

O

Odysseus 111-112
Origen 185-186
Original Sin 16, 171
Otto, Rudolf 34, 36, 41, 51, 175-176
ousia 17, 113, 197
Ovid 31

P

parable, use of 198
Parade, cubist ballet 185
Paradies und die Peri 92
Parker, DeWitt 65-66, 67, 69, 72, 73
parochet 188
Paul, Apostle 44-45, 47
Paul VI, Pope 100, 194
Pausanias 38
Peirce, C.S. 186
Pepper, Stephen C 187
Pepys, Samuel 65
Pericles 134-135
Peter, Apostle 55
Petrarch 113, 200

Petronius 51
Phaedrus 67
Physics 17
Picasso, Pablo 17, 18, 35, 89-90
Pico della Mirandola 90
Piero della Francesca, analysis of
 Madonna della Misericordia 21
Pieta 36
Pindar 97
Pinnochio 74
Pirandello, Luigi 32
Pittenger, Norman 39
Platform Sutra of the Sixth Patriarch 91
Plato 2, 66-67, 113
Platonism 21, 161, 185, 197
play, or game 107, 199
 līlā 135
Plutarch 39, 134-135, 176
Poetics 112
Poetry 18-19, 50, 62, 70-71, 88, 97,
 103, 115, 118, 136
Pollock, Jackson 100
Pollitt, J.J. 187
Polloaiuolo, Antonio and Piero 154
Portraiture, eastern criticism of 20
prajña 124
prayer 17, 72, 76, 90, 95, 98, 199
predella 20, 57
pretty, contrasted with beautiful 180
principium 45
Pritchard, James B 169
Prophets, Jewish 20
 contrasted with
 soothsayer 54-57, 65
Proust, Marcel 7, 13, 96, 169
Psychology 4, 5, 11
 laboratory procedure 152-153,
 157
 psychological understanding of
 art 65-66
 psychologism 62, 63, 106-107,
 110, 182
Ptolemaic cosmology 122
pun 125, 199
Python 124, 127

Q
Questions of King Milinda 60

Quietists 72

R
Ramakrishna 4, 25, 32, 33, 95, 168
Ramsey, Ian 120
Randall, John Herman 70, 186
Raphael 86
rasa 193
Redon, Odilon 84
Reims, Cathedral 8
relics 60-61, 72
Religion, defined 2, 9, 12, 15ff
 as decadent 8
 as minor or secondary 8, 59
 as naive 8, 172
 doubt 16
 etymological associations 15
Rembrandt 52, 93, 95
Renaissance 5, 59, 64, 162
Renoir, Pierre Auguste 92, 138, 155
Representation 19, 20, 22, 78
 naive 19, 20, 21, 27, 172
 psychological 20
 representative symbol 71, 72,
 83, 186
Rhys David, T.W. 182
Rig Veda 28
Rilke, Rainer Maria 68
Rima 35-36
Robinson, Edward Arlington 71
Rodin, Auguste 89
Rogers, Neville 96
 treatment of Shelley's *Mont
 Blanc* 193
Rorty, Richard 172
Rousseau, Jean Jacques 60
Ruisdael, Jacob van 2, 155

S
śabda, contrasted with *sphota* 188
Saint Croce of Jerusalem 61
Saint Denis, abbey 8
Saint John Passion 29
Samsara 69, 186
Sancho Panza 24, 74
Śankara 95, 171

Santayana, George 48
Sarah Dohakosha 69
Sartre, Jean-Paul 25, 27, 155, 180
Satipatthana 60-61
Schechner 172
Schiller, Friedrich von 8, 169, 172
Schleiermacher, Friedrich 46, 205
Scholem, Gershom G 175
Schönberg, Arnold 176
Schopenhauer, Arthur 13
 interpretation of the Christian
 "Lord's Prayer" 56
Schrodinger, Erwin 116
Schumann, Robert 23, 92
Schutz, Heinrich 22
Science 6, 12, 120, 122, 135, 149, 150,
 152ff, 157, 198, 199
 difficulty of definitions 14-15
 quanta facts 115-116
 physician's laboratory
 procedure 153, 157
Scott-James, R.A. 162
Scrooge, Ebenezer 115
Sculpture 192
 systems-oriented 32
 Greek Kouros model 28
 Khmer tradition 71
Seebohm, Frederick 179
Semele 38
Seneca 113
Sergueyev 22
Servan 172
sfumato 31
Shakespeare, William 8, 96
Shapiro, Meyer 188
Shelley, Percy Bysshe 193
Shephard, Ernest H. 156
Śhiva 25
sign 186
Significant Form 93, 129, 192
silence, liturgical 16
Simson, Otto von 169
Singer, Isaac 33
sinopie 71
Six Characters in Search of an Author 32
Smith, Wilfred Cantwell 167
Sociology 11
Solon 103
Sonata 22, 23, 153

Soothsayer 73
 contrasted with prophet 54-57,
 65
Sorcerer 73
Sorel, Agnès 64
Souillac 83
sphota, contrasted with *śabda* 188
Spivak, Gayatri 172
Stanislavsky 172
Stein, Gertrude 17-19, 27, 35
Stendhal (Marie Henri
 Beyle) 192-193
Stevens, Wallace 30, 31, 32, 88, 92,
 97, 141
Stockhausen, Karlheinz 22, 125, 199
Stoics 198
Stonehenge 127, 131
Stravinsky, Igor 22, 149
Strawson, Peter F 11, 170
style 59, 90
Sublime 188
Suger, Abbot 8
Sun Also Rises, The 63
Surrealism 66
*Sutra of the Heart of Perfect
 Wisdom* 78-79
Suzuki, Daisetz 89, 92, 114, 203
Svetasvatara Upanishad 17, 102
Svevo, Italo 155
Swan Lake 22
Sweeney, James Johnson 142
symbol 70, 186
symposium 67

T

tabula rasa 2
Tacitus 31
Taittiriya Upanishad 77, 91
Talmud 46
Tathâgata 60-61
technē 76, 182, 187
Tempest, Dryden's 3
Ten Oxherding pictures 201
terribile 36, 118, 127
 terribilatà 36, 127
Theaetetus 67

Theater 93, 171-172, 173
 Elizabethan 22, 171
 Environmental 32
 Greek 38
 Kabuki 22, 27, 171
Theology 177
 fascinosium and *tremendum* in
 tension 39-40
Theophilus 83
Thomas, Apostle 61
Thomson, Virgil 128
Thucydides 135
Tiger, Chinese symbol 42
Tillich, Paul 29, 141, 144
Timaeus 2
Titian 29
Toklas, Alice B 17
total drift 123-125, 127, 129, 130,
 150, 151, 154
*Tractates on the Gospel According to St.
 John*, Augustine's 104
Tragedy, Greek 38
Transmission of the Lamp 142-143
tremendum 34-37, 39-40, 51, 52,
 175-176
Trinity, doctrine of 45-46, 179
Tukaram 69

U

Übermarionette 172
Unamuno, Miguel de 68, 180-181
Upanishad, defined 15-16

V

Vakapadiya 55, 76
Van Buren, Paul 192
Van Gogh, Vincent, see Gogh,
 Vincent van
Variations series, Picasso 89-90
Vasari, Giorgio 36
Vassos, John 156
Vedas 28, 67, 82
Vermeer, Jan 84-85, 121
Verrochio, Andreas del 154
Vijñana 124
Virgin Mary 21, 82-83, 118-119, 172,
 198

Vishnu 47, 67
void 16
Vollard, Ambroise 36-37
Voltaire, Francois-Marie 43
Vyâsa 95-96, 97

W

Wagner, Richard 37, 167
Waismann, Friedrich 147
Walsh, W.W. 169
Warner, Marina 198
Weiss, Peter 32
Weitz, Morris 148
Westminister, Abbey 8
Weymouth Bay 126
What is Enlightenment? 185
Whistler, James 74, 114
Wilde, Oscar 136-139, 202
Wilson, Edmund 128, 200
Winckelmann, Johann 168
Wisdom, John 9, 107, 151, 169
Witch 186-187
Wittgenstein, Ludwig 13
Wivenhoe Park 141
Wolfe, Thomas 63, 154
Woolf, Virginia 96
Wordsworth, William 62
Works and Days 52
Worringer, Wilhelm 57, 59, 180
 on Gothic and Greek
 architecture 49-50

Y

Yeats, W.B. 91
Yellow Book 73
Yoga Sutras 95

Z

Zen 16, 53, 72, 104, 138, 142-143,
 182, 199, 201,
 Renzai and Sôtô compared as
 per koan 60
 Renzai and sudden
 illumination 63
Zeno 146
Zeus 38, 146

Ziff, Paul 148
Zola, Emile 19
Zuurdeeg, Willem 202